1

The Orchid House

The Orchid House

Art Smuggling & Appointments
In India & Afghanistan

Clark Worswick

Midnight Books, LLC

For their careful, thoughtful editing labors, ideas, and assistance:

Lucia Levine, Sabra Besley, and Zoe Kirby.

Clark Worswick/Midnight Book LLC
1283 "A" Fruitville Road
Sarasota, FL 34236

Book Layout © 2014 BookDesignTemplates.com

1st Print edition, 2nd Edition.

Library of Congress Cataloguing-in-Publication Data

Worswick, Clark

The Orchid House, Art Smuggling and Appointments in India and Afghanistan

Includes Biographical References

ISBN 978-0-9969280-4-5

1. Travel. 2. Indian Art. 3. Biography, Worswick, Clark 1940. 4. Art Smuggling, India. 5. India. 6. Photography of India

Cover Photograph:

The Lake Palace, Udaipur, Colin Murray, 1872. Albumen Gold toned print.

Dedication

For Joanie who always believed. To Lucia our
darling daughter, and to Sabra Besley, my lovely
sister, who made this book possible.

PREFACE

When I first traveled to Bombay I arrived by boat, like the preceding four and half centuries of westerners who first settled a set of small, unpromising malarial islands at the edges of the Arabian Sea. In time, the city, with its disparate populations that had dared to populate a swamp, became one of the greatest, most important trading enclaves of the world.

For uncounted millennia the western coast of India linked the trade routes of far Asia to Egypt and the civilizations of the Mediterranean.

In the many bays surrounding Bombay, the trading *sambuks* and *dhows* came to rest. Sailing forever between the Pacific, and the Mediterranean they sheltered safely from the monsoon amongst low lying islands waiting for trade winds that would carry them on their endless journeys.

In 1947, at the moment the British Raj ended, a hopeful new country emerged that was named India. In the political re-configuration of an entire subcontinent, however, such became the power of latter-day sectarian populist adventurers that an ultra-right wing Bombay cartoonist affected the erasure of Bombay from the maps of the earth. In a new era of political correctness, the city was sonorously renamed Mumbai, after a forgotten mud bank and a small 15th century village.

This is a book about a vanished place. It is also about a city, which like much of India in the last half century, has changed utterly, except perhaps in memory.

DELHI, DECEMBER, 1963

The coldest month. December. Daylight.

The sun struggled to emerge from a pall of dust which covered north India to the Himalaya.

As it always did, the day began with small, undersized Indian promises. Daylight touched the walls of my hotel room. The walls looked like they had last been painted in 1947. In darkened hotel corridors I made my way towards the breakfast room and my daily newspaper at my usual table. In the moment it took to open my newspaper the way I'd lived my life turned towards plans of escape from India. Running then down the corridiors, I vanished into the darkness and my room, like the hyenas of hell were about to turn me into instant bloody froth.

Into a small mirror workbag that fit around my chest, I dropped one Leica M2 circa 1959 that I'd bought in Hong Kong. Next went sunglasses, a hat, three shirts and an extra pair of shorts. I stuffed $4,250 in $50 bills into a money belt. I shoved the belt into the small of my back. Ready to go. The rest of my possessions I left for the Indian Criminal Investigation Division.

Years before, in Asia, I learned caution. If the need ever arose at some future inconvenient moment, I had obtained two different passports. One passport was fresh and never used. The other was ragged and dog-eared. The older passport was decorated by six, two-foot-long accordion-like extensions which, over the last four years, had been franked with over a hundred thousand miles

of travel. Both my passports had different names and they came from different countries.

Once in Connaught Circus, I passed through the crowds moving toward the largest store in New Delhi. The Khadi Emporium, which sold antique curios, tribal art and hand loom textiles, was teeming with people. A vibrant, bird-colored pageant of silk-sari-clad Indian women surrounded a display of Northeastern Frontier tribal art. Lately, the art of the Nagas and their previously unknown tribal artifacts had made the Indian upper classes of Delhi feel culturally aware and significant.

Two minutes later I exited the building, fleeing into the alleyway behind the Khadi Emporium. I had to reach the Chandi Chowk, the main bazaar of old Delhi, where I could disappear. Spilling out of the alleyway onto Curzon Road, I flagged down an Ambassador taxi. I jumped in while it was still moving, giving precise directions and a route for my escape to the Sikh driver.

"My friend will meet me at any of two places along the way," I said. "I want to pass first by the Houses of Parliament. Second, we move out to the Muttra Road. Jaldi hai? I'm late for my appointment with my friend. Old Delhi, hai?"

The taxi accelerated down Curzon Road. I looked back through the rearview window and took a deep breath as I sank back against the seat. Across the broken sidewalks, I seemed to have made an escape without being followed, although trying to remain invisible to my pursuers was virtually impossible on the wide tree-lined boulevards.

In the back seat, I changed into shorts and a different color shirt, while the driver watched me in the rearview mirror with growing alarm. At Muttra Road I waved left toward Old Delhi. As we sped northward, I told the driver that I had lied about meeting a friend. I admitted, instead, my mistake of a promised matrimonial alliance with a lady of the upper classes. I leaned forward and explained the exquisite difficulties of conflicting cultural values.

The brother of my intended was a dashing Rajput army major of the Ganga Jaisalmer Risala and the Indian Army Camel Corps. He was threatening my life. With this admission, the driver laughed a kind of hooting guffaw and agreed to aid in my escape. The Sikh taxi wallah pounded the steering wheel with delight.

From a stapled packet of one rupee notes, I dropped three times the normal taxi fare onto the seat next to him. The man looked down at the money looking as though he hadn't had such a good time in months. I pointed toward the main mosque in Old Delhi. At the Jami Masjid I rolled out of the taxi.

The wind was picking up. A veil of dust covered the morning sun. I turned toward the mosque and perhaps religious salvation. A huge flight of seventy-five-foot-wide stained steps tilted upward into the mosque. At the top of the stairs, I waited in the shadows of the entrance. As I studied the street below me, somehow, as if by malignant magic, two Indian-made white Ambassador cars jerked to a stop.

In seconds, four men erupted from the cars and rushed toward the steps. Beyond the gateway, I was already moving across the

vast courtyard filled with thousands of worshippers. How the Criminal Investigation Division had followed me was a total mystery. Then again, how difficult was it really to stalk a lone, distinctively dressed American?

I faced many decades in an Indian prison. No one survived a single decade. This was getting suddenly quite terrifying.

In the giant crowds which swirled around the mosque courtyard, I thanked my luck it was Friday prayers. Keeping a careful pace, I forced myself not to look back. From the center of the gigantic interior mosque courtyard, I elbowed toward the nearest exit toward the Chandi Chowk and pulled my hat from my bag. Ahead of me, hundreds of people were now pushing past into the mosque for morning prayers.

At the north gateway I turned. Three hundred feet behind me, the men stood searching the crowds which filled the courtyard. They were dressed in fresh white clothing designed to go unnoticed in a crowd of five thousand worshippers also wearing white. Moving through the huge gateway, I fled down the steps.

In the Chandi Chowk, after ten minutes of pushing my way along through an ever-shifting scrum of bodies that populated the most crowded street in India, I found the alleyway I wanted. In this crowded alleyway buried in the depths of Old Delhi, was a used clothing shop.

In the back of the store, out of sight of the street, I bought a plain, once white, used kurta, and a pair of billowing pajamas. In another store down the alleyway I found a ready-tied dilapidated Jat turban of an ochre color, faded by years of wear that went with my beaten, aged Katiwhar sandals. I stared at the person

who stood before me in the cracked, heat-stained mirror in the darkness. Passable.

I hunched my shoulders. I stooped forward with the look of a weary, drugged-out ryot who had met his match and gone down upon a tidal wave of ganja. Beyond the shop, in the alleyway, I rubbed my hands over the ancient dirty walls of the buildings. Moving back toward the Chandi Chowk, I rubbed my palms, now coated with grime, over my legs and arms then my neck and face. My bag I looped over my chest under the voluminous, shapeless, dirty kurta.

I emerged from the alleyway a new man. I was a stoned peasant ryot, of the lowest order of Indian society. I staggered along the heat-cracked sidewalks. I was one of scores, a hopeless case, and a man near death. On the Chandi Chowk I'd come to the end of the line.

Against a wall I lowered myself onto my haunches. I bent my head downwards and then put out a very dirty hand, palm upward. Ten minutes later, next to me on the sidewalk, was small pile of paisa coins. A pair of shiny black military-style shoes stopped in front of me. The shoes stood there for fifteen tortured seconds and then a foot whacked my shin. I groaned.

After a moment the man moved away. Down the street there was a flash of blinding white, newly washed clothes. The only place to hide had been in plain sight.

Two hours later at the Old Delhi railway station, I passed CID men in couples who scanned the street entrances. Inside the station, more policemen scanned the crowds with a kind of

terrible, almost casual grace. India had lately augmented its internal security by hiring a huge number of CID personnel. Just over a year ago, the Chinese had invaded India with not one, but two armies. Perhaps, today the CID was looking for Chinese in the Delhi railway station? I thought it more likely, however that the Indians were hunting Americans, or rather one American in particular.

I moved slowly down the platform toward the Delhi-Jaipur train. No one looked at me. There were probably hundreds of ryot indigents like me in the station. We were the treasure of the bhang fields of northern India. We had given up our lives for travel and ganja. The freshly pressed CID men avoided my eye as I shuffled past them. Perhaps the police felt uncomfortable with the karma of ticketless travelers who'd slipped into the abyss.

At the end of the platform I climbed into a crowded third-class coach train leaving Delhi. In the afternoon heat the great steam locomotive began to slowly huff and chuff its way out of the station. I was lost inside the train in an overcrowded welter of sweating bodies as the engine pulled its bogey load of uncomfortable travelers out of Delhi.

It had all been there in *The Hindustan Times* that morning. A gang of international art thieves had broken into, then looted the King of Afghanistan's treasure house. How long had the CID Special Branch been following me? What a terrible way to wake up.

I tried to calm down, and caught my breath, trying to go back over the last few days. Had they been following me since I'd

returned from Paris? Probably. Had they obtained arrest warrants from the Afghans? Possibly.

Certainly they had been ready to cast their nets, then reel me in. Somehow, I'd simply bolted.

Cramped hours later, in the late afternoon, I climbed down off the lee side of the third-class compartment of the Delhi-Jaipur Down Express. In Ajmer, I dropped onto the tracks. Then, I ducked under the waiting Jaipur-Delhi Up Express on the next track. On my journey that afternoon from Delhi, there were scores of operatives of the CID who seemed to be practicing police work and turning out the populations of every railway station we passed.

Climbing up onto the platform, I settled inside another horribly crowded third-class compartment. Huddled next to the toilet compartment, I stood in a cold sweat. Through the crush of bodies, through the jail-like bars which covered every window of the compartment, on the opposite platform passed six or seven pairs of well pressed CID men. Up and down the quarter-mile-long platform they moved, peering into each compartment of the train. An eternity later, the engine began to pull my new train out of the station.

On the far outskirts of Ajmer, I managed to reach the compartment door. The third-class trains ran with their compartment doors open because of difficult-to-obtain ventilation. Losing my footing, I stepped off the train into mid-air. As I began to fall, I looked back and registered the surprised faces of my fellow passengers. Cradling my head under my arms, I hit the steep rocky embankment. Then, I went rolling

down and down, over and over, across the rocks until I finally struck the hard-packed desert.

A minute later, tired of staring up at the blank sky, painfully I stood up. I checked for breaks or wounds. My workbag with my clothing and money, both wrapped around my Leica, was still pressed against my back. Bending over, I stripped off my kurta and my pajamas and gave myself a sand bath to get rid of the Delhi grime on my face, arms and legs.

Dusted off, and more or less whole, I realized that the Delhi-Jaipur highway was a quarter of a mile away. As I moved toward the highway, I was still wearing my turban as well as a pair of long pants and a tennis shirt. At the side of the highway, or rather what was considered the highway, I waited. In front of me was a single, twenty-three-foot-wide thinly macadamized track of paved-in bumps and whorls.

In the distance, the train disappeared. I took a deep, very deep breath. It was time for me to visit the ashrams in Saurashtra or Gujarat.

Ten minutes later, standing on the side of the road, I waved down a huge Tata Mercedes diesel truck that came careening down the highway. The truck braked two hundred yards down the road with a hiss of protesting machinery. It was driven by a villainous-looking Sikh. After bargaining with the driver, I dug out of my pocket the last rupees from my stapled packet of one rupee notes.

I passed the notes to the driver's assistant, who in turn handed them to the driver. Holding them up to the sunlight to see if they

were counterfeit, the huge man turned. He sat there for a moment staring down at me.

The soul of caution, the driver asked why, as a firangi I was going to Rajasthan and what was my destination.

I said that I was a pilgrim from the West. After the Sikh gudwaras of the North, in Amritsar and the Punjab, I was planning a tour of the Jaina holy places in Rajasthan where I planned to stay in pilgrimage serais. I explained that I was visiting the world-renowned religious sites of Rajasthan Saurashtra, and perhaps Gujarat in hopes of escape.

The huge man handed my rupees to his assistant. He was one of the largest men I'd ever seen in my life. He had black shoulder-length hair set off by a mouthful of crumpled, rotting teeth. He pointed at me and then told his assistant to return my money. The huge Sikh would not take a pice (1/64 of a rupee) from a man bent upon pilgrimage to the holy sites.

In a deep booming voice, he said I should climb on top of his loaded truck. He, the driver of this magnificent Tata diesel, would himself transport me to the holiest pilgrimage places of Rajasthan.

I chose my usual place at the very center of the hugely loaded truck. I'd discovered this spot previously when hitchhiking on another of these huge trucks which traveled the grand trunk roads of India, crossing Pakistan, Afghanistan and Iran. I settled back and was surrounded and then buried inside the trucks monster, overweight load.

As we passed through Ajmer, its citizens fled for their lives as the truck came hurtling out of nowhere into the crowded streets of the city. With the din of its air horn and the terrorizing continual shriek of its attack, the huge machine blasted through town. Cars screeched to a stop moments from cataclysm. The truck swerved. An ayah with a baby carriage froze in her tracks.

Then we were through the city, and barely twenty minutes later the truck moved down through its gears through the low hills above the city. After the hills, we entered the barren outskirts of a desert populated by dust devils and the ruins of princely dreams. Some 2,300 years earlier, Alexander had marched to the edges of this desert. Spread-eagled over a consignment of cotton bales and jute-packed bicycle parts in lumpy bags, I lay on top of the truck. I stared up at the darkening sky.

Above me the clouds moved slowly northward toward Afghanistan. In the last weeks, I'd been in Italy, France, England and Switzerland. Before I'd gone to Europe, I'd come down through the Khyber, down out of Kabul to Peshawar.

I considered my recent fortunes. Thinking back to the newspaper article that had caused my flight from Delhi that morning, I shuddered.

I suppose the authorities in India and Europe saw my crimes as art smuggling. I however considered myself an art collector. My transgressions and malefactions involved moving art across international borders. Lately, I had to admit that it had become very expensive art which I'd been secreting through the barbed-wire-separated borders. Taking the long view of things, I simply moved my art from one place to another.

In the great heat and the dust of this vast desert, I was free somewhere above the wind. Ahead of the dusk, the Rajasthan deserts waited for the coming night. Beyond the desert there were the small Indian ports with cargo laden dhows sailing the Arabian Sea for east Africa, for Muscat and the Gulf.

Last September, I was twenty-three years old. God what a run I'd had!

Jack Kerouac had once said that for a story to exist, as life exists, the plot of a book was like a deck of cards. You dealt the cards out in any order. The story would remain the same.

This book is about what happened.

In the end I don't believe in story plots anymore. Life has no plot to it.

Notebook1

1959

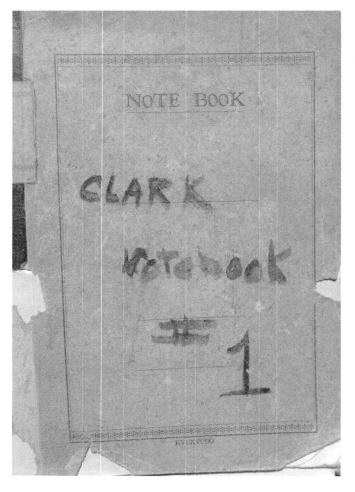

My first Notebook: Purchased in Yokohama

BOMBAY, MAY 1959

I arrived from Yokohama at midday during the great heat.

I took a room on the second floor of an airy, pleasant Edwardian hotel on a deserted tree-lined street in Colaba, two blocks from the Arabian Sea. The street was filled with tiffin wallahs carrying buckets of food for office workers' lunchtime meals. The city had a languorous, heat-drugged calm.

On the Colaba causeway, outside the Regal Cinema, I bought my first book in India. I bought it from a sidewalk vendor and it was a tattered history of Bombay that began in 1705. During a long, leisurely lunch I began to read my new purchase at an Iranian restaurant, a block away from one of the only two air-conditioned movie theaters in all of western India.

I devoured my book on Bombay. The story of Bombay was totally improbable. There were frantic escapes and scarcely believable survivals. Great naval admirals appeared and the fates of the emergent British presence in India were held by a thread. Somehow, against the French, the Portuguese, and even the Dutch, the British prevailed in India.

The city of Bombay was a British city. It had been founded and then expanded over the surface area of seven small islands when the British had fought a two-century battle up and down the Indian coast. By the beginning of the eighteenth century, Bombay had become one of the chief entrepots of British trade in India. As I read my new book, it described the slow creeping

cadence of the British and their discoveries of India, during the seventeenth and eighteenth centuries. It was a period when the British struggled to occupy the entire subcontinent based on the practicalities of avoiding usurious, crushing taxes levied by various local nawabs and maharajas.

In the vernacular, Bombay was called Mumbai. In the local dialect, the Kali goddess Mumbai was the consort of the Hindu goddess Siva, the creator and the destroyer of the world. The city was aptly named, at least for the British. Immediately after the British arrived in Bombay, the city's graveyards began to fill up precipitously. Populated with freshly dressed, now deceased young Englishmen, the Bombay "planting grounds" were filling up with factors and clerks of the East India Company.

The problem with Bombay was that the newly emergent city was located in an area of tidal swamps full of malarial swarms of mosquitoes which devoured Europeans. At the very least, one could say Bombay was not ideally located.

Very little fresh water was available. Combined with "the vastly incautious practices of the British in the tropics," as one visitor put it, young men dressed in tight clothes and heavy pants as if they were in the climate of northern Europe. Their manner of living was equally incautious, with seven-course meals accompanied by bottle after bottle of arrack (a local rice wine). As tempers blossomed in the tropics, dueling and "riotous pranks among the British inhabitants of Bombay" resulted in wounds that quickly went septic in the heat and which caused "most rapid bodily rot."

An Englishman's last step, in his all-too-brief lifespan, was into an open grave in a churchyard, where the water level was three

feet below ground. Heavy rocks had to be placed on top of recently buried coffins so that the new inhabitants of the churchyards of Bombay wouldn't rise to the surface during the monsoon in a kind of disorderly reincarnation. A year later, the sad news would arrive in some small township in England or Scotland, and another younger son's details and name would be carefully set down in the family bible.

* * *

On my first journey to India, out there on the burning wastes of the Bay of Bengal during the last days of May, the never ending heat had been brutal. I thought I'd known what it was to be hot, but I was wrong. In Bombay the heat devoured you. The atmosphere of the city itself was like a vaporium, and people moved through the leaden air as if swimming in slow motion inside a strange aquarium. At midday, birds fell out of the sky from heat stroke and apoplexy.

I stayed for a month in Bombay, where every movement after ten o'clock in the morning was an act of incredible exertion. You put your arm on a table for five seconds, and when you lifted it you left behind a puddle of sweat. In the heat, every physical movement was a studied calculation and you moved with caution.

In the heat, your skin began to bloat with edema. Men went mad from sunstroke before they collapsed in the midday heat. With sunstroke, the temperature of the skull casing rises to superheated levels. You then die by measurements of slow quarter hours.

In Bombay, I waited for the rains to break. It was here, that for the first time in my life, I began to listen to what people told me. I was told that central India was a burning, broiling inferno that turned whole cities into a desert landscape. I stayed on in Bombay and waited for the rains to break in central India before trying to cross India to Bengal. It was in Bombay that I first learnt caution.

In June, twenty-one days after I arrived in India, the monsoon finally arrived. Water fell in blinding sheets. With the rains, the city changed into a lush, cool paradise. In the middle of the streets, both men and women stood in these first monsoon rains. No matter how they were dressed or what their station in life, they lifted their faces toward the rain, drinking in the sudden, delicious coolness like it was a fine liqueur.

They had survived. They had lived through another year of the great heat. And then, after the rains came the cool smells of the monsoon soaked the earth. It brought the scent of the damp soil, the odors of humidity, and the Arabian Sea. The perfume of flowers, palms, and the jujube trees. In the evenings streaks of rain against purple monsoon night skies, that lay under ranks of massive cumulus clouds, and trees steaming with humidity.

In my mind, I went back to the first moments I saw this city , and my reckless journey to this place.

* * *

THE NORTH PACIFIC, MARCH/APRIL 1959

For eleven days I'd been seasick.

I staggered up onto the deck. It was nighttime and I had no idea where we were. In the ship's feeble running lights, towering waves were whipped into a maelstrom. It was a scene from some watery hell. The wind sounded like some immense monster which hovered over the ship as it moved through the darkness toward some indefinable destination. I had been on this floating hell for two weeks since I left San Francisco. A storm born off the coasts of Siberia broke over the bow of the ship. In the wind, it felt like knives were slowly being run down my cheeks.

Out of the darkness, a truly gigantic fifty-foot wave struck the bow of the ship. The ship shuddered. It canted suddenly at a crazy angle as it struggled to recover from tons of water that broke over the deck. I retreated hastily off the deck through a heavy metal door. Behind the door, it sounded like giants were beating the ship with huge hammers, as the sound of the thundering ocean pounded against the ship's plates. Weak with nausea, I moved down a dimly lit corridor to the dining room.

With each roll of the ship place settings suddenly clattered off the tables, then piles of steaming food and broken crockery began traveling the length of the deck from one side of the dining room to the other. I looked down at the ruins of dinner.

The rugs of the dining room were actually furred with the wreckage of the past week's dinners. A waiter appeared. He

began to wet down the tablecloths so the meal he brought wouldn't careen off onto the rug. Oblivious to the culinary ruins underfoot, I sank into a chair and I ate my first full meal in days.

The journey on the American President Lines ship from San Francisco to Yokohama took twenty-two days. I reached Japan in what was supposed to be spring, but a freak spring cold wave had covered Tokyo with a thin layer of ice. In the cold, the people of Tokyo were hunched shapeless figures of indeterminate age. They huddled mutely inside worn out cotton coats which gave little heat. Old newspapers were used for insulation from the cold. People seemed fixed on journeys toward indefinite, difficult addresses. Tokyo still had bomb damage from the war, and whole blocks of houses had been burnt in its devastating firebombing.

The people were mute. Japan was a defeated country without hope. The sun was without heat. As late as the mid-1950s, the GNP of Japan was still the same as some minor west African country. I walked through the Shinjuku district. It was a wilderness of weeds amid the burnt, rotting ruins of a city that had been destroyed in 1945.

During 1959, everything was scavenged in Tokyo.

People inside their bundles of shapeless newspapers wheeled little carts full of bottles and empty tin cans past me as I moved through Shinjuku. I met a French journalist in Tokyo. He was a thin man yellowed by nicotine and disappointment. "Nothing happens here. The ground eats people," he said.

In the winter of 1959, the ground had opened up. It had swallowed whole Japanese villages. Thousands of diminutive newspaper-wrapped cotton-shrouded people were missing.

In Yokohama I changed boats. I decided to go deck class from Yokohama to Bombay on a rusted, almost derelict French boat of unknowable age owned by the Compagnie des Messageries Maritimes.

The passage I booked was for a twenty-five day ocean voyage with stops in Hong Kong, Saigon, Singapore, Colombo and finally, Bombay. The fare for fourth category deck class from Yokohama to Bombay was seventy-nine dollars for a journey of indeterminate length, which would last almost a month. Deck passage meant just that—you slept on the bare deck.

* * *

The first night out of Yokohama, I slept buried in the darkest innards of the ship. I thought of this ship's journeys. I thought of Somerset Maugham and Joseph Conrad and their forgotten joint decades of traveling up and down the coasts of Southeast Asia. On the splintering wooden deck, I unrolled my sleeping bag. In the empty cargo hold that smelt of rotting coconut milk and raw rubber, I breathed dreams of the tropics.

The next day, on the passage from Yokohama to Hong Kong, the world was reduced to a slate grey shroud, as the wind rose into another familiar howling storm of ice. Huddled against the cold, the only entertainment I had on the passage to Hong Kong was lying on my side in my sleeping bag, dreaming of being warm. For hours each day, I lay there watching the cockroaches which were as long as your index finger.

In the cold darkness of the ship's hold, I fed these huge insects scraps of my grandmother's fruitcake. It was her going-away present to me. My grandmother's sight was evidently failing. The beautifully made going-away cake was filled with walnut shells that sadly rendered it inedible.

My fellow passengers in fourth deck class were of indeterminate and mostly unknown nationalities. They spoke languages I had never heard before. In Hong Kong, some Poles boarded the boat, along with a Dutchman. Next, there appeared a whole troupe of acrobats from Hungary who seemed to be traveling on a meager socialist budget. In Hong Kong, two Germans slipped aboard without their passports. In Far Asia, the mere fact that you traveled fourth class proved to most people that you were dead broke.

* * *

I think back. I never understood why travel itself became more important than any destination. It was a riddle I tried to solve during years of crossing mountain chains, deserts, and continents. It is curious why one embarks on a life of travel with no fixed destination. In the South China Sea I met a group of travelers who changed my life.

Perhaps the Germans had passports but more likely they didn't. Two days out of Hong Kong, on the rusted Messagerie Maritime ship upon which I'd taken passage to Bombay, they had materialized on the ship's deck. What I'd discovered about my floating slum was that once you got on board this ship —once you'd moved down into the precincts of the fourth class on the lowest deck of the boat—you were part of a stateless group of

financially damaged travelers, about whom few questions were ever asked.

On the ship, I went days without speaking to anyone. The secrets of my fellow passengers on this ship were guarded by their crimes and their silence. Probably, the Germans had bribed someone to get out of Hong Kong without papers.

Days slid into weeks.

Hong Kong slipped away, then Saigon and Cholon. Finally, Singapore came and went. Deck passage to India was from another bygone era of travel. No one appeared from the ship's company to ask for a ticket of any of the fourth class passengers. Perhaps I was the only person in fourth class deck passage that actually had a ticket.

For me, travel on this ship became an almost existential condition of minimal circumstances. Breakfast, lunch and dinner consisted of octopus arms. The octopus arms were served floating in a watery octopus soup. With imagination, they tasted like you were chewing bicycle tires. I sometimes washed dishes for the crew so I could add a daily ration of bread to my octopus arms.

Given the general financially distressed condition of many of my fellow passengers, and their lack of documentation, once our ship reached a port, they tended to disembark after 2 a.m., in the darkest part of the night. I noticed these disappearances always seemed to occur after the local immigration authorities had left.

Three quarters of fourth class disappeared in Singapore as
Australia was only one island chain away more or less.

Journey's end came when you simply vanished. In the late
1950's, if you were of European origin, you could easily
immigrate to Australia. In this way, the Polish dancing group
disappeared, as did our single Dutchman. The whole troupe of
Hungarian acrobats dematerialized themselves. Perhaps all of
them dreamed of brighter thespian futures in Australia.

* * *

It often felt like the mouth of a blow furnace below the decks.
One night beyond Singapore, in the heat of the Bay of Bengal, I
came up onto the deck for fresh air.

I walked across the ship in the darkness, passing the shape of the
ship's huge crane. The only light came from the ship's running
lights. The only sounds were the throbbing lashings of the ship's
diesels. In the dim light, I rested against a bulkhead. I sucked in
a huge lungful of fresh air. I saw the two Germans who'd
boarded in Hong Kong. They sat on the bare decking with their
backs against the still-cooking superstructure of the boat.

I hadn't spoken to another human being since Singapore. I
wondered if I had lost the power of speech on the strange
journey I'd taken. One of the Germans patted the deck next to
them, motioning for me to sit. We sat in silence with the
rumbling of the ship's huge engines filling the darkness.
Finally, one of the Germans was moved to speak.

"For us, India is the promised land. In Singapore we decided
against Australia. Who knows who's on the *gottverdammten*

lists they keep in Australia. Did you know that you can disappear in India? You can utterly disappear into the vastness of a whole subcontinent."

The man who spoke inhaled upon a cheap French cigarette and then he continued. "In India no one will ever find you. You start again. Whatever your crimes are, they are erased from your dossier because there is no dossier. Have you noticed that neither of us has gotten off this boat since we joined you in Hong Kong?"

I answered cautiously. "I noticed this."

"After two years, we managed to escape from China and now we live in a condition that might be loosely called . . . a lifetime devoted to perpetual ticketless travel."

In the darkness, they looked like studious teachers, both of them. In the dim light, I studied them. They were slight men of unknowable age, somewhere between 45 and 50. Their faces were hollow from lack of food. Neither of them weighed over 145 pounds.

The German who had been speaking continued, "In Hindustan, a European can live in a tropical paradise. It's marvelous. When the British went away from India, they left the Indians a glorious bureaucracy. Everything, every record, is in triplicate. In India you can live for years without anyone knowing that you are there."

I'd never thought of India as the nirvana of fugitives.

"From India you can go to Pakistan. To Afghanistan. Iran. Turkey. Back to India. Burma. Anywhere. All these countries are very confused bureaucratically. And money is no problem. In India you can ride free with the Sikh truckers, everywhere if you tell them you are a mendicant on a pilgrimage. You don't beg like Indian pilgrims. The Indians give you money. It is very strange. They give you money. Indians don't like Europeans to be poor."

In the night, I stared at them. They were neatly turned out. I didn't know how they did it, but their khaki shorts were neatly washed and pressed. Both men wore white shirts which were freshly laundered. They had taken great care shaving. Their hair was carefully cut.

The man stared at me for ten or fifteen very long seconds in the night. "You are so very young. You are so quiet. What does it feel like to be so young and quiet?"

In the night, the man answered his own question. "We used to be young. We've survived cataclysm not once, but twice! When we were very young, we survived the Russian front in the SS. We were in an SS penal battalion. After World War II ended, we next survived an Asian war of monstrous dimensions that everyone has forgotten about."

In this strange soliloquy, the German continued, "Can you tell me why we were in the penal battalions of the SS? That is a very good question—if you perhaps ever find yourself in a similar situation." He barked with laughter.

"We would not agree to kill enemies of the Reich. We were Germans of conscience. We were young Germans of conscience. So during the war we were placed in the SS penal battalions instead of being executed. Members of the penal battalions were never given leave. Can you imagine four years of war on the Eastern Front? It's surprising anyone could survive that."

The man paused. "And now, we are the survivors of the cataclysm, but we are but beggars, sir. By sophisticated well-fed people, we are blamed for crimes against humanity. But the greatest crime of all was done to us. To us. Do you understand that?"

What did one say? I wondered. Afraid to answer, I settled on silence.

The German continued, "And what now? What do we do with our lives? Do you understand why we hide during the day and live only at night?"

In the darkness, the second German laughed again. But it was a laugh without a single trace of humor. The taller one, whom I later learned was named Heinz Peter, got up from the deck. He sucked at his cigarette. Throwing the butt overboard, it spun off into the darkness.

The other German, the silent German, rose slowly. I watched them as they both disappeared into the night.

* * *

CALIFORNIA, MARCH 1959

How does one describe a terrible mistake of travel?

I travelled to escape the place where I'd been born. I traveled to escape where I was. To me, America in the 1950's was possibly the most stunningly dull place on earth.

In the post-war years and the decade of the 1950s, Americans sincerely believed—with an almost total evangelical sincerity—that the future of America was the mini-future of all mankind. If the world was lucky, so the thinking went, everyone on earth would be an American. Imagine . . . the entire world, covered everywhere with us—the Americans!

After World War II, the United States hungered for something it called "security." In the drive-in restaurants of the land, everyone opened their fortune cookies and found that America was suddenly the richest country in the world. This was their reward for winning the Second World War. The American middle class believed this idea with a heartfelt simplicity. It was like a religious revelation. The other benefit of victory was a new car and the uncomplicated life in a place called suburbia.

Unfortunately, too soon after World War II, the Russians also had the hydrogen bomb. "Security" hadn't lasted very long. If one were a humanist, one now had reasons to worry.

In the great United States Democratic Experiment, during the decade of the 1950s, the generation which had survived the hardships of the Depression of the 1930s and World War II went

into hiding. In the 1950's, America became a business- and progress-obsessed society which turned inward.

Under threatening nuclear skies, I remember being taught to hide under my school desk to escape being erased in a nuclear blast. It was during the 1950's when the American dream was warned about something sonorously called "the military-industrial complex."

Almost silently, tagging along like a little spotted dog wagging its tail, this burgeoning "defense industry" began to devour an entire country, as America embarked upon a series of seemingly never ending wars. It was as if some strange mutant flowering weed had grown up in a poisoned patriotic garden. This weed quickly overran an entire country, and "progress" became a multiplicity of interlocking industrial corporations which came to dominate and subsume the American future.

It was a strange sort of progress. In this new America of corporate surrender, a trade-off was affected. In exchange for independence and individual political thought, the American middle class got something called "a lifetime job." With employment came the shackles of a brand new house, a thirty-year mortgage, and the ever-present background terror of annihilation.

I first went to work in San Francisco. In 1959 I was a "mail boy" as they were then called by some unknown wit. I worked for the Stauffer Chemical Company. That year, my first year out of high school, I became a failed college student. I didn't like being an American college student. I didn't like delivering mail to the poor souls who worked year in and year out, decade after dreary decade, for the Stauffer Chemical Company. It was a

terrible life. I'd gone to a magnificent boarding school in Sedona, Arizona. My school taught me that beyond America, out there across the oceans, a whole world waited for those brave enough to set their feet on the invisible road of their own future . My school was named Verde Valley—the Green Valley.

Life after my boarding school was not so very green. I was impatient. I was bored. I wasn't prepared for life in America during the 1950's. Nothing fit. I didn't fit America either.

<p style="text-align:center">* * *</p>

In the 1950's, Americans had become a corporate people. These corporate people were my parents. They were the fathers and mothers of all my friends.

Populating the interlocking bureaucracies of big business, government and academia, somehow America had become the land of the good corporate citizen. I came to think that our various wars had trained Americans to be a new breed of corporate soldiers of a weird sort. It seemed to me that in the minds of my parents' friends, the journey from the beaches of Normandy to a lifetime of working for a corporation was a short journey.

 In America, everyone worked for a bureaucracy. I believed that if you didn't, you probably were migrant labor, or possibly you lived in a cardboard box under a bridge somewhere.

In 1959, I applied for and was accepted into a wildly different sort of university. It was as far away from America as I could get. It was in India.

At the age of 18, I seemed to be a failure at becoming a real American. After my labors for the Stauffer Chemical Company, and then as a dishwasher in a folk music club, I determined to put as much distance as possible between myself, America and a life packed with "security", by means of gold plated guarantees of "lifetime corporate employment."

My university was about as far away as anyone could get from America before the age of practical space travel. I had discovered Upper Bengal on an old map which had somehow been placed inside a discarded file cabinet in the Berkeley Municipal Dump.

I remember there was a very long silence after I explained my university plans to my parents. From where I lived in Berkeley, the University of California campus was only a ten-minute walk down a hill. An Indian university seemed a queer and impractical alternative to this short walk.

India was a place full of famine. It was a place seeded with religious riots and disease. The look on my father's face was an expression of total bafflement. "My God," he said morosely. "India's the spiritual home to people who are human pincushions. Do you want a car? You don't mean Indiana? You can't be serious. Jesus. India?" My father settled into staring off into the middle distance.

I explained to my parents that even though India was quite far away from America, with the opening of the Suez Canal after 1868, it took only a month to six weeks to travel to Europe from India on the average boat. I then told them that, before the opening of the Suez Canal in the 1860s, it had taken three to eight months of travel from Europe to get to India. This

depended, of course, upon the trade winds and the vagaries of seasonal ocean currents. By comparison, travel to India today was a miracle.

My father settled upon trying to look optimistic. He looked at me, then simply shook his head. For weeks, and then months, I had made plans for my escape. In time, my parents came to believe that my university plans were a startling, intercultural travel adventure. It was an adventure that they could do nothing about. For years I'd stared at a huge bridge that spanned the Golden Gate, six miles away from our house.

I'd wondered what it was like to travel beyond the bridge into the cold winter fogs that plagued Northern California. I wondered about boarding a ship that travelled westward and then disappeared off the edge of the world.

In the early spring of 1959, from pier number 24 in San Francisco, I took a ship to India.

As I sailed under the Golden Gate Bridge, I realized that my house where I had grown up was disappearing in the wake of this journey. I climbed up onto the ship's highest passenger deck. My house was somewhere across the bay, lost now among the steep vegetation of the Berkeley hills.

Everything I knew was separated now by the longest six miles of my life. Beyond the bay, as the ship passed into a sharp Pacific chop, I looked up at the underside of the great bridge. I realized at that moment I'd entirely committed myself to a westward journey with no definable end.

* * *

THE SOUTH CHINA SEA, MAY 1959

The lowest deck of the Messagerie Maritime ship, with all its residues of voyages past, was now fermenting bountifully. The odors that once were exotic and strange had now become almost unbearable. As I lay there, day after day, on my sleeping bag spread out on the splintered decking, my life was full of lassitude.

To get away from the heat which had collected below decks and to breathe fresh air, I took to sleeping underneath one of the lifeboats. Under the lifeboat, I was out of sight of the crew who routinely chased deck-passage passengers back down below whenever they saw them. My life, when I considered it, was about strange encounters. It was about meetings with people who'd embarked on unaccountable journeys to nowhere.

I turned over in my mind the lives the two Germans had lived. Why had they told me about their lives? My nights were filled with the groaning of the ship's plates as I thought about them both. I didn't know if I believed anything they said.

Somewhere out there on the edges of the Bay of Bengal, the monsoon was brewing. In the night, there were sheets of heat lightning which held an almost menacing humidity at bay.. Towering clouds rose thirty and forty thousand feet into the coal-black night. In the darkness, the ship plunged forward on its journey with no apparent end. My only company was an appearing, then disappearing distant wafer-thin moon.

Lying there under the rusting bulk of my lifeboat, I watched the horizon night after night. I thought of my classmates in America. While my classmates fashioned useful, carefully calculated lives, and attended college, I watched sunsets that were indescribable. How could I explain this journey to anyone I knew? In the heat, I was suddenly cold.

I lost count of the days, then the weeks. The ship reached Sri Lanka, finally.

In Ceylon, the Germans and I went ashore. We got drunk on cheap toddy wine at a beach restaurant where we ate hot-spiced sea prawns.

On ten-inch rectangular plates, the prawns floated like sunbathers in a pool of red-hot curry sauce. After dinner, I walked alone on the beach toward the lights of the Mount Lavinia Hotel. I'd left everything I knew. How would I ever get back to where I had started? I felt overcome by a feeling of a desperate, incredible homesickness. What was I doing here?

I'd been on a ship for 43 days. I hadn't received a single letter in any of the ports where I'd stopped. I had never felt such desolation in my life. I learned then that there was an exceedingly steep price to solitary travel. It was as if I was being slowly erased.

After the ship sailed from Colombo a night later, I walked through the ship's interior and the deserted passageways. Somehow on this journey, I'd changed. Should I go home? I gave up the idea as impractical. How do you retract a journey that has completely undone you and made you into somebody different? I could never go back to being the person I had been.

I wondered how I could ever rectify my terrible mistake of travel.

I climbed the five or six sets of rusting stairs toward the main deck of this worn-out ship. At the top of the stairs, I closed my eyes. I took a deep breath and I committed myself to this journey, wherever it would take me.

Out there on the Arabian Sea, the moon had risen. It hung there an inch above a total blue-black horizon in a sky made of crystal. I'd never seen a night like this. I felt I was alone at the moment before time commenced.

I looked at my watch. It was 3:06 in the morning.

Across the main deck on a forward hatch cover, there was a faint glow. One of the Germans was up here on deck. We hadn't spoken since our dinner in Colombo. He sat there staring at the moon. It was the second German—a man who was buried under a life of incommunicable anger. During my dinner with them, he'd never spoken to me. I wondered at the time if he'd lost the power of speech.

From his cigarette, the German lit another. Wordlessly, I sat down next to him with my back against the rust spotted metal plating of the bulkhead.

The German looked over at me and went back to looking at the moon. I was damned if I was going to speak first. After perhaps five minutes, the German turned to me. He rubbed a hand across his eyes as if he was utterly exhausted. "I must tell you that after four years of battles in Russia, at the end of the war, I went home. I went home to Alsace. My name is Joachim Hartmann."

To me, Hartmann had never had a name and now he had one.
And then he told me about his life. It was the kind of story one
could not imagine.

"When I was 16, I went to war in France. It was 1939,"
Hartmann explained. "I survived the campaigns of Greece,
Cyprus, North Africa, and then Russia. By the time I was 22, I'd
lived through six years of war which few soldiers survived. My
only emotion after the war was simply that I was surprised:
I was still alive. How many men lived through this debacle?
Few. Very few, mein herz."

The German paused.

"It was autumn when I got home to Alsace. It was the autumn of
1945. I aged half a century in six years and everyone in
Germany was trying to grow potatoes to get through the next
four months of winter. My country was reduced from the empire
that had conquered Europe to a country that was not growing
very nutritious potatoes."

Hartmann laughed. "If you can imagine, an entire country's
single national preoccupation was survival. Five hundred years
of German culture were slaughtered in the mud of Kursk after
the failure of von Manstein's last great attack on the Russians.
When we got home, there was nothing to come home to.
Germany was a wasteland of broken brick and ruined cities."

Against the ship's bulkhead, Hartmann sucked at his cigarette.
"In Colmar, seven months after the war was over, I was walking
on the street with a friend. The French arrested me. Then they
interned me in a prison camp in Aix. The camp was set up
exclusively for ex-members of the SS.'

"For a carton of cigarettes, an informer had disclosed my membership in the SS to the French. I tried to tell them I had been given no choice in the matter of my association with the SS. I pointed out that I'd been put in an SS penal battalion for being a German patriot because I didn't want to execute Jews or innocent Russians. I was a German of conscience."

"After two appalling years in this French prison camp, both I and my friend Heinz Peter were told that we'd been sentenced to 20 years in a French prison. It was for the crime of belonging to a criminal organization—the SS. Perhaps a month after we were sentenced, in a sort of comedic parody of the French legal system, we were told that France wanted to give us a gift. We could devote the rest of our lives to 'community good works,' as they called them."

"Across the street from the prison was a recruiting station for the French Foreign Legion. So Heinz Peter and I walked out of the French prison and we crossed the street. Of our own free will, we chose to join the Legion. And now, according to the French, we were free men who could devote the rest of our lives to humanism and philanthropic enterprise."

"In 1948, the Legion was made up of thousands of ex-SS men. All of us were bent upon good works and social rehabilitation. There were even a few French ex-SS men in the Legion who had avoided the firing squads. There were Polish SS, Dutch, Norwegian, Hungarian, Danish, Swedish and Spanish Blue Division SS."

"We all shipped out to Algeria for our first picnic on the desert. I might say, in passing, that we'd already been trained

exceptionally well. The French had nothing to teach us. At first we fought the Berbers in Algeria. Then, we were sent off to French Indochina to fight the Communists, who wanted to steal the Michelin rubber plantations from the French."

On the slowly moving boat, the moon hung there against the velvet-black sky. It was too hot to sleep. Hartmann offered me a cigarette and I shook my head.

Hartmann continued, "The Vietnamese Communists had started an insurgency that threatened to topple the corrupt French colonial government of Indochina. We'd fought the Communists in Russia for four years and now we got the opportunity to bravely fight more Communists for three more years, because we were humanists. At the end, I must say that Vietnam was terrible, but it was nothing like the winter of 1942 on the outskirts of Stalingrad. The ground was frozen solid at Stalingrad, so we stacked our dead like cord wood. It was wonderful to be warm in Vietnam."

Hartmann paused and looked over at me. "Do you know what happened to us in Vietnam?"

I shook my head, and so Hartmann told me. "One day we simply quit. On a route march, just before Dien Bien Phu, and the final catastrophe for the French in Indochina, we just walked away.

We both decided that dying in the jungle was better than fighting any longer. Heinz Peter and I had survived Russia. But most of the SS who survived World War II left their bones rotting in the jungles of Vietnam. Of all these tens of thousands of men, only one perhaps, or two of us, out of a thousand men walked out of Indochina alive. Heinz Peter and I walked into the

jungle with all our equipment. Like tourists, we thought we could walk northward toward China but the jungle swallowed us."

"You walked out of Vietnam?" I asked. Only a few soldiers had.

"We walked for two months, and after that I lost all track of time. We survived the French misfortunes of Dien Bien Phu, but we were reduced to living on filth and snakes. Finally, we ate bugs.

"Bugs are quite tasty when there is nothing else to eat. The rest of our escape is still a dream of depravation, hallucination, and starvation. We went around and around. Sometimes we were in Laos. Sometimes, I think we walked back into Vietnam. After six months, we stumbled into China, where we were still fugitives. After a few years in Southern China, working on peasant's farms for food, we finally escaped China and we got into Hong Kong."

"The German consul didn't want to hear from us. The British authorities pretended we were invisible because we were stateless persons. We survived—barely."

I was afraid to ask how they'd survived. The fall of Dien Bien Phu was in 1954. This was 1959.

"So here we are on a beautiful moonlit night, hein?" Hartmann said. "Heinz Peter and I are happy travelers with a new friend. Everything else is unimportant. Except being here. Except for reaching India."
"Tomorrow we dock in India. Somehow we have to get off this boat without papers. But somehow we have survived too many

impossible problems, haven't we? And next week, do you know what is going to happen? " Hartmann asked.

I shook my head.

"Next week, I am 36 years old. I went to war when I was 17," Hartmann said, as he watched the wake of the ship.

After a few moments he got up. He turned, and then disappeared into the darkness.

This story of their lives left me shaken.

* * *

BOMBAY, MAY 1959

The Germans had found us a rooming house that accommodated the poorest of the poor in Bombay. In time I came to loathe my accommodations in Bombay. They were simply beyond horrible. I didn't sleep as much as endure nights in my ultra-low budget hotel room . The place smelled of decay and exhaled kitchery, a poor man's curry prepared for the downtrodden on the sidewalks of Bombay. I, along with seventeen other inmates, lived in a grey twilight of suffocation and never ending vileness. During the monsoon, the walls of our slum turned a slimy, slippery black-green putrescence that actually glowed.

In this cozy this little patch of hell, filled with its floating population of cramped Goans, two Germans and myself, sweated in a darkness lit only by a single five watt light bulb.

I learnt that if you had the bed against the wall furthest from the door, when you felt the nocturnal necessities of nature, the only way to exit the room was by means of an elaborate balancing act. This entailed walking on the sides of the bed frames and creeping from one bed frame to the next toward the door. The stink was awful. At night, completely without ventilation, the temperature in the room would often rise toward 105 degrees.

As a reward for surviving another night, each morning I walked along the Colaba causeway. I tried to resuscitate myself by inhaling great lung full's of fresh air. Then, I would treat myself to a breakfast at one of the Persian-owned European-style restaurants hidden on the back streets in Colaba. I decided I liked best a restaurant decorated with flyblown British-made

Heinz bean cans. Inside the restaurant, the bean cans, from a purer era of British commercial dominance, rose majestically upward to the ceiling along the entire left side of the restaurant.

Most promising was the restaurant's inspired name, "The Hygienic Food Emporium."

At the back of the restaurant, a fan spun slowly in the fried-egg-scented air. I took my usual seat, with a view of the street beyond the door.

On the back wall of the restaurant was a carefully framed picture of a Parsi saint appearing particularly well fed. He had bright red lips and he seemed to be wearing lipstick. This was a Parsi-owned business establishment, owned by exotic fire worshipers. An electric halo, which seemed to emanate from the saint's head, appeared to be controlled by an electrical switch set into the wall next to the cashier. Near the switch was a dark hole cut into the wall. Through this hole, stairs led downwards, presumably into the restaurant's hellishly dingy kitchen.

At nine o'clock in the morning, my restaurant filled with Indian office clerks. Their difficult work in various offices throughout the city seemed, over the decades, to have drained them all of vital energy and body fluids. They moved slowly, like old men. Probably, they had once been normal brownish-hued Indians, but now they looked like grey, unwashed bedclothes.

Each morning after taking a seat at my rear table, I would thank God that I had survived another roasting session in my four-cent-a-night room. Then I would tuck into my first work of the morning— watching the clerks who slowly filled The Hygienic Food Emporium.

Tea would arrive and the clerks would begin their breakfast ballet. Almost in unison, they would slurp their tea up from their saucers with pink snake-like tongues. Imagine forty clerks drinking tea in perfect cadence. The performance was nearly musical. In the heat, I had the feeling that I was becoming a little strange because things like this had come to interest me deeply.

Each morning, one of the clerks would ask me the same question, "From what country are you coming?"

To Indians in 1959, America was far away. Americans were an unknown and exotic species full of mystery. Indians' fantasies about America were unnerving. America was the home of movie stars with names like Rex or Roy or Rita. America was the home of Coca Cola. It was the home of a president/general named "Ike." In 1959, most Indians had never met an American.

Under the milky glass used by three generations of diners, the now-brownish menu of the restaurant listed something like seventeen unique styles of egg dishes. This was the sole menu option. After careful experimentation, I concluded that the hard fried eggs were preferable because they usually contained less contaminants and dead flies.

A waiter approached. I ordered breakfast. "Large tea. Toast, butter, marmalade. Two hard fried eggs. Chips. Jaldi hai," I ordered.

I was trying to learn Hindi.

The waiter listened in silence to my order. Of indeterminate age, he wore a black vest tightly buttoned over a seldom-washed shirt. He made a quick swipe over the table with a grubby rag,

then mechanically, in a voice almost disguising his lisp, he would repeat my same daily order. The waiter would disappear into the hole at the back of the restaurant. Eight minutes later the same waiter would reappear with my breakfast, which he dropped onto the table with a loud clatter.

Every day after breakfast, I wandered toward the Prince of Wales Museum, a block from the restaurant. Inside the museum grounds, I lay under a large tree at the center of the only lawn in Colaba.

Each morning I badly needed the sleep that I hadn't gotten the night before. At eleven thirty, I'd usually be awakened and surrounded by a group of ten or twenty people. They always seemed more interested in a dead or perhaps just comatose European than the art in the museum. Groggily, I would stand. Brushing off the grass, I would wend my way toward the commercial heart of Bombay and the area of the Flora Fountain.

Opposite the fountain was the American Express Company. At the entrance of the building, a Nepali guard clutched an unloaded shotgun. Each day, the same guard defended the entrance to the American Express Company with an inert vigor. I smiled. He smiled. I entered the door of the building.

The center of my life in Bombay was the American Express Company. The highlight of my day was checking to see if I had received either a letter or a money transfer. By well-worn habit, I approached the banking section of the office first.

At another desk, a hundred feet away labeled "clients' mail," another man stared at me unhappily. Clients' mail arrived twice a day at the American Express Company, except for Sunday.

Twice a day I appeared here. After almost sixty requests for my mail, these visits were a painful reminder of how broke and alone I was. As I approached, the mail clerk shook his head.

I didn't even have to ask any more for my mail or wire transfer confirmation. Until my wire transfer came, I was a prisoner of the American Express Company.

Mail from California—the messages I'd given up on— sometimes took two months to reach India by boat.

* * *

As I walked around Bombay in my first days, its recent history seemed to crush this city. Bombay seemed fixed in a time warp at the height of the British Raj, when England ruled the whole subcontinent. Twelve years before my arrival, the subcontinent had been subdivided into brand new countries called Pakistan (east and west), Ceylon, and Burma. The remainder of the subcontinent became another new country, and in a great post-colonialist experiment this new country was India.

It seemed to me, as I studied the newspapers in Bombay, that the recent history of India had somehow unmoored the subcontinent from both its past and the future. Bombay, and I supposed India itself, seemed to live somewhere between large, if not stupendous, epochs of time. The last moments India had been united as a country was in the period of the Buddhist king Ashoka, who lived from 304–232 BCE. Somehow, in their hasty, hurried departure from the subcontinent, the British had adopted the classical example of a king who had lived and died two thousand two hundred and fifty one years before.

The Indian newspapers frequently referenced Ashoka and his kingdom, like he had been batting in a recent winning cricket match. These odd references to a man who had been dead two millennia seemed a fragile structure to use in the building, then unification of an entire subcontinent. In Bombay, everyone seemed to be beside themselves with often repeated, terrible burdens of history.

The history of Bombay went something like this: the Portuguese first appeared on the western coast of India in 1498. In 1523, the Sultan of Gujarat, Bahadur Shah, ceded the coast and the islands of Salsette, Bassein and Bombay to the Portuguese. In a more recent period of history the emergence of Europeans on the western coast of India was compressed into an almost brief three hundred-year period.

During the seventeenth century, in 1661, Bombay was in turn presented by the Portuguese to the British, as part of Catherine of Braganza's dowry upon her marriage to the British king, Charles II. Seven years later, in 1668, Charles II handed the small malarial islands surrounding Bombay over to a commercial enterprise called the British East India Company. The annual rent for Bombay and the surrounding islands was ten pounds.

* * *

During my days in Bombay, I walked near the Prince of Wales Museum in Colaba on the tree-lined streets. The streets of the city were uncrowded. The entire downtown area of Bombay had been built in the late nineteenth century in a Gothic Saracenic style, riven by a strange kind of fantastical orientalism. The

whole city was a peninsula ringed by the Arabian Sea. In Bombay, history was never far away.

The city was full of government buildings and law courts, all done in a similar Victorian Thousand and One Nights' Scheherazade-like style. The finest example of this Bombay style of building was the mammoth Victoria Terminus railway station replete with domes, Italianate towers, and scores of Moorish arches. On the façade of the Victoria Terminus were acres of gingerbread decoration.

Comingled with the present day life of Bombay were the histories and the fortunes of the sea kingdoms that had ringed the Arabian Sea for millennia. In 1959, Bombay was the queen city of the Arabian Sea. No other city on the coasts of Arabia or the western coast of India could come close to making this claim.

<div align="center">***</div>

Off one of the poorly painted side streets of Colaba, I stepped into a shop selling used electrical appliances. Under the draconian import rules then pertaining to post-British India, new appliances were on a government blacklist intended to save foreign currency. A wide range of appliances, from radios to steam irons and refrigerators, were used and recycled.

I had been told to bring a flashlight with me to India, as they were apparently unavailable. Inside the shop, which sold electric fans and primitive-looking cooling devices involving water, a small man with bird-sized bones and thick bottle-end glasses stared at me wordlessly.

I placed my flashlight on the counter in front of the shop's owner. I switched it on and off. Nothing happened. The owner, appearing quite desolate, stared at my flashlight.

"It is damaged, sir. I fear your torch is fatally damaged. In India, because of import restrictions, we don't have American switches. But never mind, sir." The man waved my problem away as if it was of no importance. "We shall have afternoon tea, yes? You are my first customer today."

I nodded, looking down at the corpse of my flashlight. An assistant appeared with two glasses of Indian milk tea.

With his index finger, the small man pushed my glass of tea across the counter toward me. I then received from my new friend a spontaneous lesson on the commercial history of the group of people known as the Parsis. Originally, the Parsis came from Persia. They were Zoroastrians and worshippers of fire. The remnant Parsi population in Bombay, surviving from the second millennium before Christ, was possibly the oldest religious community on earth. In the moment when Europe was covered by trackless forests, Zoroastrian kings ruled much of Central Asia.

The shopkeeper drank his tea as he elaborated on the Parsis and their successes in Bombay during the twentieth century. "It is true, sir, the remarkable many successes of my peoples—Parsi peoples."

The small man's voice dropped into a reverent whisper. "There is, of course, Mr. Jamsetji Nusserwanji Tata, owner and developer of the Taj Mahal Hotel. Mr. Tata was not allowed to stay in any British hotels in Bombay—because he was a native

man, sir. So Mr. Jamsetji Nusserwanji built with unique vision the greatest hotel in India for himself and others to stay in.

It is across the street from the Gateway of India of course, in and of itself, a historical landmark. Current Mr. Tata, owner of Tata Motors, is the Indian Mercedes distributor. He is also the Indian assembler of Mercedes diesel trucks made in Germany."

He explained there were other estimable Parsi Indian industrialists besides Tata.

"There is the noteworthy Mr Godrej, the renowned owner of Godrej Soap Company founded in 1922. Mr. Godrej is also being the owner and founder of the Godrej Lock Company, the most famous lock company in India. Finally, Mr. Godrej is the father of world-class Indian technology, producing, in 1955, the first and most remarkable indigenous Indian typewriter."

I was overwhelmed by these accomplishments. After the Parsis had fled Islamic religious persecution in Persia, they moved eastward to India. From that day forward, at least it seemed to me as I walked around the city, the Parsis of Bombay seemed to be permanently, in quite their delirious, fevered municipal benefactions, to outdo one another in their benefactions.

There was the Sassoon Institute ("lectures are delivered and prizes awarded"); the Jamsetjee Jejeebhoy Institute ("150 charities for the poor, as well as a boys and girls school"); the Prestonji Kama Hospital ("for women and children"); the Gokaldas Tejpal Hospital ("for poor Indians") and the Institute of Science ("acknowledges the generosity of Sir Jacob Sassoon, Sir Cowasjeee Jehangir, Sir Currimbho Ebrahim, and Sir Vasanji Tricumji Mulji, etc.").

I finished my tea and hurried toward the door of the electronic repair shop. I was hoping to escape yet another barrage of Parsi accomplishment.

* * *

I walked everywhere in Bombay. From the center of the city to Colaba. From Colaba I walked five miles along Marine Drive, which fronted the Arabian Sea to Malabar Hill, and then to the Walkeshwar tank.

In India a "tank" was a kind of bathing pool for Hindus. At the tip of Malabar Hill, where the highest geographical feature in Bombay tips into the Arabian Sea, I found Walkeshwar. It was to me one of the most intimate and appealing places in India. Somehow, amidst the clutter of a huge metropolitan city, Walkeshwar , with its tank, retained its character of a small, intimate rural village.

On my walks around Bombay, I discovered a cake shop at the bottom of Malabar Hill, where I bought wonderful pastries filled with a sort of tropical custard-whip cream of the British period. Since I didn't die after my first helping of this concoction, I made these pastries a bi-weekly treat during the course of my travels through the city.

After my first few days in Bombay, I began to feel that the people of the city progressed along an individual track towards an eccentric alternative reality. To a person new to Bombay, the inhabitants of this place seemed chronically undependable. When I tried to exact directions to a building or shop, or a different part of the city, the simplest directions often became

surrealistic permutations of utterly and splendidly impossible information.

To the newcomer in India, corrupted by fact rotted Western punctualities, the realities of Bombay seemed to be the byproduct of a deeply unhinged adventure in misdirection. I realized also, that I carried with me, crippling liabilities of location, and degraded Western feelings about punctuality.

Bus routes in Bombay bore no connection to destinations clearly marked upon the buses. Clothing sizes marked on tags sewn into a pair of pants or shirts were suspect. Shirts intended to fit dwarves were marked with tags that read "Extra Large."

There were, however, the small compensations for the strange realities that seemed to mark Bombay. You went to places you'd never have gone to except by mistake. Alternatively, important appointments were simply postponed or forgotten, leading to new, and exciting, and even less productive uses of one's heat-filled day.

Among the irritations and frustrations of my first weeks in India, and it is only in retrospect that I can say this, my whole life was changed by the simplest, most ordinary act. During my first weeks of misdirection and frustration with the city, I purchased three wildly different books on India. My first purchase was titled *A Brief History of India*, while my second purchase proved to be my absolutely indispensable *Handbook for Travelers in India, Pakistan, Burma & Ceylon*. Promisingly, the book was in its eighteenth edition, and it had proved useful to generations of travelers.

A few days later I purchased a Manhattan/telephone/directory-sized guide to the timings of the complete Indian railway system. Only in a country where no one would trust the information of anyone else, and in a country that was basically out of control, could I discover a book like this.

The bookseller told me, "One travels everywhere in India by train, sir. Without this guide I fear train travel is impossible. Sahib, this book is delineating myriad miles of Indian train tracks. It is a veritable personal diary of everywhere in the jumble of India, sir. It is the only manner of getting around the mofussil!"

Mofussil was the Hindi word for "the country districts." I learned later that India was mostly the "country districts", with over 600,000 villages.

I asked slowly, "Why on earth would anyone in India need a three-inch thick, thousand-page, four-pound guide to the complete Indian railway system?"

"It is being so, sir. That is why!" My bookseller continued bravely onward in the full cry of useful travel advice. "Never trust verbal informations, sir. Indians are very undependable peoples. Always incorrect and . . . kharaab!"

I quickly learned this word kharaab. It was translated variously into the words, "bad, undependable, mischievous, wrong, etc., etc." and seemed to sum up every direction I'd ever received, in both India and in Bombay.

I bought this guide on the off chance that someday it would help me to make a vitally important, almost missed railway

connection. But the real result of my book purchases was that I discovered whole groups of monuments, as well as entire branches of narrow gauge train systems, that no one else seemed to have traveled or ever heard about. Struggling out of the bookshop with my new five pounds of purchases, I added to my pile of new books a sort of master guide to India, and its entire railway system—all 39,350 miles of it. Surreal.

As a bonus, inside my gigantic book of Indian train schedules, there was a map of the Indian railway system which resembled the scratchings of a nearly dying chicken.

Apparently, maps of the Indian railway system were difficult to get in India because of an ever-looming war with neighboring Pakistan. I discovered later that maps of the Indian railway system close to border areas were identified as an issue of "national security."

Two weeks before, in the district where I lived named Colaba, when I asked for directions to the Kanheri caves, I received as usual four different sets of directions. One of the men said I should take a boat to the caves. Two of the four men agreed that the caves were to the south a hundred miles, near Goa on the coast of the Arabian Sea. The last direction giver said that the two-thousand-year-old caves had been destroyed in the recent heavy monsoon rains of last year.

It transpired that the caves were actually to the north, at the end of the largest local commuter line in India, which transported half a million people daily. No one had pointed north.

From Church Gate Station, I took a third-class train to Borivli, the last station on the local norther commuter line. In the growing shadows of afternoon, I left the town of Borivli and began walking towards the caves. For an hour, I walked along a narrow, melting macadam roadway, through pools of molten tar, as the road cut through the jungle towards the site of the Kanheri caves. According to my guidebook these caves were part of a larger network of Indian religious sites crosshatching the subcontinent. They were also a wonderful quadrant, of an almost forgotten millennial architectural tradition in Indian art.

On a sheer rock hillside, almost hidden and above the road, were precisely 109 caves. The caves had been carved into living rock by Buddhist artisans. My guidebook stated that the earliest caves had been excavated nearly 2,000 years before:

"From Borivli Station thence (it is) five miles to the caves by a rough country road (upon) which carts ply. . . . Cave number three is eighty-six feet long by forty-feet wide, and has a colonnade of thirty-four pillars which encircle the dagoba, standing sixteen-feet high at the back. . . . At the ends of the great veranda are two figures of the Buddha, twenty-one feet high."

What one doesn't realize from reading this entry is exactly how large a 21 foot Buddha is when you stand alone in front of it in the gloom of a deserted cave. I felt that I was the last, or the first, person to ever find this place. As I stared into the deserted cave, I was overwhelmed by the mystery of discovering this place. In the distance, the only nearby living beings were two kites that flew tirelessly in never ending circles high above the earth.

Jungle vines covered many of the cave entrances. Evidently, the jungle had matured and nearly overwhelmed the caves since the first edition of my handbook had been published in the 1890's. I climbed upward, toward more caves which were utterly deserted. I passed more nearly pitch black caves where you could barely see whole sculpted walls full with life-sized stone sculptures of Buddha and his attendants.

Nothing in the life of an 18 year-old had ever prepared me for a place like this. It was beyond my imagination. The only inhabitants of the caves were monkeys and bats. Disturbed by my passage into their kingdom, the bats flitted in and out of the narrow exterior-facing doorways. Inside the caves were more intricately carved interior galleries, and in the darkness, one could just barely make out more scores, if not hundreds, of figures cut into the walls.

 In one cave was a colossal reclining Buddha, which one couldn't measure in the darkness, it was so large. The caves in this place, all 109 of them, came from a civilization and a religion which had utterly disappeared on the Indian subcontinent. How many generations had passed through this place since these caves had first been carved? I calculated: 66 generations. It was an incomprehensible amount of time.

In the dusk, as I walked along the last paths between the caves towards the road below, it was utterly silent.

* * *

BOMBAY, JUNE, 1959

Lately, both Germans seemed happy, which was most unusual.

As I thought about this perhaps they felt released from their terrible decades-long journeys. It was, however, actually something else entirely that made them so cheerful.

One of the Germans, I think it was Hartmann, had gone to a local dentist and had had hundreds of dollars of contraband gold removed from his teeth. In Hong Kong, gold was $36 an ounce but in India gold was pegged by the government at something like $400 an ounce. For years the Indians had pursued a vigorous, if bizarre, policy of maintaining the Indian domestic gold price at a level ten times that of the gold elsewhere.

By my fourth week in Bombay, my only friends, the SS soldiers, were keeping me alive with loans from their gold fillings' transactions. No doubt they were doing this in hopes of receiving some good Indian karma. Good karma in this case was keeping me in fried eggs, paying for my four-cent-a-night room and providing me with a rupee equivalent of a dollar a day in mad money.

What the Germans smuggled in the way of gold was a raindrop compared to the ocean of gold that the slow-moving, sail-driven Arab dhows smuggled into the country from the Gulf. By 1959, Indian gold smuggling supported whole economies, like those of Kuwait, Dubai, Oman, Bahrain and Abu Dhabi. In Bombay, my German friends discovered their natural home. After what they had lived through on the Russian Front and Vietnam, I

suspected they were glad to discover a warm climate where practiced lawbreakers seemed heartily welcomed.

After my two daily visits to American Express, I wandered through the deep arcades that followed the D. Naoroji Road. Under these arcades, away from criminal German smugglers, I discovered the great Bombay bookstore, Taraporevala's. On the long shelves that ringed the shop, I discovered Martin Hurlimann's astounding *India*, published by D.B.Taraporevala in 1928. Hurlimann's book had almost three hundred pages of rich, velvet-black gravure plates. I felt the need to visit the places on the Indian subcontinent depicted inside this inspirational, handsomely crafted book.

On another shelf was Cartier-Bresson's book, *The Decisive Moment,* which included pictures of Kashmir and of Lord Louis Mountbatten, the last Viceroy of India. In Cartier-Bresson's book, there was a picture of Mountbatten and his wife Edwina standing next to Jawaharlal Nehru. Nehru was laughing. At the moment the picture had been taken, there was a diversity of reasons for Nehru to be full of mirth. The first was that the British were about to quit India, after ruling various pieces of the subcontinent for three and a half centuries. The second reason, and a footnote to history, was that at the moment the picture was taken by Cartier-Bresson, Nehru was having a lustful affair with Edwina Mountbatten, the Viceroy's wife.

After Taraporevala's, I'd spend hours each day walking to Bombay's other bookstores. In the late afternoon, I'd wander into the congested side streets of the city toward the harbor. In Bombay, I'd discovered used bookstores like Kokil & Company, and the stalls of the Chor Bazaar, which were stuffed with thousands of mildewed and worm-holed books, left over

from the British Raj and the hurried English exit from India in 1947.

In this jumble, I found tattered books on British military campaigns, but I also discovered startling British memoirs of Indian life in the eighteenth and nineteenth centuries. In piles of these wrecked and abandoned second-hand books, my nineteen-year-old imagination overflowed with disassociated Indian archaeological and cultural facts, written by an extraordinary group of utterly forgotten Englishmen.

Given the facts surrounding my travels to India and my association with second-hand bookstores, my college studies in India were over before they'd even begun. I was totally broke, and I had no way to reach either Bengal or my university. The last stop of every American indigent in Asia was a trip to the consulate, where you could beg or wheedle a humiliating one-way ticket home. That June, as I sweltered in Bombay, my university career in Bengal seemed unlikely.

On my sixty-first visit, with a twice daily appearance at the American Express clients' mail drop, I received a letter. In the letter my father said that he hoped I'd reached India safely.

Enclosed was information about a wire transfer for $1,000 that my father hoped would ease my financial needs I'd described to him in a letter from Hong Kong. In Hong Kong, I had incautiously purchased a Leica M2 camera that was then the world's most expensive 35 mm camera. My father said that he, too, loved photography.

Both my father and mother wished me well. They sent their love. As a postscript, my father added that any time I wanted to

return to America, I could attend the University of California in Berkeley, a twelve minute walk from our house.

Of course, the date on the wire transfer indicated it had been sent to American Express a month before. In India, people had either misplaced it or forgotten to give me my money. From being a freeloading mail client irritant, I was suddenly transmuted into a wronged customer. The normally surly American head of the Bombay AMEXCO branch, a nasty American creature with a receding chin, happily converted my money wire into traveler's checks from my wire transfer.

At a tourist store near the Victoria Terminus railway station that sold Indian sandals and Indian mirror work textiles, I changed two fifty-dollar traveler's checks on the Bombay black market. During my stay in Bombay, I'd become an eager student of the black market, where I received substantially more for my dollars than I would have obtained had I cashed my checks at the "official rupee rate" at AMEXCO.

Centered exactly above the managers desk in the tourist store where I changed my travelers checks was a police circular. It referred to a never enforced law, and informed the unwary that "cashing money or travelers checks on the black market is a crime punishable with up to six month's rigorous imprisonment." My two Germans had taught me well regarding the cracks and crevices of Eastern crookedness.

Out on the street again, my pocket bulging with illicit Indian rupees, I noted with some satisfaction that, like my two Germans, I too was becoming a practiced Indian lawbreaker. In the Chor Bazaar, I bought a canvas carryall bag for my travels.

In neat black lettering, I inscribed on the bag: "C Worswick, Bombay – India."

The next morning I paid off my debts to the Germans. I said goodbye to Hartmann and Heinz Peter probably forever. Both the Germans watched me as I descended the stairs for the last time. As I went down the stairs, my future seemed to extend forever. To an eighteen-or nineteen-year-old, there is no such thing as the future.

From the courtyard below I looked upward.

Both the Germans were peering over the weather beaten railings of our boarding house. Looking down at me, both Hartmann and Heinz Peter had looks that were filled with loss, and with things never found again.

I turned.

I didn't look back. Beyond the building was the street, and beyond the street was the shimmering heat of India. I was too young to understand what melancholy was.

* * *

EASTERN INDIA, JUNE 1959

It was hot. Very hot. There was neither a cloud nor a bird in sight.

I'd taken a rickshaw in rural Upper Bengal across the fiery plains of Birbhum. I bumped my way down the thin melting macadam roadway and reflected upon an entry from the university brochure that I'd received almost in California nine months before. The brochure stated, "In the lush countryside of Birbhum there is a great university which is the premier academic institution in eastern India. The university was the dream of Rabindranath Tagore whose Nobel Prize-winning verse, short stories and novels demonstrate colloquial language, melodic lyricism, wholesome naturalism and philosophical meditation."

Santiniketan, Tagore's university in Upper Bengal, had been founded by the only Bengali Nobel Prize winner. The Nobel Laureate poet of 1913 was also a cultural icon, a polymath and a painter of note, "who defined Bengali art by inventing new specific Indian forms."

With the aid of my huge railway schedule book, I changed trains and stations easily in Calcutta. To cross India, I'd taken a fifty-three-hour trip. From Bombay, I crossed the width of the India subcontinent to Calcutta. Exiting the Howrah railway station on the west side of Calcutta, I'd taken a rickshaw pulled by a thin coolie to Sealdah Station, located in central eastern Calcutta. In Calcutta I witnessed my first Bengali rain storm. This was no ordinary rain. It was a deluge, an inundation inside my rickshaw. Calcutta floated by. The rickshaw man was sometimes waist

deep in river-like puddles. We made it to Sealdah Station without witnessing any pedestrian drownings. From Sealdah Station, I traveled upcountry to my university at Santiniketan.

* * *

In Upper Bengal, a half day train trip from Calcutta and the station at Bolpur, the nearest railway stop to my university Santinikitan, the midday sun hung in the like some malevolent, sculptural object. I'd traveled from torrential rain in Calcutta into a burning hell. I watched the desert from my bicycle rickshaw, pedaled by another emaciated coolie, as the slow-moving coal-burning train traveled north toward the Himalaya.

The train, my only connection to the world beyond this burning inferno, glided toward the heat-shimmering horizon and disappeared. I took a deep breath. Underneath me the macadam oozed in the heat. The cycle rickshaw man bent over his handlebars and was careful to avoid the puddles of melting tar floating along the road like sluggish black serpents. After a three-month-long journey, I'd arrived, finally, at my university. Along the road, women in thin, earth-colored saris carried bundles of sticks on their heads. They slipped across the road and disappeared like sleepwalkers into dried-up paddy fields.

Bengal was so exotic I shivered. I was ready to plunge into learning the Bengali language. As I rode along, I thought to myself that I was happily prepared to undertake an exhaustive study of Indian history. I was ready to immerse myself in the deep waters of the subcontinent's cultural and spiritual values. I'd arrived at my destination. I'd reached Santiniketan.

Inside the gates of the university, I climbed out of the cycle rickshaw. In front of the gateway leading to the university, I passed a Bengali peasant driving huge, black, dust-covered water buffalo toward the river. I stood there watching these strange creatures. Paying off my rickshaw man, I left my bag at the gateway with a chowkidar—a local policeman/guard. I walked down a deserted tree-lined street until I saw a sign directing me toward the administration offices of Visva Bharati University, as Santiniketan was more formally named.

Inside the administrative office, I moved toward an adjacent small room. The building was constructed in a squat, rectangular shape. Heavy walls created a barricade from the furnace-like day outside. In the small room ahead of me were three men sitting at individual desks.

In the silence that seemed to go on for an unnaturally long time, I finally stated who I was. I spoke of my modest educational goals in Upper Bengal.

None of the men replied, and after a long silence, one of the men began to rifle through a large eighteenth-century-like ledger. I interpreted my welcome as an omen of something nasty. Was this a sign of important educational goals not moving in my direction? Beyond the administration office, out of the single window in the room, I noticed another one-story building with chipped and neglected white paint. A flock of birds had come to rest on two skeletal trees. Out of the almost milky-opaque window, I stared at the birds. One of the birds started a song then gave up, looking exhausted. In the incredible heat of Upper Bengal, none of the other birds moved.

Beyond the administration building the heat radiated from the baked red sand of a courtyard in undulating, slow-moving waves. Slowly, the man with the ledger opened his huge book and found the page he'd been searching for. The other two men continued staring at me.

"May I have your good name, sir?" The man behind the book asked.

I told them my name, explaining that I was an American who intended to study at Visva Bharati University.

Across the small room, the man with the ledger stared at the huge page in front of him.

"I fear that in our admissions book there exists no record . . . I regret to inform you . . . of yourself." The man paused. "There is no record whatsoever of a single foreign sir's application."

At a complete loss, I repeated my name. I repeated that I was a foreign student.

From his desk, the admissions clerk plucked a single sheet of paper. He studied it and then he held it up for me to see. "This is the only record of a student from outside we have presently, sir. She is a her. You are not a Russian her?"

I wondered right then if I should feel sorrier for myself or for Santiniketan's only other foreign student. I had absolutely no strength left to leave this place. I was abandoned at the edge of the world.

I wondered if one foreign student made Santiniketan an international university.

On their spindly wooden chairs across the small room, the three clerks sat quietly. All three of them settled upon staring at me. It occurred to me that they had the same baffled, yet incurious look of Indian goats. It was a look that accepted everything, yet took responsibility for nothing.

The man behind the ledger smiled pleasantly. In a singsong voice he said, "Have you noticed heat, sir? It is hot season. Heat has just commenced."

The man hesitated before giving me another dose of unwelcome news. "It is very difficult in heat for students to study or read courses. So, university is presently in recess. Two months summer recess. Recess for hot season. That is why there are not people here."

In the semi-darkness of the small room, another of the men chirped in heartily. "Indeed, beastly hot, sir! Students return to their native places to sleep off the many difficult university mental exertions."

In a high falsetto, the third clerk added happily. "It is, naturally being hot season, a moment of rest!"

"We suggest that you rest, young sir. Rest until university is being in session!"

My whole future was in the hands of these totally unpromising individuals. I took a deep breath. I looked at all three of them. Were these men telling me my growing love of India was a

mistake? I'd come to India to learn Bengali culture and Indian history and was instead being informed that I'd made a completely futile journey halfway around the world.

Carefully, I wiped my sweaty palms on my pants. "I am disappointed, of course, in your lax university record keeping." The man with the file ventured words of hope. "Never fear. When it is dark it is actually almost becoming most light, because it can get no darker. Yes? We fear you have only been misplaced, not lost. From here onward we will work for a perfect solution!"

I produced my now very worn and creased letter of acceptance from the university with a shaking hand. I placed the letter on the desk in front of them.

Wordlessly, I pointed slowly to my letter. It was from the head of admissions of Visva Bharati University at Santiniketan in West Bengal. The letter stated that I was a successful candidate for admission to the university, underneath an engraved letterhead.

I was wondering then, how I could spend two months in this hellhole before I began my studies. How did I get into this? I was not only missing, I'd arrived at a university with no students.

Across the dark room, the three of them consulted in whispers. With damp fingers, they passed my letter from hand to hand. The last clerk held the letter up to the light. Perhaps he was trying to check the watermark in the paper to see if I had forged the letter? Silently, then each of the other two men checked the

watermark as well. The last man nodded. Together they all nodded in unison and twisted their small faces deep in thought.

Then, one of the men volunteered spontaneously, "We are most hoping that this does not reflect upon India itself and ourselves at Visva Bharati University. We are . . . most sorry for the young sir's misinconveniences. We have thought unanimously about your difficult case, young sir. You are hereby admitted to said university, although we have no record of this whatsoever."

I tried to smile bravely. Undoubtedly, the dean of admissions and everyone else of importance in this burning pit of academic discourse had vanished during the hot season.

Was "misinconviences" even a word?

A man with hairy ears, the chief, smiled grandly. "We are thinking that in Calcutta you will like better food, sir. In Calcutta they will have firangi food for you. Certainly, yes?"

In a soft lilting voice, the second man ventured his own opinions. "Oh, chi chi! So marvelous is Calcutta! Such a very happy place! A paradise of the most modern up-to-date things and modern Hillman British motor carts!"

The third man, a small man who had not spoken much at all, agreed vehemently. He grinned madly. "Calcutta, a garden, sir. So many happy people of your own kind. British people! This is an absolute must being, sir! In Grand Hotel they are having living potted flowers for happiness next to dance floor. And gin and whisky."

The only sound in the room was the fan overhead. It was whirring, whirring.

It was just then catching up with me that, as far as promises of admission to Santiniketan were concerned, this was terribly ad hoc. To make me happy, I had been given the incredible suggestion that I should return to Calcutta and go dancing! Along with these suggestions were even more unbelievable ideas concerning good food tips, companionship and drunken bacchanals that were apparently still held among the potted flowers at the Grand Hotel. I'd learned in the last few weeks that the people of India might promise you anything in exchange for your departure.

I carefully retrieved my letter of admission. I broke out into a cold sweat. It was the only proof I had of my admission to this place. I asked for a formal letter of admission to be placed in the enrollment ledger of the university. All three men nodded simultaneously.

The leader of these diminutive bureaucrats assured me, "When you return in two months, you will be admitted as a pukkah foreign scholar of Santiniketan."

Carefully, he opened the huge ledger. At the appropriate page and in exquisite copperplate nineteenth-century-style handwriting, he wrote carefully, "1. American scholar admitted, to international division!"

He called me over to look down at the book. Apparently, the other foreign scholar, the Russian woman, was also enrolled in the same program.

All three men stood up. "Thank you," I mumbled.

I rose and went outside into the furnace. I looked at the courtyard beyond the admissions building. The heat-struck birds were all dead or dying. They lay underneath the sun-blasted tree in a forlorn little heap.

CALCUTTA, JUNE, 1959

I took the train to Calcutta the next day at high noon from an upper Bengal railway station with a platform of tarmac literally melting in the heat.

The engine was a coal-fired relic from 1900. When it pulled up to the platform from upcountry, I thought back to the great days of railway travel when steam engines, equipped with multiple and gigantic driver wheels placed on either side of the engine, drove trains like this across the length and breadth of the British Indian Empire.

The journey to Calcutta was slow and infinitely languorous. The train with its fifteen bogies stopped every twenty minutes or so to pick up or discharge groups of Bengali peasants and their livestock. As the train departed from one small station and headed toward the next, I was surrounded by barren, sun-bleached fields of rice paddy in every direction. In the midday sky, towering cumulus clouds promised rain, huge amounts of rain, but in a few weeks, not now.

That night, I finally arrived in Calcutta on what had to be the slowest train on earth.

Outside Sealdah station I engaged a rickshaw. In the night, my rickshaw, pulled by half naked man, passed thousands, or perhaps tens of thousands, of sleeping shapes huddled on the sidewalks. The shapes were faceless, without discernible gender or personality. If the shapes were still alive under their shrouds, they had been reduced to the lowest denominator of survival.

For me, like the sleeping bodies everywhere around me, Calcutta was the last stop. I couldn't travel any further. I was totally broken. I'd been traveling for almost three months.

That night at 9:30, I managed to book the last available room on Sudder Street, at the Salvation Army Hostel.

I'd been lucky to get into the hostel at all. A missionary was arriving from upcountry on the same train I'd taken. He arrived at the Red Shield Hostel just before me, and they had kept the front desk open for him, hours past their usual closing time. The desk clerk wore a clean black jacket and an immaculately starched white shirt. He asked me how long I was to stay in Calcutta.

"Two months. "I replied gloomily.

Carefully, in a day full of disappointment, I filled out the registration forms and surrendered my passport to be held for the police to study. Five minutes later, I entered my room, and switched on the light.

 In the heat, in a condition of utter exhaustion, I lay on an iron cot. I looked up at another whirring fan bearded with dust. Lying on my hospital-like bed I searched for the right word to describe my trip to India. I thought the word "disaster" fit nicely.

* * *

I discovered that the Salvation Army Hostel was full of the same sort of people I'd met on my boat trip from Japan towards South East Asia and Singapore. The only difference was these people seemed to have all wandered eastward from Europe instead of westwards across the Pacific. They appeared to be fleeing the delights of Turkey, or the fleshpots of Lahore and Delhi. In Calcutta, they waited and wandered around the docks looking for a boat to take them to the promised land and European banalities of Australia.

The morning after my arrival, I sank into an emotional torpor, punctuated only by the treat of my morning feedings of Indian - made Kellogg's Wheaties and soggy eggs. I had the hope, chewing on cardboard toast, that someday, at some incalculable moment, the rains would come and end the heat.

The inhabitants of the Salvation Army Hostel seemed to me too ordinary looking. They appeared disoriented, and stunned.

In the breakfast room I wanted to discover soldiers of fortune, or down on their luck tramp steamer captains. I'd also settle for gun smugglers, loose women, busted and broke British military officers of an army which didn't exist anymore, or perhaps out of work tea planters in a new era of coffee drinkers. All I saw were washed out faces looking like they suffered from terrible disappointment.

In the Salvation Army Hostel, my chief amusement during the first two weeks in the city came to be watching infinitely slow fingers of sickly white fungus creep up the walls of my room.

As my weeks at the Salvation Army Hostel aged and died during breakfast, there appeared however, a quite strange assortment of

dissatisfied humanity: A Danish archaeologist en route to Alice Spring, Australia to dig for early clues of aboriginal migratory patterns: a hydrological engineer from the U.N. fixated upon the uncleanliness of the city and the seldom-occurring local Calcutta garbage pickups. A Spanish painter appeared who was fleeing the art scene of Paris, who lived on a diet of curds. His chief complaint, apart from a poorly functioning dietary track, presumably clogged now with curds, was the erratically functioning forty year old Calcutta streetcars.

In the Salvation Army Hostel, I met a small Anglo-Burmese Christian, who lamented over his cereal each morning that a huge proportion of the local population seemed to live in unclean, gigantic, out-of-doors municipal campsites where nothing ever dried, and everything was always soggy. I pointed out these were the nighttime streets of Calcutta. He looked at me sadly.

Amidst the myriad agonies of a city that seemed never to dry out from the now incessant monsoon rains, my agonizing death-by-heat- stroke crossing of Central India by train receded into a nasty memory.

<p style="text-align:center">***</p>

In the seventeenth century, Calcutta was a city constructed on the mud banks of a tributary of the Ganges River. This junior river, called the Hooghly River, was a two-hundred-yard-wide monster. It was leavened with ship-eating, ever-shifting sandbanks that were particularly lethal during the monsoon.

It rained on the first night I'd arrived in Calcutta. It rained the second day I was there. It was still raining months later when I

left the city. I felt marooned in Calcutta. I sometimes felt like I was a strange sort of prisoner in my dark, small room near the rear walls of the Salvation Army.

In retrospect, Bombay seemed a sun-filled paradise with its cosmopolitan mix of races and cultures. Plunked down on the shores of the Arabian Sea, Bombay, in comparison to Calcutta, was a bastion of art and culture. Bombay had French restaurants and Russian restaurants. There were drama clubs, bookstores, museums and even a strange film industry.

Calcutta, by comparison, seemed to be a city hunkered down in the middle of a swamp. During the monsoon I gave up wearing shoes and started wearing practical rubber thong beach sandals instead. The city seemed to generate various vicious, negative obsessions in the foreigners I met. I decided, as the weeks wore on, as a resident of an indeterminate residence in Calcutta, I had no other choice than to think lovely and always positive thoughts. Just look at the Bengalis. They all seemed weirdly cheerful. In my new, positive, now zoned-out happy frame of mind, I decided the city was simply a state of mind.

When you viewed Calcutta as a sort of alternative reality, it just percolated with an almost unbelievable energy. The Bengalis seemed to actually thrive in this swamp.

I didn't dare look too closely at this idea. Perhaps the great steaming heat had damaged the Bengalis' chromosomes over the period of generations. Perhaps the rains and the heat had created a race of people who were, by turns, brilliant, and deeply querulous. By some strange quirk, though they were always

positive and cheerful, somehow they didn't seem too much like one other. With their own language and their distinct literary and dramatic traditions, the Bengalis seemed to be lovers of inundation and the steaming chaos of their swamp. Definitely, I decided, the Bengalis were a genus of people who'd been produced nowhere else on the planet.

In time, during the months ahead, I began a kind of catalog of Bengali oddness, and quirkiness.

A Bengali could argue for hours about the smallest political, historical, literary, artistic or semantic point. To add to this jumble of hysteria, there was the cantankerous nature of the Bengali himself, which appeared to be the result of a peculiar plan of living. Universally, he was difficult, petulant and argumentative, infatuated with being correct about everything.

Each day on one of the Calcutta trams, I'd watch Bengalis engage in screaming matches about who had occupied a trolley seat first. Alternatively, there were other screaming matches about who was in line first to board a trolley, or who had broken the line outside a shop to buy flour or lentils. Nothing was too trivial for a Bengali to argue over. They were, in addition, a particularly quirky and deeply inaccessible group of people which, as I said before, always seemed peculiarly happy.

During my third week in Calcutta something happened to me. Perhaps it was finding myself in this mystifying place. Issues that had previously irritated me beyond any measure, I now accepted as being part of life in Bengal. I began to look forward to the inconveniences. I came to take things for granted, like the monkeys who lived in the Salvation Army compound and

carried off half my clothes from the communal clothesline. Instead of rising to anger, I watched the entertainments of monkeys climbing up into the highest branches of the hundred-foot trees, then ripping my clothes to shreds as they pissed and shit down on me, screaming in delight.

To me, Calcutta and the Salvation Army monkeys were a sort of skewed, alternative dimension coexisting with the world in which normal people lived elsewhere. There wasn't another place in the world like Calcutta, or quite like the Salvation Army Hostel on Sudder Street.

Suddenly, without rancor, I accepted the curiosity of the seventy-seventh Bengali pedestrian that day who would enquire about why I was here in Calcutta. Was I a spy? Was I a salesman of prophylactics and sexual rubber goods? I discovered that the Bengalis were enthralling and even wondrous, as long as you could return to your hotel room and close the door. Then, you could read a book and be transported somewhere else, with the benefit of maintaining your equanimity and sanity in Calcutta.

* * *

In Calcutta I began to take photographs.

Each time I finished a 35 mm roll with my Leica, I'd take my film to a British period Calcutta photography shop named Johnston & Hoffman. It was in low-ceilinged, dark cubicle, tucked into an arcade with a collapsing roof off the New Market. It was two blocks from the Salvation Army. Perhaps the second or third time I went to the shop, I noticed the nineteenth-century

photographs of Calcutta inside smudged, almost opaque glass ,display cases. I asked about these photographs, and what they were, as I'd never seen photographs like these before. From small ancient cardboard boxes, under the counter, the frail Bengali clerk produced other photographs that documented the great historical monuments of the subcontinent in a startling fashion.

Looking at the pictures at Johnson & Hoffman, I was struck by the miracles of technique in these extraordinary photographs. I'd never seen photographs like this before.

I'd contact-printed negatives on POP ("printing-out paper") in the mid-1950's, on some of the last paper of this type ever manufactured. It was difficult to get suitable print using POP paper. Time and again, I had tried and failed. I'd attempted scores of prints, with no luck apart from the disappointing smudgy murk of another failed photograph.

The artistry of Johnson & Hoffman was achieved, I learnt, on POP paper that had been carefully toned with a wash of pure gold. The prints were completely beyond the capabilities of present-day photographic techniques for something like the last three generations. The clerk produced the last catalog of photographs sold by the Johnston & Hoffman firm. The catalog had been produced in 1900. It was a fifty page thick catalog, which had been a complete photographic survey of the most important Buddhist, Hindu and Islamic monuments on the subcontinent.

The sheer scope and number of monuments documented in this vast corpus of work that spanned India was incredible.

I'd never seen these pictures illustrated in a book, a magazine or an exhibition. After my fifth visit to the shop, more print boxes were opened. The owner of the shop spilled scores of gold-toned prints across the cracked-glass counters. I discovered an entire archipelago of pictures documenting the cultural treasures, and architecture of India. Perhaps the most remarkable of all the pictures I saw were of a stupendous Jaina religious site at Mount Abu, in western India.

That night, in my *Murray's Guide to India,* I looked up Mount Abu. The statues and columns of the temple that had been so carefully wrought, from the eleventh to the thirteenth centuries, were carved from pure white marble. The sculptors of the temple were paid in equal weights of gold to the marble dust they removed.

My *Murray's Guide* noted quite simply, "…the temple contains the finest marble carving in India."

I returned to the Johnston and Hoffman shop again and again, not only to pick up my negatives the firm developed, but to look at their photographs.

With the money my parents sent for my college tuition, I could never afford the quantities of pictures that Johnson & Hoffman possessed, so I settled on buying a small number of prints. Dutifully, after each purchase, the clerk would place my small pile of pictures in a Johnson & Hoffman lithographed envelope produced a half century before. It was astonishing this work had been created, then totally forgotten. No one had looked at these pictures in decades.

I learnt from the owner of the shop that these photographs were created in the late 1880's and early 1890's. The chief operator of the firm had been P.A. Johnson, who had died in 1891. The survivor of the partnership, Theodore Julius Hoffman had lived into the 1920s.

The photographs of the firm had been made with old-fashioned, heavy and difficult-to-operate "full-plate" cameras with attendant plate glass 8'' x 11'' negatives. The nineteenth-century pictures of Johnson & Hoffman were then "contact printed" on printing-out paper and next fixed, washed, and finally bathed in a solution of gold, which permanently sealed the print. The Indian family who presently owned the firm had taken over the business after Hoffman died.

One dismal day in 1962, I heard that the Johnson & Hoffman shop had been a victim of flooding. Practically nothing was saved, and the firm's negatives which had existed until that point, perished in the inundation. None of the negatives survived. In 1963 I returned to the shop, and the owner of the firm, a sixty-year-old Bengali gentleman dressed in a bush shirt and starched white pants, showed me a few remaining examples of the firm's prints.

Sadly, no one apparently knew, or has cared about the loss of thousands of Johnson & Hoffman pictures and negatives. They were a catalog of an entire subcontinent created by a staggeringly ambitious imagination.

* * *

88 · Clark Worswick

In Calcutta, I discovered another secret. It was a secret similar to a complicated wooden Chinese puzzle box, which held for the beholder unseen mysteries, until it was opened.

Directly behind the Salvation Army Hostel on Sudder Street were the rear portions of the India National Museum. Without ostentation or artifice, entire millennia's of the subcontinent's history, culture and the considerable glories of India were described in gallery after dark gallery.

The India Museum was the oldest museum in India, and it was the largest. For a century and half it had waited there to be unearthed by each new generation.

Inside the museum to right of the entrance, was the singular and unearthly Bharhut stupa, with fragments of the original railings that had been erected around the Bodhi tree, under which Prince Gautama had received enlightenment in 544 BCE at Sarnath.

Still other rooms were stuffed with dozens of masterpieces of Gupta art which had been made at the height of Buddhism in India during the sixth century AD. The center of these rooms held what was, to my own mind, the absolute finest example of Indian art extant. It was a red sandstone, twelve-inch high Buddha head, done in the high Gupta style of the sixth century, and it was an out of body experience, looking at this sculpture, so exquisite was its form.

In another gallery were bronze and stone masterpieces of Hindu art which had somehow survived the puritan ravages of the

Muslim conquest of north India, at the beginning of the tenth century. Another gallery held examples of Greco-Gandharan art, created by people who were the leftovers of Alexander's legions, they had been abandoned on the Northwest Frontier beyond the Khyber Pass, after the death of Alexander the Great, at the centuries old palace of Nebuchadnezzar in Babylon.

Of all the treasures in the India Museum, however, there was one object, if you could call it an object, which to me was an unexplainable total mystery of museum going. In my own pantheon of growing indescribables, perhaps this was primary, stand-out emotional favorite, as the weirdest museum exhibit in India. Each day I came to the museum I would stand near this object, and I'd marvel at the placement of this object in a museum.

Along the length of the huge gallery facing Chowringhee Road, raised perhaps fifteen feet above the gallery floor, was a huge wooden board mounted across the entire wall. Upon this board were affixed scores of metal bangles and bracelets.

In the afternoon light that spilled into the gallery, the jewelry glistened and it shone magically. However, without reading the caption affixed to the wall, one had no idea what this peculiar display actually was.

The caption stated that the jewelry on view had been taken from the estimated 340 victims of a giant Ganges River crocodile, which had been assassinated by a British officer in the previous century. To my mind, now beset by the strangeness of Calcutta, the crowning glory of the museum was the actual crocodile

itself. He was pinned there, affixed to the wall looking like a huge, grinning, well-worn leather suitcase.

* * *

At the end of June I received the first letters to catch up with me from the Bombay American Express. My mother wrote me, telling me I was greatly missed.

She hoped I was in Eastern India by now, and thriving upon exciting adventures. She hoped, also, that my college had received me with warmth and care.

My mother wrote that my father, too, had been a good photographer, without referring to me bankrupting myself in Hong Kong, with my purchase of a Leica camera. Both my father and mother hoped that my photography of India would grow and thrive.

Perhaps my father should have written to his cousins in England to obtain introductions in India. She said she would try to obtain these introductions, if it were necessary, then she observed that the British were a very brittle people, who thrived on introductions. She wondered if there were still many British left in Calcutta and in Bombay, after the Indian/Pakistani Independence and Partition.

Meanwhile, another draft had been dispatched to me at the American Express Bank in Calcutta. My parents hoped this would cover my college fees, and a monthly allowance for my maintenance. When my funds "needed topping up", as my mother said, she requested I relay the message to them with a

two month time frame. The American Express Company in San Francisco seemed baffled by exactly how long it took a bank wire order to get to India.

In a plaintive way, my mother asked when they might expect me to come home. In closing, both my father and mother sent their love, saying they hoped I was happy in India and my studies were progressing.

I folded the letter back into its envelope. I went to the American Express bank teller and asked if I had a money draft waiting for me.

The teller looked at me blankly. I reflected upon my lengthy wait for my funds in Bombay. Why, exactly, I'd embarked on this journey to India eluded me at that precise moment.

In my Chinese restaurant off Park Street, I later tried to lose myself in my *Murray's Guide to India*, which had a large section on the British involvement in India from the 16^{th} to the 20^{th} century.

Between ordering my lunch, and my reading, I admitted to myself I felt closer to the British and their period in India than I did to the Bengalis. It occurred to me, that up to the present moment, the four hundred year presence of the British in Calcutta was only a brief, inconvenient, specular phenomenon to the Bengalis. I'd had the feeling too many times in Calcutta that the Bengali's looked through me, as if I was invisible to them. Like myself, the British had probably been invisible as well.

The irony of this invisibility was that Calcutta was, in fact, a

wholly British creation and city. In the last years of the seventeenth century, the city had been founded by the British as an Indian trading station, during the period of the Mughals. As the city had grown, it had been administered, and then paid for by the British.

But lately, the city seemed to have lost its economic center.

In 1947 there came the very odd moment of Indian "Independence." Quite suddenly the British decided, a few short years after World War II, with their own consequent insolvency from fighting two world wars in the 20th century, to "award" a new country, called India, its freedom.

As the British departed, they left the Bengalis in charge of insurance companies, tea estates, real estate trusts, steamship and port facilities. They also left the Bengalis the Calcutta race track, museums, the railway and postal infrastructure, as well as the judicial apparatus of the government and the entire commercial infrastructure of Bengal. The economic result of this decision was that Calcutta became a semi-starved stripling of its former self, with a new state government that had never governed anything.

One day in 1947 millions of people had suddenly found themselves belonging to a country which never existed before. By 1959, though Calcutta remained a city with hundreds of factories, the raw materials needed to run the majority of these factories were now in a place called East Pakistan, now a completely different country.

In Calcutta there were still English-operated newspapers and magazines. In 1959, thirteen years after the British Indian Raj

had disappeared, seventy-five thousand British residents still lived in Calcutta.

The British still had their own pastry shops and restaurants. British businesses remained, employing only Englishmen in the executive ranks. There were also British only sporting events with inbred cultural societies devoted solely to "things British". This was the city I wandered through each day. Both the Tollygunge Club and the Bengal Club refused to admit Indians.

In the seventeenth and eighteenth centuries the British had fought off the Mughals and then the Mahratta's. They had died of fever and plague, and excessive drink. Even more unhappily, they apparently died by eating mangoes out of season. In the nineteenth century, still other generations of Englishmen had fought off wave after wave of Sikh, Pathan and Afghan soldiers in the Punjab and the Northwest Frontier. On Park Street were the British graveyards. They dated back two and a half centuries and they were planted to the walls with heroic Englishmen.

Calcutta in 1959 was still a British city in the English mind. But it was a city with two and a half million Bengali inhabitants of which only three percent were British.

* * *

In my quest for new things that were exotic in Calcutta, I discovered the Sir Stuart Hogg Market. After Independence the market, unimaginatively, was renamed the New Market. In the darkest recesses of this market, just a block away from Sudder street and the Salvation Army Hostel, merchants sold everything and anything one could possibly imagine. Particular shops sold

cork-filled solar topee sun helmets once favored by British policemen, and country magistrates. They sold the thick bed rolls used on Indian trains by every traveler who boarded a train on the subcontinent, who wanted a sound sleep during uncomfortable, upcountry journeys.

Other shops sold Japanned tinned trunks for other sorts of journeys upcountry. Still others offered odd, hard black rubber devices for erotic stimulation, and sinuous Czechoslovakian prophylactics for birth control.

Dimly lit stalls were heaped with sacks of cashew nuts from Trivandrum, piled high with dried apricots from the wilds of Eastern Iran, and stocked full of apples and pine nuts from the valleys of Chamba in the Himalaya. In the live animal section of the market, merchants offered chickens and ducks for the evening meal, but in the same section of the market there was also an area devoted to the sale of inedible animals.

Here you could find an assortment of the most exotic animals imaginable: living baby tigers from the forests of Imphal and Assam, mongeese, Assamese forest deer and scores of exotic birds and parrots from the Chittagong Hill Tracts or from Upper Burma.

The market was a relic from the high Victorian period of the 1890s. At the New Market, the British made up their stocks of emergency supplies of something called Horlicks. The New Market was also the spot where the British in Calcutta still bought the difficult to import tinned butter from New Zealand, and potted lobster from Fortnum & Mason.

In the darkened aisles, under the glass roofs of the New Market, one could always find scores of stuffy, imperious and silent British housewives, who were out making their weekly shopping rounds. Invariably, they appeared well starched and primly put together. These women comported themselves as though they were survivors of the siege of the residency in Lucknow during the Indian Mutiny of 1857. Trailed by fifty-year-old decrepits, they sonorously called "boys" in trilling female British accents; they were well used to the command of Indian servants in their slacker battalions.

Depending upon how hard they were worked, these "boys" of the memsahibs lugged large rattan basketfuls of the week's rations with differing expressions ranging from irritation to gloom.

In my own passages through the market, I came to the conclusion that only the British could eat the foods purchased by their *memsahibs*. There was Fry's Turkish Delight Heinz Salad Cream (a sort of heat-resistant mayonnaise and salad dressing combination), bangers, Coleman's English Mustard, Marmite, C&B Treacle Toffees, the ingredients for Batchelor's Mush Peas, and of course, Mowberry pork pie, the latter bought at the Chinese butcher, along with a sausage called a banger.

But one should certainly not forget the old-time British culinary standbys of evaporated milk, Bird's Custard Powder and certainly the one indispensible ingredient, which held everything together, the glue of Anglo-Indian cuisine, authentic Heinz Ketchup.

Chirping and swallowing their British accents at the end of each

sentence the British ladies would retreat with their purchases to black, perfectly polished pre-war British-made cars waiting with uniformed drivers on Lindsay Street.

It was something close to heroic, this willful rearrangement of time. Only an Englishwoman in the tropics could have accomplished this feat of weekly shopping. One would have thought, from looking at these women, that time didn't exist in Calcutta. Every one of them hailed from an era that had died practically everywhere else in the world.

]
In Calcutta the Victoria Memorial was centered astride a park that dominated the central part of the city. The building was a monument to the British presence in India. It had been erected as an adjunct to the Empire, which the British had gathered in bits and pieces during their three hundred and forty eight presences in India. It was filled with the loot they collected along the way. Seen another way, perhaps, the Victoria Memorial was a British conceit, which attempted to rival the greatest building in India with the gravitas of the Taj Mahal.

The park in which the Victoria Memorial was placed owed its creation to a period two centuries before. The area had been created as a "clear fire" for the cannon of Fort William, which anchored the British presence in East India.

The blinding white marble of the Victoria Memorial shimmered in the heat. When one finally stood in the lee of the Victoria Memorial, in the shade, only then was one able to view how truly gigantic the building was. In scale, it was tremendous.

One entered the building by climbing a faultless, fifty-foot-wide grand staircase. The stairs rose upward toward an outsized, vaulted entrance of carefully worked white marble that had been transported across central India from Makrana in Jodhpur.

Inside the building, cool staircases climbed upwards to museum galleries. On the second floor, still more staircases led to balconies, which in turn were supported by marble columns as thick as an elephant's back.

The Victoria Memorial was utterly deserted.

Inside the building, each surface was wiped at fifteen-minute intervals with damp cloths, by an army of men dressed in khaki uniforms with brass buttons and bare feet. Literally generations of men had polished these same marble floors. Each generation had handed this job on to the sons of the next generation, until the marble glowed with an interior white patina, which only hundreds of thousands of man-hours of polishing could produce.

The building, a monument to the British and their Raj, had been erected by the greatest of all the British Viceroys of India, a cripple named George Nathaniel Curzon. It was a monument to the 63 year reign of Queen Victoria. Filled with military relics, and the memories of terrible forgotten battles, the irony of the Victoria Memorial was that, though it had been built as a celebration to the British accomplishments in India, it became the mausoleum of the Raj.

But what unbelievable collections were housed in this vast building.

There were north Indian cannons, fashioned in the iron shapes of huge animals. They had been seized from conquered native brigades, raised by European mercenaries, who had fought the British in 18th century India. The brigades fought in the armies of the most powerful Indian maharajas, nawabs, and Princes, against the British. There was the jeweled sword of Tipu Sultan, one of the last Muslim rulers to hold the British temporarily at bay, during the last years of the eighteenth century.

In glass cases, in another wing, were delicate ivory chess sets fashioned in the figures of Mughal courtiers from the seventeenth century. In still another gallery were priceless jeweled treasure boxes, and jade hilted daggers. At the end of the durbar hall was a huge, six-foot-in-diameter stone throne of the Nawab Nazims of Bengal Bihar and Orissa. The throne weighed tons, and it was hewn out of a monolithic slab of black rock. It had been carved in 1641, during the reign of Sultan Sujah, the Subadar of Bengal, and the second son of the Mughal emperor Shah Jahan.

In 1765, Robert Clive, the greatest British Indian general of the eighteenth century, sat beside the Nawab Nazim of Bengal on this throne when Clive, under the aegis of the British East India Company, proclaimed the assumption of British rule in the areas surrounding Calcutta.

In the largest gallery of the Victoria Memorial, were gigantic, carefully composed oil paintings by the itinerant British artists Thomas and William Daniel. They measured by the yard and depicted Calcutta, Upper Bengal and the Ganges River basin in the late eighteenth century. The Daniel's art described a place of ancient caves, of ruined fortresses, and huge rivers. When I saw them in 1959, the works of these extraordinary travelers, and

eminent British artists, had been forgotten. Presently, they were unknown.

With its yard-thick stone walls, the building was the only place in Calcutta that wasn't hot. Each day when I returned to this building it was cool and completely deserted.

In Calcutta I came to love the British and their absolutely unhinged, out of control passion for discovery. Each of the men who collected and annotated the discoveries in this building had been sent out to Bengal as young boys. They had been equipped, most of them, only with a knowledge of Latin and Greek. By the time they were nineteen they were supposed to have passed rigorous language examinations in Persian. In turn, they anthologized and translated the many living and dead languages of India.

They undertook exhaustive studies of Indian jurisprudence, revenue gathering, road making, hydrology, and the construction of dams and buildings. Additionally, they learned the complex protocols entailed in dealing with the court precedence's of the local Princes and Rajas, who previously were allied with the predecessor government of North India, the Mughals. All of this was preparation for young men, who became old men, in the country districts of India, where they ruled the lives of millions of their local British-Indian subjects.

For a young Englishman, an appointment to a cadetship in the British East India Company, entailed for too many, an early death, or 30 to 40 years, exile from England.

Each day, upon leaving the Victoria Memorial, I walked toward Park Street, and I passed the Royal Asiatic Society, which had been founded in 1784. The library of the Asiatic Society contained fifteen thousand volumes and the bulk of Tipu Sultan's own personal eighteenth-century library of Arabic and Persian manuscripts.

The two-story Asiatic Society building was next to the Chinese restaurant where I ate my meals.

At the Society librarian's desk, I presented my acceptance letter to Visva Bharati University at Santinikitan, proving that I was a student at an Indian university, and I should be thus granted a difficult to get membership card.

Each day, I climbed the age darkened and wobbly stairs. Each day I then settled myself into the same chair inside the Asiatic Society Library on Park Street. I spent my time lost in the splendid, published corpus of Islamic and Hindu Indian painting, which had emerged as my passion in India. In Bombay, in the bookstores, I'd seen my first books on this unbelievable artistic tradition that opened a window on classical Indian court life of the previous centuries.

First, I labored away at paintings done in Tabriz in Persia. Over the weeks, I moved on to the paintings of the city of Herat, and to the greatest of the Persian master artists, Kamal al-Din Bihzad. Bihzad began his painting in the late fifteenth century.

After Bihzad, I turned to work done in India by the itinerant Persian artists, who had traveled to the north Indian courts in the early sixteenth century. These artists were Bihzad's heirs.

It was from this style that the Indian Mughal and Rajasthani schools of painting were developed, spanning the sixteenth to the nineteenth centuries.

My days were lost looking up cross references. I set myself the task of trying to read every book on Indian painting published from 1820 to 1960. Fortunately, books on this subject were not common. Eventually, I formed a meager three-foot stack of dense and difficult-to-read tomes.

Between 1555 and 1655, a hybrid Persian-Indian style of painting developed, and by the nineteenth century this brief century long epoch of painting came to be known as the Imperial Mughal style.

Working with fine brushes, the Indian artists carefully animated their work. Both the scenes and portraits painted by these artists held an understated subtlety. Though quite small in dimension, usually no more than 10'' x 12'' (25 cm x 30cm), the energy in these paintings contained bravura artistic craftsmanship. There was no corner of Indian life that the court artists did not describe: with landscapes, wars, pilgrimages, state hunts, life in the bazaar and the formal portraiture of courtly life. These artists also created intensely naturalistic paintings of animals including highly animated portraits of heavily armored truly gigantic elephants in battle.

It was probably the battle paintings of the Mughal court, which were first collected by the 18th century British and French soldiers, and these paintings began a strange migration. After the breakup of the Mughal Empire in the eighteenth century, these paintings of India moved westward into European collections. * * *

SANTINIKETAN, UPPER BENGAL, AUGUST 1959

The three men I'd spoken to on my first visit to Santinikitan two months before apparently had vanished. No one knew of them.

Apparently, my promising life as a scholar in India was more complicated than I imagined. I seemed to have been betrayed by the Indian academic bureaucracy a second time.

Once again, in the same cramped office, I displayed my letter of acceptance to Visva Bharati University. After a two-hour negotiation with the assistant to the president of the university, I was admitted as a "special academic case of merit" into the student body of Santiniketan. I also learned that no one knew anything about an enrollment ledger.

At the official university guesthouse, during my first official academic lunch, I also decided that the food at Santiniketan wasn't just awful, it was actually horrendous. My meal consisted of watery rice, added to which was dal (lentils). The chief treat of my first meal at the guesthouse were barely visible, little rocks that had been used to adulterate my rice, to make it weigh more in the bazaar.

In retrospect, Calcutta was a culinary paradise compared to Santiniketan. The one piece of bread I ate, a *chapati*, I managed to swallow, barely. It appeared to have gritty dirt baked into it.

I sat there inside the university guesthouse in a total funk. At the end of my meal there was a small pile of rocks on my plate

flecked with dal. Could my life at my new university get any worse?

In the student hostel, I was allocated a bare room with a wooden bed frame and a window. In the local town bazaar, I purchased a mattress, and bedding and a Godrej padlock. I also bought a primus gas stove enabling me to cook my own food, along with an electric fan and a bicycle.

The next day I took up *hatha yoga* and became the student of a Santiniketan professor of yogic studies, whom I'd met by chance next to the nearby river. He was a corpulent gentleman in a dhoti. As the sun was setting, on my first day as an "official student," I was told by this man, who constantly adjusted his dhoti because it always seemed to be sinking toward his lower calves, that my "aura badly needed tuning up."

After my mauling in the admissions office, I was surprised I still possessed my aura.

In the next weeks at the university I went to classes taught in Bengali, in Oryia (the language of Orissa), and in a sort of upcountry, barely recognizable Indian-English. Because it was still hot in September, the classes were taught outdoors. Classes usually took place upon the bare earth. In a crossed-legged circle on the sandy ground, the students listened to their professors with bright eyed concentration.

Like Wimbledon tennis players the 22 students in the class were dressed in obligatory plain white cotton clothes.

In the heat, the professors each day droned on and on in their three different languages. All the while, increasingly as the weeks crept painfully and agonizingly forwards, my legs began to cramp into hard knots. The professors, of course, with the perk of ranking higher in the university's hierarchical order than his hapless students, sat resplendently upon chairs while they delivered their soporific lectures.

At Santiniketan, the only course during which I can claim I learned anything was my *hatha yoga* tutorial lesson, where I was the single student. On his own part, my lovely corpulent instructor in his always sinking *dhoti*, taught me how to access my subconscious. The trick he taught me was to clear my mind and make it blank. If I had a problem, or a question in my life, after blanking my mind, the answer to my enquiry would pop spontaneously into my mind. Today, tomorrow, next week, or in the next month perhaps.

"It is young sir, that you ringing up your subconscious, like you are talking on the telephone. You speak to subconscious. Then, later Pop! Your subconscious phones back. All without words, young sir. It is amazing *hatha yoga* trick!"

Like so many things I witnessed later in India, for his own part, my yoga instructor floated away like a gentle wind one day, never to return. No one knew where he'd gone, and the comings and goings at Santinikitan, apparently happened and then unhappened. As I learnt still later in Indian concerning those who practiced the Tantric arts, perhaps my yoga instructor had been sucked up into some gigantic, atmospheric cloud of

perfection and completeness, of pāramitā, and he'd become some other substance invisible to the rest of us remaining on earth.

In the lessons taught to me by my professors at Santiniketan, I seemed attacked by odd clouds of speech, where it became increasingly difficult for me to make out what was actually reality. I'd go to a lecture in barely recognizable Indian-English.

Then, for example: after listening to a lecture for 45 minutes, I'd realize the instructor was not speaking about events in the Buddhist period of the 6th century, but of Jawaharlal Nehru, Prime Minister of India, and his visit to Santiniketan two years earlier. What this had to do with early Indian medieval history, I had no idea. Perhaps the lecture had existential, philosophical, or even historical nuances which I didn't understand?

After making a journey half way around the world, in my own mind, I tried to reduce my problems of disquiet into a single sentence. In one thunderous epiphany I finally understood Santiniketan. The teachers didn't seem to know anything about anything. It was as if my teachers were caught in a trance of exhaustion. They seemed barely able to move. In my own trance-like state of total boredom, under the huge white billowy cumulus clouds in the deep blue Bengali sky, I listened to my own subconscious, then I heard the siren call of India.

I remembered the extraordinary pictures I'd seen at the photographers, Johnson & Hoffman in Calcutta. I didn't want to be taught about things Indian. I wanted to see the extraordinary

and unbelievable places in these photographs.

I sold my bedding, then my stove and my mattress.

 I sold my electric fan and my bicycle. I checked out of my university.

I sorted out my few belongings. Everything I owned fit into the eighteen-inch square bag I'd bought across the street from the American Express Company in Bombay, with my name painted on it.

I left Santinikitan and Visva Bharati University with one invaluable, wholly irreplaceable document. The document was undated. It was a student discount voucher for unlimited Indian train travel. In my brightest, and now newly imagined future, I supposed I could travel in forever India, on a massive student discount.

* * *

INDIA, JOURNEYS 1959

With my university sanctioned, government-issued student train
voucher, the 54 hour journey from Calcutta to Bombay,
traveling in third class, cost 55 U.S. cents.

 For a 42 hour trip from Bombay to Madras, I later paid 44
cents. Added up, I spent five days and four nights on
transcontinental trains, for less than a U.S. dollar. I must say,
given the reasonableness of my travel expenses, traveling was
cheaper than staying in the cheapest Indian hotels. Admittedly,
Indian third-class train travel was never easy.

 Oftentimes, 30 to 40 people were stuffed into a single ill-
ventilated, broiling, cramped, and vile-smelling space 22 by 24
feet. Measured empty, this space was seven paces one way,
seven paces across. A single journey could often last for days,
and trains were apt to stop in the middle of nowhere for hours
before beginning their unaccountable progress once again.
When looking out the window of my new home, India scrolled
past like a magnificent, painted diorama, with stereophonic
sound and unbelievable sunsets.

On the eastern side of the Indian subcontinent, at the edge of the
world during September of 1959, I set myself a basic "course"
of seeing 130 different Indian monuments, scattered over tens of
thousands of railway miles.

I wanted to visit the most imposing Buddhist, Jaina, Hindu and
Muslim monuments on the subcontinent. I needed a large goal:
130 monuments seemed just right. Armed with my four-inch
thick book of Indian railway schedules, a Leica and my

Handbook to India, I set out on my travels. That September, I was still eig18 and turned 19.

If I'd thought travel from Japan to Bombay in fourth-class deck passage was a bargain, travel in India with my "student train discount letter of introduction," obligingly supplied by my now ex-university (and my last visible link to my career as an Indian student), my travel budget in India was a table-pounding, once-in-a-lifetime deal.

This new world was a place of burnt plains and hills, worn down by long millennia of human use. The massive, coal-burning locomotives would stop frequently. Perhaps cows or water buffalo had wandered onto the tracks and been struck by the engine. Or perhaps a hapless goatherd, or a woman tending her cows, had been run over. Or maybe the railway signals malfunctioned, and they couldn't immediately be repaired. The only thing that never seemed to happen was meeting an oncoming train traveling from the opposite direction on the same track.

Indian train journeys were interminable.

There were small pleasures on these journeys. In wayside stations you could buy your meals freshly prepared and then wrapped in sweet, fresh green banana leaves. There was chai (tea) sold in disposable earthenware cups that passengers threw out the train windows. If you were lucky, at the beginning of a journey, you might have the fortune to claim one of the overhead luggage racks ringing the third-class compartment, where you reclined amongst the other passengers' luggage. On these endless journeys crisscrossing India to visit monuments, I

read books purchased in the used book stalls of India. Mostly, they were those lovely green or red paperback Penguins published in Britain.

An a journey from Bombay to Calcutta I went through one Ayn Rand novel. The journey to Madras from Calcutta was two Somerset Maugham's, and a John Buchan trilogy of novels.

In time, I traveled seventy thousand miles in Indian third-class trains. Over a period of the next three years, during my journeys, I spent seven months, day and night, on Indian third-class trains. But there was the greatest pleasure of these trips. It was the pleasure of being young. It was the pleasure of having the whole world to see, if only you brave enough to make your way toward the horizon, wondering what was beyond the next range of low, misty hills covered by dense forest.

* * *

Away from the railways in India, in virtually every small town on the subcontinent, there were "dak bungalows" where one could stay inexpensively for a dollar a night. These bungalows had been built for British Public Works inspectors, for Anglo-Indian policemen and for traveling magistrates, during the period of the British Raj. Inside the bungalows, cavernous rooms were filled with leftover British bric-a-brac that included sideboards, rattan chairs, and wobbly beds. In the semi-darkness away from the omnipresent heat, you had to be most careful about serpents.

The most common snakes you saw were cobras. But if you were very unlucky, you would see a small, light green and much more lethal krait, wiggling across the floor to take up a resting

spot under a chair. Or, perhaps, he darted silently under the bed while you were reading. As a general rule, you never ever got out of your mosquito net at night without picking up your Ever Ready flashlight and shining it first down at the floor. Next, you peered under your bed. You then made your measured, careful way to go to the bathroom or to have a drink of water. Snakes loved the cool darkness of damp of bathrooms. Probably, the least safe, most lethal place on the continent of India is a bathroom.

* * *

Gradually, without knowing what was happening to me, I began to live to get off one train, to explore a ruin or a temple, then find a train to another place. My life became a haze of travel. There were late night arrivals and early sunrise departures.

Beginning in 1959, I traveled to north India then to western India, and finally to south India. Day and then night, I slept on trains.

One very cold morning, I remember being on the train from Siliguri, in northern Bengal to Darjeeling. The train looked ancient and tiny. According to a brass plate mounted on the side of the engine, it had been built in 1892 in Glasgow.

Through the dawn clouds, the sun rose. Seventy miles away stood Kanchenjunga, the second highest mountain in the world. Beyond the train, pulling slowly up the grade, the mountain didn't gradually appear; it simply materialized there above the clouds. It was like some giant otherworldly structure of the gods emerged suddenly from the mists. The mountain was lost from view as the train rounded a corner.

In Darjeeling, I wanted to meet Namgya Wangdi, the Sherpa known as Tenzing, who had climbed Mount Everest with Edmund Hillary. Two days later, one very cold morning I had my picture taken with Tenzing Sherpa.

In central India 15 days later, I stepped out of a train at 4 A.M. on another winter-cold morning. I spread my thin cotton dhurri out on the station platform to sleep on the concrete, and the sun came up two hours later. In the distance, perhaps a mile away, was an earthen structure that jutted upward from the flat plain. I started walking toward it. The closer I got, the indistinct earth shape slowly resolved itself into a wall.

This wall stretched off into the distance as far as I could see, and the wall was 52 miles in circumference. In the thirteenth century, Marco Polo had visited this city ringed by its giant wall. The town was called Warangal. According to my *Handbook of India*, the outer mud walls of Warangal hid from view an inner stonewall of unimaginable proportions. This huge wall was described as a marvel of engineering.

At perhaps seven o'clock, I reached this second wall. The inner wall stretched seven miles around the city of Warangal. It was constructed from granite blocks, and it was 45 feet high. Climbing hand over hand to the top, I was beyond shock.

Of this once huge city, simply nothing existed anymore. The giant wall protected a city that had disappeared from the memory of man. The city-state of Warangal had completely vanished. There was not a single tree, nor a single house, nor a single street. In the distance, all that remained of this once great metropolis was a single temple, miles away balanced upon a distant rock outcrop.

I sat on the giant stones at the top of the wall. I looked for the remains of a city, and for the once mighty city that was the diamond capital of India. Carried away was every artifact, every voice, and every dream of the people who'd once inhabited this place. I perched there at the edge of an ocean of time. Time had swept everything away. A city that Marco Polo had once described as housing over a million souls had utterly vanished.

The solitary inhabitant of this place was a farmer who plowed dark furrows in the earth with a team of bullocks.

* * *

In the south Indian temple city of Madura, inside the greatest existing Hindu temple complex on the subcontinent, the elephants come out of their stables each night at dusk.

Slowly, carefully, they move past throngs of pilgrims into the huge temple complex. The rituals inside the temples of Madura have remained unchanged since the middle of the fourteenth century. Each night, for the last 800 years, the temples become crowded with half-naked pilgrims in an ever-shifting, ever-moving mass of worshipers.

Each night, somehow, the elephants navigate the narrow outer courtyards of the temple and the crowds. In the darkness, there is the hooting of conches, the ringing of temple bells and the chanting of pilgrims. In the darkness, acolytes whisper millennial Hindu prayers seeking relief from never ending cycles of life.

My *Handbook to India* stated, "The dark corridors with a lamp gleaming here and there being peculiarly ghostly . . . this temple is the most interesting to visit of all the Hindu shrines in India,

giving the most complete idea of Hindu rituals. It should be visited at night."

With their foreheads painted in age-old tantric patterns, the elephants are led around and around the inner temple complex by their mahouts. In interminable circumlocutions that echo through the Hindu millennia through the gloom, flickering torches guttered weakly. At Madura, nothing has changed, and in the Meenakshi Temple tens of millions of pilgrims appear during a single decade.

I try to come to grips with this place, as the Brahmins stare into the never ending darkness seeing God. For them, one century merges with the next. Phalanxes of Brahmins chant their prayers as the centuries slip past. They wait as supplicants for time to crush them as they reach out in prayer.

Overcome by God in his ten thousand manifestations, the Hindus believe the deity steals through the superheated air, but no one sees him. Things are as they have always been, and they will always be in this place.

* * *

NOTEBOOK 2
1960

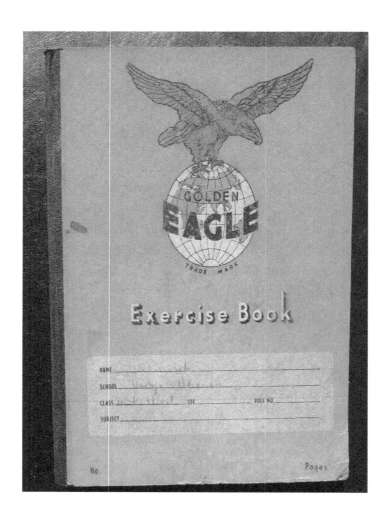

KABUL, 1960

In my life the holy grail of European travelers in western Asia for the previous seven centuries was never Tibet. It was Afghanistan. Years before, I had my first yearnings to go to Kabul, and to Afghanistan. I was fascinated by Afghanistan. I kept thinking about Afghanistan. I'd been in India for over a year until I decided to climb the Khyber Pass into Afghanistan.

Over the centuries, Afghanistan had been a place that was almost impossible to enter for Europeans. Until the late 1950's the country was still the most difficult place to reach in Western Asia, and to me it always remained the most exotic lodestar of travel in the world. Until very recently, it had remained a place nearly inviolate of Western "progress."

The landscape of the country, was one of the harshest on earth. Once inside the country it was problematic traveling from place to place. Seemingly crafted by an angry god, Afghanistan was a place created by an angry god. It was composed of formidable, barely climbable desert mountains. It was also a place riven with clan feuds with every village in the country constructed around family-owned, heavily armed, mud-crafted fortresses that were engaged in absolutely remorseless, homicidal, generational wars with their neighbors.

For centuries, Afghanistan had been absolute terra incognita to foreigners. In 1839, a British army marched through the Khyber Pass from India into the country. In 1842, of the 15,000 souls in this army, only as single man marched out of Afghanistan.

In my bookstores in Bombay I searched for travel memoirs of Afghanistan written between 1862 and 1950. They didn't appear to exist.

If one wanted to see an example of how difficult it was to get into Afghanistan, hidden behind its deserts, and populated by blasted mountains of crumbling rock, one had only to look at the travails of the British-Hungarian archaeologist Sir Marc Aurel Stein. Perhaps one the world's greatest travelers of the early 20th century Stein found that Afghanistan was a county of an almost impenetrable self-exile from the rest of the world.

Both Stein's travels and his discoveries in the deserts surrounding Afghanistan are unique in the history of exploration. But over a forty-five-year period, between 1895 and 1941, in decades of manic persistence Stein repeatedly attempted to enter the country to no avail.

Undeterred by four decades of frustration, an academic lifetime, instead, Stein circled the deserts of China country looking for the archaeological treasures, which he knew existed in Afghanistan.

In western China, after he crossed one of the largest deserts on earth from India in 1907 Stein discovered a gigantic trove of ancient Buddhist manuscript collections at the Chinese cave temples at Dunhuang. It was here that Stein discovered the Diamond Sutra, the world's oldest printed text dated AD 868.

From Dunhuang, Stein removed over 40,000 scrolls of texts written in Chinese, Sanskrit, Sogdian Tibetan, Runic Turkic and Uighur. Each of the scrolls was carefully wrapped for travel. Then, they were dispatched by camel caravan across both the

Gobi and the Taklamakan deserts for a two-year-long journey
towards the British Museum, and their final resting place.

In my readings about Stein, and his looted trove of ancient texts,
I found that unhappily many of the cases he shipped so
laboriously to London, across the Gobi in 1907 have not as yet,
been opened.

After decades of unleavened, almost inhuman persistence Aurel
Stein, the doyen of Chinese Silk Road studies and of the Greco-
Buddhist civilizations of the Oxus, succeeded finally in reaching
Kabul in the autumn of 1943. Now an old man, over the long
decades it had been Stein's dream to walk the millennial
Buddhist sites spread throughout Afghanistan.

Shortly after he arrived in Kabul Stein died of pneumonia. After
a lifetime devoted to the exploration of ancient Buddhist sites,
and the transmission routes of both the millennial Chinese and
Indian cultural and religious exchanges, Aural Stein was buried
in Kabul. The final irony of his life, and a man whom was
perhaps one of the greatest traveler of the 20th century, was that
Afghanistan was the only country he was never able to explore.

* * *

Perhaps the grimmest joke of travel I ever heard was that in
1960 it was the French junkies who discovered the delights of
Kabul. Emerging from the nightmare of Central Asian travel the
junkies discovered first Afghanistan, then in Kabul, nirvana.

In Kabul you could go into any pharmacy and get an ultra-low-
budget shot of heroin five ten cents.

On the streets of Kabul you saw this new brand of world travelers. They seemed to walk around in a state of zoned-out disequilibrium. Perhaps wholly unique in the history of drug-taking Kabul held an ever-replenished smorgasbord of Afghan drugs. Off the main bazaar in the squalor and cold junkies had come to rest in an area of derelict hotels.

To the surprised Kabulis, suddenly for no known reason, groups of near indigent Europeans the year before had simply materialized in the central Kabuli bazaar. Off Chicken Street, gaggles of junkies had come together in the Mustafa Hotel, or in the truly horrible Hotel Olfat. In Kabul they seemed to devote most of their time to a near somnolent state caused by drugs and depravation.

It was as though this strange group of world travelers had been released like genies from some magic bottle into the Kabul Valley.

Staggering around Kabul they dug into a pick 'n' snatch mix of new types of Kabuli drugs. These were not ordinary drugs. Apart from heroin there was absolutely brain-busting hash-hish, of what could only be described as maximized industrial strength. What the junkies didn't know about Kabul was that it was a very bad place to fall apart. The drugs wedged themselves into a man's head, then combined with an insidious miasma of debility what emerged was half crazed dementia.

<p style="text-align:center">***</p>

In late 1960, I'd traveled westward towards Europe from India through Pakistan, to Afghanistan, Iran and Turkey. I turned then around and travelled back towards India via Afghanistan.

The few foreigners that one met moving eastwards from
Istanbul, and Turkey were migrating toward the promises of
solvent and sunny futures in Australia. They were escaping
lifetimes of drudge work and depressing apprenticeships in a
ravaged post-war Europe.

 Fifteen years after the Second World War economically Europe
had still not yet recovered. Perhaps it would never recover from
the two world wars of the 20th century, and people on the road
one met, for the most part, were young people escaping towards
better non-European different futures.

After I left Turkey in Tehran I met for the first time European
travelers of a different sort. They were passing through Iran like
I was. They were Europeans. Both were men. One was tall, and
the other was short. They never told me what country they came
from but they were both blond Northern Europeans. They
seemed very conceited about something they were searching
for. They called it, "… *der grosser suche*". I read this in
German as the big search.

I lost sight of them in Mashad in Eastern Iran when the two of
them turned southwards towards Zahidan, and Pakistan. I
continued eastwards toward Herat. They told me eventually
they were going to India. They said they were moving towards
India for spiritual reasons. We never learnt each other's names.
Even to the very last they seemed distant, and uncommunicative.
I never saw them again.

On my way back to Kabul in Kandahar, in Afghanistan, I met
more travelers making eastward journeys for spiritual reasons.
This seemed to be some sort of new version of plague. They
told me that the word had gone out along the roads of Asia that

Kabul was *it*. Kabul was the place to be. They called themselves the freaks, and they travelled for spiritual reasons.

The freaks were of a different species altogether from the junkies, or for that matter from other Europeans heading towards Australia. They knew a bit about history, literature, music, anthropology, architecture, physics, and much of everything else except their own strange dramas of spirituality, and finding the cheapest places on earth to live.

In Herat, Afghanistan I met two more groups of freaks. They seemed driven by some mystic call eastwards, towards India. I had the sudden thought that on the road the freaks were something like the new other" in Eastern travel. When I'd left India two months before, I'd only met two, or three Europeans on my whole journey. By the time I reached Kandahar on the way back to Kabul the freak population of Afghanistan seemed to be climbing towards double digits.

In a way, as I considered their appearance, they contrasted greatly with the emaciated, mostly rotting foreign junkies of Kabul. The freaks seemed to me wholly new, and unexplained phyla of the unexpected tourist.

In Kabul I discovered that the freaks arrival was something like a field of mushrooms growing up suddenly in a single night. It seemed to me that they'd arrived by a kind of bush telegraph.

As the "scene" developed in Kabul I discovered that they had been called to Afghanistan somehow.

In Kabul the freaks discovered that living was so cheap that they could manage to exist on piddling family remittances from

Europe, or America. The freaks I met on my return to Kabul were constantly asking if India was cheaper than Kabul.

As the pan-Indian freak "scene" evolved wherever they were as a group they got to work at developing their constant preoccupation. This entailed a whole new set of individually centered spiritual personas. I liked to think of them later, years later, as spiritual vampires.

In Kabul I discovered the "freaks" had settled in during my absence.

The new steady diet they seemed to favor were the crude resins of ganja (*ie. Cannabis*). As the freaks pointed out at every single opportunity, when the junkies of Kabul were mentioned heroin, after all, was a modern and nasty manufactured product. It had first been synthesized by the Bayer Company in Germany. For themselves the freaks seemed to worship naturally occurring substances. They said they were into health.

On Chicken Street, just like the junkies, the freaks seemed to have reached the end of the line. In Kabul, as I watched, the freaks recreated themselves into strange, fantastical fictional creatures. Somehow, with an almost operatic grandeur, in their own minds men and women became glorious spiritual beings. In what other place in Asia, I asked myself, could travelers go to pieces in such an alarming and impressive way.

On their travels crossing from Europe, eastwards, they seemed to have developed military cast-offs, as a fashion statement. But after a month or two acquaintance of Kabul this entire sartorial presence suffered an earthquake of taste.

Literally, as I watched, they took to wearing weird little embroidered skullcaps that set off nicely billowing chintz-patterned pantaloons. They wore gold and purple vests. They took to wearing Afghan nomad bracelets and ear rings. Finally, each of them sported elaborately embroidered Pashtun sheepskin lined coats.

Somehow the freaks assumed the look of seventeenth century pirates. With their now braided hair, in their new iteration as land pirates, they looked impressively, story book foreign.

It was at this point I came to realize that these fantastical creatures cared only about one thing. It was *the journey*. And they didn't care about much else except how they looked on *the journey*.

* * *

In the years ahead the route overland from Europe to Kabul would become a counter-culture superhighway.

In 1960, the only way you found out about Kabul, or Afghanistan was to be "connected." This connection was a strange transaction. It held that you'd discovered for yourself that beyond the mountains, and beyond the implacable and very dangerous deserts, what was out there at the end of "the road".

Few of the foreigners who stayed at the Mustafa Hotel in Kabul knew that the Kingdom of Afghanistan was three-quarter's desert, and one-quarter Mountains. No one knew the country was ruled by a king, and none of the foreigners I met had any interest whatsoever in Afghanistan, nor its history.

If you want to demonstrate the connections of every journey to Kabul during the early 1960's, take only the single experience of a American named Michael.

I first met Michael on Chicken Street, when I went to Afghanistan searching for antiquities. In Kabul, I met Michael several times in the chai shops and restaurants where foreigners gathered to do deals for various alkaloids.

Michael was 19, and we were the same age. He was blonde. He was movie-star beautiful with a perfect complexion and rusty-colored hair hanging down past his shirt collar. He was from the Midwest and he was that rare American in Afghanistan, like I was. One night in a dirty chai shop near the Kabul bazaar, where we spent too much time drinking too much steaming hot Indian milk tea, I asked Michael how he'd first heard about Afghanistan.

Michael rubbed his head as if it hurt to answer questions. But he thought about the question. At first he'd been very hesitant and shy, then his voice rose in anger.

"That fucking wall. It was just suddenly there, man. It just jumped out at me from nowhere. BAM."

That morning Michael had crashed his bicycle into a Kabuli wall that was attached to a house, which no doubt had unexpectedly sprung up in front of him.

In the gloom of the chai shop, he had a Band-Aid across the bridge of his nose, donated by one of his doper freak buddies. I was a few months older than older than Michael. I wondered, looking at him, if he'd make it to 20.

"I first heard about Kabul… yeah! In Mexico. To answer your question, I was on the Isla—Isla Mujeres. It's off the Yucatan coast…"

Michael rubbed his ribs. He touched his purple and silver Afghan vest. It looked like he'd been totally stoned on ganja for the last week.

Michael paused. He sipped his tea.

"These guys out there on the Isla were living on the beach in a palm hut. On the Isla they *knew* man. And I first heard the words . . . 'SHOW UP IN KABUL'."

"On the Isla, everyone lived on fish, and marijuana, and frijoles and cerveza. Everyone was into natural things. These guys came to the Isla to "rest" after being in Tangier. Before Tangier they'd put in some serious time in Almeria. That's in Spain. They'd worked in spaghetti westerns as extras. They made lots of dough. Did I tell you any of this already?"

Michael tended to repeat himself. I shook my head. Michael had a dreamy look. Perhaps it was from his concussion.

After his accident, perhaps he was checking to see that he still existed. Michael ran both hands over the top of his wide blue-black Pasha pants.

"Hey, I remembered." Michael paused, then he laughed at himself.

"These guys on the Isla earned enough money from the movies working in Spanish cowboy movies, and pretending they were

Mexicans, to live anywhere they wanted for the next two years. They'd heard about Kabul from some French guy they met in Almeria. These guys on the Isla wanted to decompress. They were looking for something and they were going to Afghanistan."

More freaks came into the chai shop. Everyone nodded to one another. An English boy who looked in the last stages of exhaustion approached Michael. He hadn't shaved for weeks and looked as though he had recently been beaten up. He motioned Michael toward the outside of the chai shop. On the street they held a whispered conversation.

Through the dirty window I saw Michael sliding a bill into the English boy's hand. The boy moved down the street to get a refill for his bad habits. I watched the English boy disappear in a peculiar shuffling gait.

Michael returned. He continued his travel narration.

"On the Isla Mujeres I asked where Kabul was. Can you believe that? I'd never heard of Afghanistan, or Kabul. I asked them how to get to Kabul. They just said, 'find the road.' Jesus fucking Christ! That just blew my mind. Find the road! And now here I am. Hey! Amazing, huh? I found the road."

I wondered if Michael had walked to Afghanistan, or if Martians had beamed him down. "From Nebraska, how did you get here?"

Michael smiled. "Well, after the Isla I went back to Nebraska to visit my family and to say goodbye to my dog, Gonzales. I felt

sorry for Gonzales because he had to stay behind in Omaha. What fun does a dog have fun in Omaha? Hell, I don't know."

God. I was sorry I asked the question.

"What can a human being do in Omaha to have any fun?" Michael asked suddenly. Then he answered his own question.

"It would have been great to bring him along with me out here, but I didn't want to get hung up with a dog, or a girlfriend you know? From New York, I took a cheapo Holland America Line boat to Rotterdam. I asked someone on the boat if Rotterdam was close to Afghanistan. Just joking."

" From Rotterdam, I got down to Turkey by hitching through Germany, Austria, Yugoslavia, and then Greece. In Istanbul, at the Gulhane Hotel. I found out that if you crossed Anatolia to Maku, on the Turkish-Iranian border, then on the other side of the border you could hitch down to Tehran, in Iran. You could usually hook up with one of those big Iranian-German transcontinental trucks that finish up in Tehran."

"Have you been to Maku?" Michael asked. He was beginning to nod off. Maybe he'd had too much tea?

I'd been to Maku. It lay in the shadow of Mount Ararat where Noah had come to rest after the flood.

My own out-of-body experience in Maku came when I found a hotel key I'd forgotten to leave behind in Tabriz, on the opposite and Iranian side of the border. I'd crossed back over the Turkish border to the Iranian side to give the key to a trucker who was

returning to Tabriz. I was feeling I was such a good goddamned citizen. Meanwhile, back in Turkey, the border guards changed.

When I reentered Turkey, a new shift of border guards grabbed me. I was apparently trying to sneak across the border into Turkey, and as my punishment the guards kicked, and then punched me. Finally, I was screaming so loudly I got rescued by a Turkish officer who spoke a little English. My head was bleeding. Someone had stomped on one of my hands. I'd told the officer I'd gone back to the Iranian side of the border to return a hotel key.

The officer got me out of the clutches of his border guards, then he put me on a bus to Erzurum.

In the chai shop, Michael looked very tired. Cannabis does that to you. With an effort he began his story all over again.

"I crossed Iran. I hitched over to Mashad, all the way across Iran. In Mashad I got stoned . . . with rocks man. Real rocks! The religious fanatics there hate Europeans. Mashad. I hate that fucking place. I got through the Iranian-Afghan border and crossed the desert to Kandahar in Afghanistan. I don't know how anyone survives the Dasht-i-Margo desert, do you."

"I don't think I ever saw a single car out there," Michael said. "You ride way up on top of the truck loads. At night, no matter where you are, you sleep with a knife next to you."

"I've never seen so many homos as there are in this fucking country. It's like a goddamned sicko asylum for criminal masturbators . Where the hell are the women in this country?" Michael asked. "You see kids everywhere in Afghanistan.

Somebody has to make all these children. Do you know? How does that happen?"

So much to learn. Where to start?

For me, beyond the Iranian border in Afghanistan, you crossed a landscape closer to the red planet of Mars than anything on earth. After leaving Herat the trucks that crossed the Dasht-i-Margo, or Desert of Death, traveling nonstop day and night toward Kandahar. The trip could last one to three very long days. If you were unlucky, the trip sometimes took three weeks to forever. There were a lot of dead people in the Dasht-i-Margo.

I looked across the chai shop at Michael. In the near-dark chai shop filled with cigarette smoke, he was sitting bolt upright, asleep in his chair.

Three months later I heard Michael had died of a drug overdose. He'd been switching out to heroin the last time I saw him.

* * *

The cold of Kabul actually cracked, then peeled the paint from the city 's walls.

In the streets you never escaped the cold. You were caught by the frozen wind, which had slid across a continent of ice and the Arctic Circle into the Siberian tundra. In its passage, the winds crept silently through two thousand miles of coniferous forests of the taiga, into the high altitude deserts, and into the most northern latitudes of Afghanistan. Finally, the winds reached

worn mountains above the Oxus River. Few foreigners between November and Spring braved the desolation of Afghanistan.

A few weeks after I arrived in Kabul I found the Kabul Museum. The museum was ramshackle and forlorn, it was actually colder inside the museum than outside on the street.

After a half hour I could no longer stand the temperatures inside museum. Outside on the street it was actually warmer. I climbed towards the highest part of the city towards the fortress called the Bala Hissar. The fortress was high above the city, set on a steep rocky outcrop. For centuries, it was inside these battlements that the kings of Afghanistan had sought protection from the treacheries of their own countrymen.

Out of the wind, I huddled down and sat alongside a parapet.

I stared down at the city below me. In the distance beyond Kabul, mountains ringed the city. I remembered from my books the history of this city. Scores of armies had crossed these mountains. Below me, in 1841, a British diplomatic adventurer named Alexander Burns was appointed the British political agent to the Afghan king. A British army sent to bolster Burns, and his politics of invasion, tried to face down the angry Kabulis. Along with his brother, and the entire British diplomatic mission to Afghanistan, Alexander Burns was murdered by the people of Kabul. Once trapped in the city, no one had escaped. An army of fifteen thousand souls began its frozen winter retreat from Kabul on the day after Christmas. With the relentless wind at their backs, they retreated towards India, towards the Khyber Pass.

A week later, outside of Jalalabad, a single man, a Doctor named William Brydon, appeared outside the city walls. He was the sole survivor to escape this terrible retreat.

Months later I returned to my eyrie above Kabul. I sat there. The sounds of the city drifted upward. I seemed marooned in a place somewhere beyond time.

It seemed to me lately that for Europeans traveling back and forth on the long eastern roads, that the loneliness and the solitude seared you forever.

Perhaps it was the infinite spaces of Afghanistan that seduced me. Perhaps it was the people and their unspoken, unknowable secrets that fascinated me. America, by comparison, was a place to me that was infinitely boring. I thought of staying on in Asia. It was that day above Kabul that I thought I'd travel until I reached the road's end. I'd travel until the road disappeared in front of me. It was that day I decided I didn't want to go home right then.

In the meantime, the road I'd travelled to Kabul was made up of happy small favors. The little atrocities of travel were balanced by unexpected kindnesses. At times, my companions of the road were mostly unhinged European hash- hish fiends, or junkies, or swindling hotel owners. But there were always proprietors like Sadat Ali, in the Pakistani city of Quetta just over the border of Afghanistan, who gave me an extra quilt at night, or extra portions of food in his restaurant.

But there was also a kind of melancholia of the road. There were the people you met who were also travelers. They traveled to undefined destinations. Four months before, I'd gone from Calcutta to London with one of these people. I don't think we said three sentences to each other in the eight countries and the 40 days we were together. God knows what this man dreamed of. Food? Clothes? Impossible friendship? He seemed locked away in an unreachable solitude.

I walked slowly back down the winding paths into Kabul trying to find the restaurant where I had last seen my friend Michael. I'd been reluctant to ever come to this restaurant again, given the conversations I'd once had in this place.

I hugged the lee side of buildings to try and keep out of the wind. Winter was coming. You could feel it in your bones. Infrequent beaten-up cars and trucks passed me as I moved toward the old center of Kabul. It was too cold and it took much effort at this season for the thieves and badmashes to appear then try and kill you, or steal your belongings.

In a narrow building off Chicken Street was the restaurant. I shook the slush off my feet and entered. In the semi darkness, I

groped my way towards the table at the back of the restaurant.

It wasn't every day that a dead man appears out of the darkness.

At the rearmost table, Michael looked up at me and smiled. His eyes were great purple bruises. He looked sick. His fine face was haunted, yellowish and drawn from jaundice.

Michael spread his two hands out over the table. His hands shook like he had palsy and he simply stared at me.

I sat down.

"All in all, however," I said. "I suppose for a corpse you simply look the picture of health, but actually you look terrible ."

"What do you mean?" Michael asked slowly.

"I thought you were dead. You look about the most beaten up, almost 20 year-old I've ever seen."

Michael glanced up at me. His eyes were like great puffed bruises.

"It was awful man. I was there when he died, you know. That could have been me, couldn't it?"

"Who was it that died?"

"We shot up. He passed out. Then, he just died. He fucking died right in front of me."

What could I say? For a moment I was angry at Michael and I didn't answer. What do you say if you spent a lot of time over thinking about a friend who killed himself?

"He was an American. Like us," Michael whispered.

"Well, there's a really very nice side to this, you know."

"What?" Michael asked at me in the gloom.

"It wasn't you Michael. I'm trying to think of something uplifting, pleasant."

In the darkness, the ritual of Kabuli afternoon tea began. The waiter, Rustam, brought a huge pot of Indian milk tea. Without bidding, deliberately he set out two cups, then he poured out tea for both of us.

Michael stared down at the cup. He looked back up at me. "I hate this place. I get up and I'm sick. I pass out each night. I'm sick the next morning. I don't want to die. This place is so rotten."

"If you don't get out of here, you will die, amigo. Believe it," I answered.

They were all like this. In their world, no one existed but themselves. Every one of the junkies marooned in Asia was locked inside a never ending karmic loop of self-absorption. I was interested to see if he'd inquire about what I'd been doing.

"You know what I've been doing?" I asked.

"I hope it's something outside this fucking country. What?"

"I've been spending a lot of time feeling rotten about you . . . about how you died."

Michael stared at me. Tears filled his eyes. "I'm sorry. I'm so sorry. I'm really am sorry. I heard the stories about how I died, too"

I rubbed my face that was chapped from the cold. I supposed if it was a topographical location, irony was never a valley that Michael had walked into. Both my lips had split. On my hand was a thin film of blood.

"I think that's the first time I've ever heard you think of anyone besides yourself, Michael."

I didn't say another word to him. He was beyond advice. After a minute I still didn't speak. I got up and I looked down at him.

"Get out of here Michael. Just get out of here. Go home. You look awful. Drink your tea. Rustam took the trouble to make it for you."

Slowly, Michael drank his tea. After fifteen seconds, as I watched him, Michael whispered "Okay."

Michael got up. He left the restaurant without speaking to me.

Two days later I went back to the restaurant and expected to see Michael at his usual back table. He wasn't there.

Five minutes later Rustam appeared. He brought me a pot of tea and he set out a single cup in front of me. Rustam was of late middle age. He looked kind and always worried.

"Sir. Your friend, the American boy. Mr. Michael ..."

Rustam paused, trying to arrange the difficult and unfamiliar English sentences.

"Too many have come here to die. Many too many. Very too many. It is so sad for me."

I looked up at Rustam. I knew the last part of this. Suddenly I felt very far from my own country. I didn't want to be in Afghanistan.

From his dirty vest Rustam produced a small cloth sack. "He said to give you this." Rustam placed small cloth sack in front of me.

"Yesterday, sir, he left for Pakistan. Through the Khyber."

Then, Rustam turned and he faded into the darkness of the smoke of the restaurant.

I opened the small sack. Inside was a dog's license tag with a name on it. The tag read, "Gonzales".

As I came and went from Kabul, I heard later from a man that I knew at the US Embassy, in Kabul that Michael had gotten home.

The man said he working for his father's hardware business in Omaha, Nebraska. His parents had written that he was getting married to his girlfriend, a high school cheerleader. His parents got him into detox. I was glad for Michael and his redemption in Nebraska. Michael never said goodbye. He was running for his life.

In the months and years ahead the road ate scores of people alive.

They were victims of no food and the fatalities of too many drugs. Nothing in their lives prepared these people for Asia.

 In Kabul I looked behind the curtain and I saw the future.

I thought of Michael often, but I never saw him again.

* * *

CALCUTTA, OLD COURTHOUSE STREET, 1960

A year after I'd first arrived in India, I'd developed a tendency to go off on grueling journeys for weeks, then months without telling anyone. If I'd disappeared, no one would have known. I had the fever of the road. After six months of continual travel, I felt I was being erased.

There was always the next sunrise. The next journey.

I had tried to learn Bengali at one point and largely succeeded but the first time I got sick was in Kerala. No one in Kerala, at the tip of India, spoke any Bengali. On the Cochin coast they spoke Malayalam, one of the four ancient Dravidian languages of India. Most of these disparate languages had pre-Christian histories, in addition to distinct alphabets. One of the difficulties of India travel was that there are 22 major languages on the subcontinent. I became the victim of unknown fevers, some of them bad, ocassionally they were terrible.

For a month, and sometimes two months, I didn't speak to anyone on my travels, as no one spoke English. Each of my journeys in India, however, started in Calcutta and finally ended there.

Each time I returned to Calcutta, I made my way to Old Courthouse Street in the old British business district of Calcutta. On Old Courthouse Street, I received my mail at American Express and down the street I had an account at Citibank.

In the foyer of the bank, I passed the Nepali guard who pulled open the door and saluted me. In the great heat, the giant Fedders air-conditioning systems hummed away.

Inside the frigid interior of Citibank, a man named Bala Ram stared across his desk at me. Bala was an Indian banker and a man who practiced a profession that typically had scant regard for its clientele.

"You do not look very well, my friend. You do not look at all well." Of all the people I came into contact with in India only Bala worried about me.

Bala was the first Indian I'd met who dressed in the new American style. He wore khaki pants and short-sleeve Brooks Brother's broadcloth dress shirts, set off by a narrow tie. Definitely, Bala was a man of the new, haute international American mode of fashion, in counterpoint to the British and their baggy trousers and jackets which looked like potatoes were being transported in their pockets.

As I sat in front of his desk, I took a deep breath. I felt simply horrible.

In the last year, I'd been struck down by fevers, by stomach diseases and sometimes by wasting infections from sores that never healed in the damp heat. In places I didn't even know the names of, I'd simply lost count of how many times I'd been sick.

From across his desk, Bala watched me. He shook his head slowly as he studied my sorry state. "You need to find someone else besides me to take an interest in your welfare, my friend."

Bala waved at an office peon. After a moment the peon produced a cup of steaming tea which he placed in front of me.

If you wanted your money in an Indian bank, it usually took hours to arrange a normal withdrawal transaction. Bala annotated a chit in front of him. On another piece of paper he wrote an address, and then he handed both papers across the desk to me.

"After you withdrawal your money, I want you to go to my friend Lewandowski's house. It's the only thing I can think of doing with you. Tell Lewandowski you need a doctor."

The banker took a phone call. I had ringing in my ears. The windows tilted. Bala Ram seemed to wink in and out of corporeal existence across his desk. Everything appeared to float slowly around the office.

Bala Ram pointed at the note in my hand. Without a note like this, an introductory "chit," no one in Calcutta would talk to you. "Give that to Lewandowski's bearer. Then, go to bed. You look very seedy, Clark. You look like you need a week or two of sleep. I've arranged a taxi for you."

This is how I met American James Lewandowski. That is how I met the engineer, the unseen European hermit of Calcutta, the odd and wonderful Lewandowski.

At the door of the bank, Bala gave me an envelope of rupees debited from my account. I'd come to the bank to get money, and I'd forgotten that. I had not quite recognized yet, how badly I was in need of immediate anchoring.

* * *

Lewandowski's house was a fantasy, or perhaps it was just that my fever was advancing more quickly than I could walk. Lewandowski lived at # 18 Rainey Court, in a palatial Calcutta mansion surrounded by a dense tropical garden.

The taxi dropped me off down the street. I noticed that for the last hundred feet of my journey, my progress had been reduced to a loping stagger, as I barely managed to cross the street.

As I clutched the fence surrounding the garden my other hand clutched my chit from Bala Ram.

 I stood there like a shipwrecked indigent. In my vision, the house in front of me seemed to dance around badly. I craned my neck backward and peered upward. The huge whitewashed house had to have at least twenty rooms. It was a two-story late Georgian-style Calcutta palace from the late eighteenth century. It was the sort of house that was populated of necessity by an army of servants . Even in my addled state, it was a strange to me that an engineer could live so well.

Down the path, inside the gate, a bhisti was watering a row of fantastic Edwardian tropical plants in the garden. In another part of the garden, two or three malis picked in a desultory way at the verge of a path which seemed to lead into a private jungle behind the house.

I opened the gate. Somehow I made it to the front door and I worked the bell-pull.

An eternity later, a well turned out bearer appeared at the door.

The bearer stared at me. I was dressed in a beaten-up pair of khaki shorts and a worn Madras cloth shirt. Over my shoulder I had my bag. Wordlessly, I handed over my chit in slow motion.

Just as wordlessly the bearer motioned me inside the hallway. Then, not even looking at me or noticing my fevered state, he disappeared with my chit.

As I sat down on a low window seat, I thought that perhaps I should try to make up for my disheveled appearance by looking keen and perky. I tried to put my mind into gear, but the world simply seemed to be slipping sideways, out of control. I didn't look like the most prepossessing of guests.

At this point my physical well being was not exactly hearty, either. I probably weighed 120 pounds, down from my usual 140 pounds, and the result of a recent south Indian wasting disease, cured or perhaps not yet cured.

The bearer returned. His face remained an absolute mask. Wordlessly, he led me over spotless marble floors toward the back of the huge house. We passed through room after room. At the bottom of a set of wide and formal stairs, the bearer pointed upwards, toward the second floor, or perhaps, I thought he was pointing me towards heaven.

With great difficulty I climbed the stairs, gripping the banister tightly. Presumably, with the bearer behind me, on station to catch me if I collapsed backwards. At the top of the stairs the butler pointed in the direction I should travel, down a long picture-lined corridor.

In the distance, I imagined I was hearing music.

"Jesus Christ," I whispered to myself. My fever was now unremitting.

A servant dressed in white emerged from a door at the end of the corridor. He held it open. I recognized the music. It was Bach. In the cavernous room beyond the sounds of piano the music became louder and louder still. In the dim afternoon light I saw that the room formal room beyond was populated with antique 18th century Blackwood Indian furniture covered with chintze.

Sitting at a full-sized concert grand piano, playing ascending and then descending chords, sat Lewandowski . His fingers barely touched the keys. As he played, his body swayed. Music like this didn't exist in Calcutta!

Beyond the piano, I collapsed onto a couch and listened. As the piece ended, in the garden the only sound was the cry of a mynah bird. At the piano the man looked down at the keys. He flexed his fingers and then turned around on the piano bench towards me.

"What do you think?"

Those were the first words I ever heard from Lewandowski. A challenge and a question.

I answered slowly, "…I think it seems . . . that I need to just sit here a bit . . . before I can form an answer."

On the piano bench was Bala's chit. The man on the piano bench opened the chit and he began reading.

Beyond the windows, the mynah moved to another tree and began its strange singing again. Across the room, Lewandowski settled on simply watching me. He had startling blue eyes and, even in his mid-twenties, prematurely grey hair. He seemed to have run out of the few words he possessed.

Right then I felt like I was going to die. I was going to die from fever, not from the oddness of this meeting, or my own musical failures of appreciation.

"Actually what I think … is that I need to go to bed. I don't think I'm very well. If that's all right with you, I believe I need to sleep for about forty years."

My voice was hoarse. My voice sounded like it belonged to someone else.

"You're an American, aren't you? " Lewandowski's eyes watched me. "I thought from your condition perhaps you'd been overcome by my music."

I couldn't answer. I felt overwhelmed by the total, almost terminal exhaustion of my fever.

"How did you get out here? How did you wind up . . . my God . .. in Calcutta India?"
For the first time Lewandowski seemed interested.

"I took the bus to Chowringhee Street. Then I walked to Citibank where I met Bala Ram." I answered as best I could.

The light that had previously filled the room began to leak away. As I fell forward, a victim of some pestilential uncatalogued south Indian disease, the darkness rushed towards me, and then it snatched me away. On Lewandowski's beautiful eighteenth-century Shiraz rug I passed out and began my travels through the unending caverns of night.

* * *

While I slept immersed in my fever dreams, Lewandowski discovered where I stayed in Calcutta. He sent some of his staff to the Salvation Army on Sudder Street. The dreadful matron argued over my meager possessions, so Lewandowski then sent Bala Ram, who could fix anything in India, to straighten out the head matron. His instructions were to bring back my clothes and whatever I owned back to his house.

A week later, as I ate my first dinner in Lewandowski's garden. I watched huge tropical moths beating their wings softly in the dusk against the windows of the huge house behind us. Later, when it became dark, we were surrounded by the sounds of parrots in the huge trees ringing the gardens.

"How can you live like you do? "Lewandowski laughed. "You don't seem to know a thing about being practical, or cautious."

Evidently, in his hermit life, Lewandowski wanted company, not just any kind of company. Upon reflection he paused, and then he continued, "I simply look around me. Even before I

know you very well, I sense that you're probably half mad, with too much of India."

I hadn't eaten much in the last year. When I thought about it, how do you measure your appetite when your life has become a walking coma of travel? The dinner was totally out of this world.

"I want to ask you something" Lewandowski said. He paused, then he continued. "The doctor asked me this, and I didn't know. He'd seldom seen a person so battered out here who was a European. What do you keep doing in India? No one seems to know. "

I told Lewandowski about India. I told him about the absolutely spectacular and scarcely believable, incredible millennial treasures of this country.

"Last year I left Santinikitan in Upper Bengal. I wanted to travel around India. Everywhere. I wanted to get an advanced degree in India. In everything. In art, culture, and history.

I told him of the completely deserted fortress city of Warangal, once the home of a million souls. I told him of Madura, with eleven story temple *gopurams* decorated with hundreds of life sized sculptures, and of the south Indian Hindu pilgrimage cities that few European had ever visited. I told him of hundreds of rock-cut Buddhist caves in western India that had been carved before the fall of Rome. I told him about traveling to Quetta, on the edges of the Baluchistan Desert. Of wanting Kabul, and of travel through the wastelands of Afghanistan.

I told him I'd been traveling the length and breadth of India which few very few Europeans had taken the trouble to see in the decades since World War II. I told him I'd been traveling for 18 months between Afghanistan and India.

"Does any foreigner you know travel 50 miles into the countryside to see what is actually in this unbelievable county? Fantasy in India begins where the macadam ends and the ancient roads of this country with tens of thousands of untraveled miles."

Our conversation ended that night at 1 a.m.

In the following months, whenever I came to Calcutta, I stayed with James Lewandowski.

He would play Mozart on the piano. I'd tell him of my journeys across Afghanistan, then into Iran and Turkey. I'd tell him of my return journeys through Baluchistan and Pakistan up to the tribal areas of the Pathans bordering the Khyber Pass. We talked of long-dead British armies which had conquered India, of Sufi poets, and of kingdoms and dynasties in India, which had utterly disappeared like the sand blowing out of the deserts of Rajasthan. We'd sit in his garden and for hours, then for days we talked.

James Lewandowski was one of those deracinated Americans, like I was rapidly becoming. He was a man of too many places, but of no particular place. He'd been a student at Heidelberg University. He had become an engineer in order to leave America. He'd worked in India setting up 26 dry cell battery factories. When I met him first, Lewandowski was 28 years old.

I had very few friends in India because I never stayed in one place long enough to make many friends. Lewandowski had few friends. He had the soul of an artist who'd become an engineer. It was a strange fit that always crowded him.

I thought how few Americans or Europeans I had met on an entire subcontinent.

I told Lewandowski of sitting opposite the Regal Cinema in Colaba, inside a Bombay Parsi restaurant. As I sat there, I counted foreigners who passed down the sidewalk in the largest city of western India. In an hour and a half, I saw four men of late middle age that I could identify as Europeans.

I came to believe that Lewandowski and I were probably the only two Americans in all of Eastern India under the age of twenty-eight, apart from the freaks who'd wandered into India. They seemed to spread out in places like Katmandu, or Goa never to be seen again. inside their magic clouds of ganja.

In the heat, in Lewandowski's garden one afternoon, I sat by myself. I remembered my journey across the Pacific the year before. The person who started that journey was not the same person who sat in this lush Indian garden, in this carnivorous city of uncertain endings.

At the end of every trip, I returned to Calcutta and I stayed with Lewandowski. I never had a friend like Lewandowski. I probably would never have another friend like Lewandowski who accepted who I was and what I was doing in India, without stricture.

I looked forward immensely to our conversations and to listening to him play Mozart. And for me, of course, there was always Calcutta to investigate. After all the time I spent in Calcutta, this strangely anarchistic, compelling city that was probably the most individualized and unique place on earth. It was a city which remained magnificently indefinable to me. It was a city filled with unending problems and diversity. It was a city placed beside a huge river of an indefinite course, which both ate ships and the achievements of men.

Everything in Lewandowski's life and in my life was in the future.

For years, off and on, I stayed with him in Calcutta. And who in India could make sure his piano was in tune, and play Mozart in a climate of 98 percent humidity, with the thermometer over 98 degrees, in the middle of monsoon thunderstorms, that almost but not ever quite drowned out the magic.

No one, but Lewandowski.

* * *

Photographs, 1959 -1968

Bombay Film Poster, Junagadh.

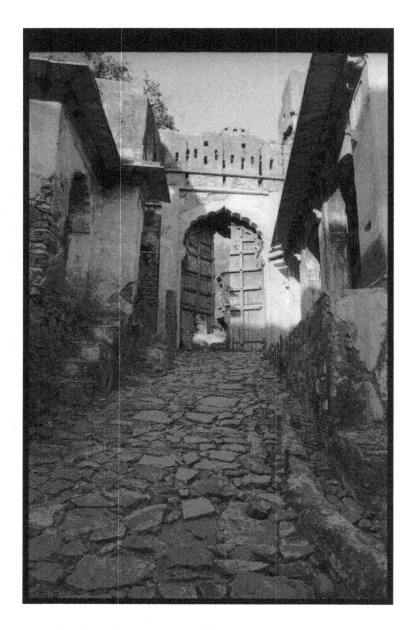

Broken Gateway, Bundi Palace/Fort, 1968

Rolls Royce Silver Wraith, Calcutta, 1959

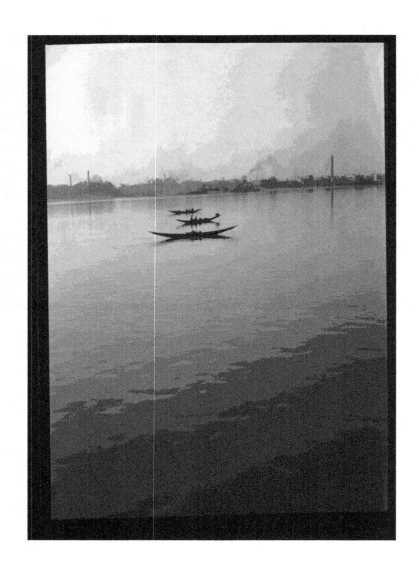

Hoogly River upstream from Calcutta, 1962

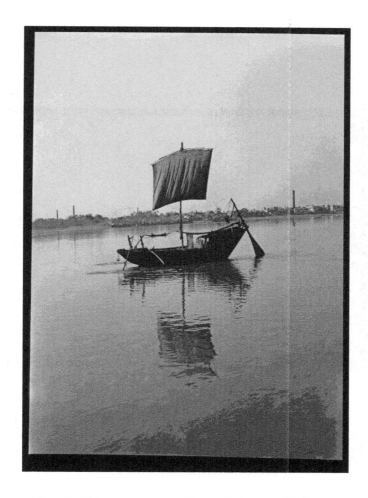

Hoogly River upstream from Calcutta, 1962

Piano Movers, Calcutta, 1959

Crowds, Maidan. Calcutta, 1959

Chindambaram Gopuras,1959

Chindambaram Gopuras,1959

Rabindranath Tagore's great grand daughter, Calcutta, 1962

Bolpur, West Bengal, Hotel & Rickshaw Man, 1959.

Clark Worswick,Tenzing Sherpa, Darjeeling, 1959

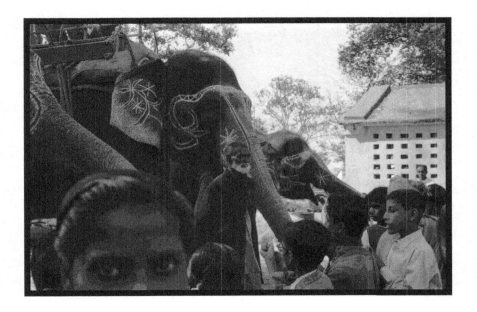

Elephants, The Zoo, Calcutta, 1959

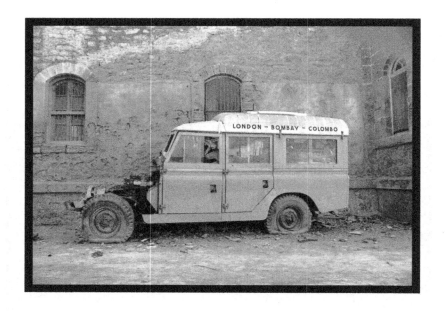

Overland to India, The 1960's

Rickshaws, Kalighat, Calcutta, 1959

Mount Girnar , Western India, 1968

Fishermen, West Coast of India, 1962

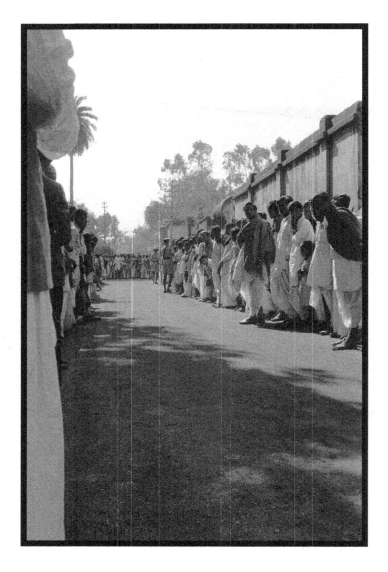

The Indian Prime Minister, Jawarharlal Nehru, Calcutta, 1959

The Indian Prime Minister, Jawarharlal Nehru, Calcutta, 1959

Whiteway Restaurant, Bombay, 1962

Plowing the Ruins of a Million Person City Described by
Marco Polo, Warangal, Cental India, 1959

Religious Ecstatic, 1968

Religious Ecstatic, 1968

The Taj Mahal & The Banks of the Jumna River, 1962

NOTEBOOK 3

1961

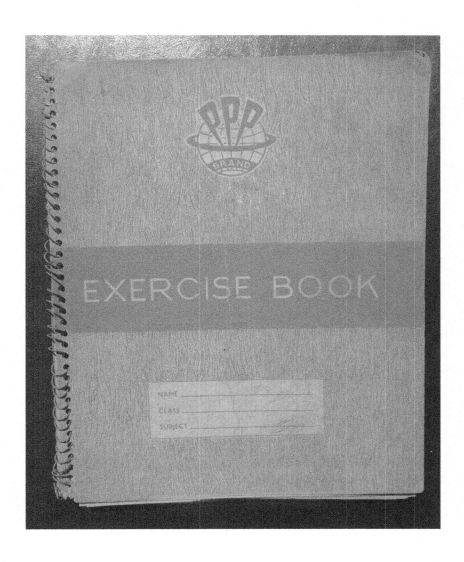

WESTERN INDIA, 1961

One year merged into the next. It occurred to me as I was floating one day in the Breach Candy Swimming Club on Warden Road that I was like a swimmer sinking deeper and deeper into the soporific, lethal depths of India.

Around me in Bombay, the sunlight seemed to change its character. Perhaps I discovered an entirely new India, that I alone inhabited in my journeys and in my photography.

I began collecting art in late 1959 or early 1960. In those years I moved by means of trading art from student to traveler, and then to art collector, passing between penury to moderate solvency. It didn't start out that way.

In 1960, there was a great and unbelievable opportunity to collect Indian art. I'd begun picking up objects in the ruins I photographed and on my travels, by increments, the siren song of art collecting overcame me. No one in India seemed to care if you removed pieces of sculpture from railway cuttings and the ruined temples the British had used as ballast in building the roadbeds. I traveled over horrible roads and down goat tracks to get to the most difficult-to-reach archeological sites on the subcontinent. I found that in collecting art you were a beneficiary of opportunity. What you discovered you owned.

Despite the Antiquities Export Control Act of India, which forbade the export of art from India, when you are 19 years old, how do you inform yourself about a law that no one follows, and that no one cares about?

It all began quite innocently in 1959.

 A half mile from Victoria Station was the Thieves Market of
Bombay, the Chor Bazaar. In the market stalls selling scrap
metal, you could buy sculpture by its bronze melt-weight.

I found in the Chor Bazaar that you could buy tenth to thirteenth
century bronze Hindu statues for one dollar to five dollars. In
other stalls you could purchase thousand-year-old stone statues
from Rajasthan, or sculptures from the pilgrimage sites on the
Nerbudda River for 10 to 20 dollars. During the first three
months I was buying objects in the bazaar, I never saw another
European. One morning, in a dilapidated shop near the entrance
to the bazaar, I bought six medieval two-foot-tall bronze
eleventh century statues from the central plains of India.

I moved through the bazaars and then into the orbit of the Indian
curio dealers. These dealers, who later came to establish
reputations as international art dealers, were just then traversing
that rickety bridge between selling Indian "curiosities" and
dealing in art.

To illustrate how precarious this bridge was during my early
days in Bombay, I met a thin, poorly-fed, middle-aged man
named Manu Naurang who frequented a bench in the park
behind the Prince of Wales Museum, Living on the margins of
Bombay respectability he existed somewhere between starvation
and success as a minor art picker for the curio dealers. Just two
years later, Manu Naurang would become the largest art dealer
in India. Four years after quitting his park bench, he would own
a chain of four-star hotels scattered across India.

At the beginning of the decade of the 1960s, as the curio dealers of Bombay moved from the edges of impoverished commercial society toward the mainstream in the art dealing establishment of Bombay, two antiquities dealers controlled the bulk of the trade. These dealers were Nasli Heeramaneck and Essaji. In the late 1960s, Heeramaneck offered his collection to the Museum of Fine Arts in Boston for over a million dollars. America had become an Indian art dealer's nirvana, and the lavish catalogue produced by the Museum of Fine Arts never mentioned the fact that Heeramaneck was a dealer, not a collector.

Commercially downhill from the establishments of Essaji and Heeramaneck were the curio dealers who catered to tourists. This trade was centered in Colaba, behind the huge Taj Hotel, which was the obligatory stop for every foreign visitor to Bombay. The curio dealers understood their business, at best, poorly. They had few great objects and mostly rubbish. They could never look you in the eye. Across the street from Essaji's shop in Colaba, behind the Taj Hotel, were the Popli brothers. The Poplis seemed to have hired every art picker in India who turned up authentic and not-so-authentic sculptures.

One of my first purchases in Bombay, which I'd bought from the Poplis, was a grey granite Buddha head carved in iron-hard stone. I was taken by the artistry of the unknown artisan who the Poplis said created this in the sixth century. The artist had worked near Prince Siddhartha's place of enlightenment at Sarnath, the great Buddhist site of worship. The Poplis suggested that the sculpture was reminiscent of the magnificent Gupta heads held in the Calcutta Museum. The head was amazing. It was executed in a modernist, art deco style.

After months of trying to date my sculpture with every Indian art historian I knew, I learned the most fundamental lesson about collecting art: when something is too good, it is probably not "right." I was told later by an old artist in Bombay that the head had been carved in the late 1920's. The stone was so hard it had taken years to carve this sculpture. It had been sculpted by a Bombay art teacher enamored with both the art deco and the Gupta periods.

Another brick was added to the Poplis' heavy basket of bad karma these two dealers had to carry with them into the afterlife. To the bone, the Poplis were absolutely dishonest. Given a choice between the truth and a lie about an object, the Poplis invariably preferred the lie, because it made them more mysterious and elusive. The lie was also, of course, always much more profitable.

<center>***</center>

When I first arrived in Bombay my interest in Indian art had been all quite innocent at first. My first conscious act of a future, which would eventually come to overwhelm me, happened when I naively walked into the Prince of Wales Museum in Bombay. Inside the darkened corridors of the museum, the galleries were deserted. In dusty cases, in corridor after corridor, paintings and sculpture lined the passageways.

The Prince of Wales Museum was a place I'd walked past for a week. The museum had a wonderfully sonorous and operatic look to it. It was a Victorian-Saracen structure built during the high Victorian period, a home to high culture plunked down on the unlikely shores of the Arabian Sea. In its ambition, with its vaulted domes, the museum's architectural style was nothing if

not fantastical. One day on a whim, I crossed the lawns to the museum. Inside the lovely dark vaulted galleries, I discovered three thousand years of Indian art.

Time had abandoned the museum. In the dim galleries, some of the greatest treasures of Indian art were piled one on top of another. Inside nearly opaque museum display cases begrimed with dirt, it was impossible to see the objects inside. Along the museum's dusty corridors, neglected examples of the greatest masterpieces of Indian miniature painting were jammed along the walls. Inside poorly constructed frames, portraits of long dead kings and their consorts hung crookedly as if exhausted by humidity and gravity. The museum had been built for the culture-hungry Indians by their British colonial masters.

Day after day I made my way to the museum and I wandered alone among the galleries. At the age of 19, I discovered an entire encyclopedia of art history that few apparently knew about or cared for.

The art I discovered in the museum was breathtaking. Apparently, it was almost abandoned, and in the deserted museum galleries I discovered the grandeur of Indian art. On and off I began to collect art. Or perhaps it was simply the other way around—art somehow began to collect me.

Somewhere along this quiet road, I became an international art smuggler, as well as a thief of Indian art. Little did I know in 1960 that this was the definition of both my activities and later of my collections. In some distant and as yet barely imagined future, what I collected in the early 1960's was to pit me against the judicial authorities of India, as well as authorities in much of Europe, the United States, Pakistan and Afghanistan.

In the judicial world of the unimaginative, and the culturally deaf bureaucrat intent upon applying his forgotten laws, my greatest crime was collecting art, then moving my art from one place to another. In a country that didn't seem to much care about its art, I saved this art from people who broke up millennial metal sculptures for their melt weight, who crushed stone sculptures for road ballast, and who had abandoned thousands of millennial rock cut temples in impassible, forgotten jungles. At least seen from my own point of view, I was doing the good work.

* * *

Artists of extraordinary vision and clarity had worked throughout the subcontinent in paper, in textiles, in clay, and in stone and bronze. Inside these galleries were whole epochs of Indian art history. These epochs been born, reached middle age and then expired, apparently unnoticed and unappreciated. In the museum I became totally lost to Indian art.

In northern India, there was the Kingdom of Asoka which from 273 BC had succeeded in almost uniting the vastness of an entire subcontinent. I was intrigued by the emperor Asoka, who had converted to Buddhism in 262 BC. The British novelist, H. G. Wells, wrote of Asoka:

"In the history of the world, there have been thousands of kings and emperors who called themselves 'Their Highnesses,' 'Their Majesties' and 'Their Exalted Majesties' and so on. They shone for a brief moment and as quickly disappeared. But Ashoka shines like a bright star, even unto this day."

I discovered the great Buddhist periods of Indian art: the Kushan period, the Gandharan and the Gupta. In AD 1000 there was the Hindu south Indian Chola period, then the Muslim slave dynasties of northern India, and finally in the mid sixteenth century, the extraordinary period of the Mughal dynasty.

In America, at that moment during 1960, there were precisely two professors in two universities (Harvard and UCLA) who taught Indian art history in part-time courses. If you were of a curious mind and wandered out to India with a penchant for educating yourself, 3,500 years of Indian art history existed within 100 miles of Bombay.

It lay there baking in the sun. It was scattered was scattered across every footstep you took. One could literally reach down and pick art up and then carry away the wreckage of millennia. You didn't have those advantages at Harvard or UCLA.

When I dropped into the tiny, not-very-well-kept shop on a dark street wedged behind the Taj Hotel, in a store kept by the dealer Essaji, I came upon miraculous weapons of a forgotten time. There were jade-handled khanjars (daggers) from Agra during the Mughal period, with carved finely worked jade hilts, and khanjars brushed with gold from the Deccani kingdoms. These daggers were made into the shapes of fantastical animals with ruby-set eyes. There were spectacular Damascus work swords encrusted with gems, suits of chain mail, and jeweled amulets.

In 1960, there were few words of caution concerning the purchase of Indian art and antiquities. There was no advice regarding quality or the existence of fakes. There was no advice about provenance, or where art originated. In India there were

few enforced government regulations pertaining to either the purchase or the exportation of art.

There was the exception of the aforementioned Indian Antiquities Export Control Act, Article 31, of 1947. It prohibited the export of antiquities without a license, which was bolstered by an even earlier draconian statute of the Sea Customs Act, 1878. Under this act, illegal export of antiquities was punishable by a fine and with imprisonment for a term "which may extend to one month."

In the new art trade no one seemed to have heard of these laws.

My *Handbook for Travelers in India, Pakistan, Burma and Ceylon,* published in the eighteenth successive edition (London: John Murray, 1959), stated in the introduction (page XXI): "Antique pieces can still be found but it is best to go to a reputable dealer unless one is possessed of expert knowledge or has a friend who can supply it. Special caution should be exercised in the purchase of Oriental paintings and porcelain. One must not forget the maxim caveat emptor and realize that, in bargaining, the final figure will always leave the small dealer with a margin of profit which may be considerable."

My path toward a lifetime entangled with art collecting was totally innocuous. I'd read a passage in the most important guidebook to India. I took the advice given to four generations of collectors of Indian art. Improvidently, I had walked two miles north from the largest museum in western India to the Chor Bazaar. Somehow, without realizing it, I had crossed some invisible line. You could buy any Indian antiquity or any Indian art you found. It was available. It was exportable. Everything was for sale. My guidebook even told me where to buy art.

In order to buy more art, sometimes I was a seller of art to the dealers. Little did I know that I'd taken a journey along a very thin line because, in the emerging art world of the West, a virtual chasm came to exist. This chasm existed between identification about who was an art collector, and exactly who was an art dealer. The world of art is divided by this yawning chasm, and the abyss which separates the dealer from the collector is a distinction which is oftentimes paper thin.

On the Indian art market at that time there were classical Indian miniature paintings from the fifteenth through the nineteenth centuries. One could buy Buddhist art from the first century BC to the sixth century AD. When I think back, I don't believe there was a twelfth century textile in the whole continent of India that was for sale for over 35 dollars. On the entire Indian subcontinent—from Afghanistan to Burma, from Ceylon to the reaches of the Iranian desert —I don't believe there was a single antiquity of any age, or any period , which was priced at more than $250.

Today I have to pinch myself.

When asked where they obtained particular objects, the dealers didn't reply. Instead, they gave you the most maddening and knowing smile before changing the subject. The mystery of where the dealers acquired their art was a secret shared with no one.

I realized, as I traveled with my Leica around central and southern India, that the whole subcontinent was a treasure house of unimagined proportions. The dealers appeared to have mined only small patches of the subcontinent for their objects.

I discovered as an unintended adjunct to growing their meager crops, 50 generations of peasants had dug sculptures out of the earth in the Indian countryside. One traveled to the sites of ancient cities where there once had stood whole empires. Time had transmuted these empires into barren fields. You simply walked down the verges of fields that had subsumed entire cities. You reached down. You lifted from the cracked earth stunning, unbelievable sculptural objects that at one time had decorated temples rivaling the architectural glories of Greece, Egypt and Gothic Europe.

 With the assistance of four or five willing agriculturalists from a village nearby, one gathered up art.

* * *

5 A.M. in central India.

 I stepped off a train. In the darkness the train receded, moving in the direction of Hyderabad. I spread my dhurri on the cold concrete station platform. I'd disembarked in a place called Warangal. On the concrete, I slept until the sun warmed my back.

In the morning light, the station and its platform were totally deserted. I stretched. I folded my dhurri into my bag. There was not a single soul in sight or any place to eat.

Upon his return from China to Venice, in his Travels, Marco Polo mentioned visiting Warangal during the thirteenth century. The greatest traveler of the European middle ages once stood before the massive gates of Warangal. The city was huge and of

great renown. It was the depot for the fabled diamond mines at Golconda. Polo noted that the city was protected by two gigantic walls. The first wall was fashioned of earth and for a distance of 50 miles it ran the circumference of the huge city. The second wall was 45 feet high and was made from colossal, carefully hewn stone blocks. One proceeded through the outer wall toward the inner wall of the city. This inner wall ran seven miles around the city's interior core. On its dusty plain, Warangal occupied the crossroads of commerce for the entire region of central India.

From the deserted railway station, I started walking.

I reached the outer wall of Warangal in a half hour. As I walked I noticed that the British-built railway had cut through the outer wall before veering southeast out of sight. I looked at my watch. It was just after eight o'clock. According to my railway book, the next train passing through Warangal would arrive in eight hours. In the distance, I saw the second wall of Warangal.

During my walk I met not a single soul. There were no carts upon the road. There were no peasants. I walked in eerie silence, the only occupant of a huge deserted semi-desert plain. In forty-five minutes, as it gradually loomed in front of me, I reached the second wall. Seeking out handholds, I began to climb. In five minutes I'd gained the top of the wall. In front of me, inside city walls which had once protected nearly a million people, there were now barren fields. The bare plain stretched off into the distance.

In the distance, on a low granite hill, was a single temple. In the

early morning sunlight, a single peasant plowed dead straight lines of barren furrows in the direction of the temple. A wind had sprung up. Dust devils danced across the creases the peasant made in this hopeless landscape.

There was no evidence, other than the distant temple, of what had once been among the most famous cities in the world. I descended the wall and walked toward the temple. On the sides of ghost fields that were no longer plowed, were the remains of sculptures produced by the Hindu kings of Warangal. The Muslims had reached this place in their wars of conquest and obliteration. In much of northern India, beginning in the year AD 1000, a tidal wave of Muslim conquests completely decimated the millennial artistic traditions of both the Buddhists and the Hindus. Each piece of sculpture had been broken.

I reached the temple and I sat there thinking of time, an ocean of time, and how all things pass in the cataclysmic storms of time.

Hours later I walked back toward the great city wall to catch the last and only train stopping at Warangal that day. I was the only person to board the train. As the train moved toward the south, I watched huge cumulus clouds that rose 20 thousand feet above the plain. In the distance, the walls of Warangal disappeared.

I thought of the feeble constructions of man, and the tidal wash of Indian history. In India everything wears away. Dynasties, conquerors, great religions. In the ageless wear of time mankind has, as yet, appeared only briefly.

* * *

BOMBAY, 1961

They were doctors, academics, and civil engineers but last and most importantly, they described themselves as "the people involved in Indian development and infrastructure projects."

In early 1961, much too soon for my liking, I was joined in Bombay by a growing crowd of suddenly animated and rabidly energized Indian art collectors. Heartbreak.

I came to think of these people as unwanted opportunists, who wandered into the art world looking not for art, but for bargains. When they weren't haggling for art, they were designing clean water projects or setting up education and feeding programs for the poor. They built dams. They excavated coal mines. They tried to reinvigorate a crumbling transportation infrastructure, which the British had simply walked away from and abandoned two decades before.

Everything the "infrastructure professionals" did was absolutely, coldly calculated, scientific and terrific. It was paid for by the splendid United Nations, which was helping make India a "modern" country. Like some kind of terrible locust infestation, from late 1960 onwards, more and more of these infrastructure professionals turned up in India. After great study in their thorough if plodding ways, they somehow set about collecting Indian art.

In the decade of the 1960's, I think this entire group, came to see their most magnificent work in India as looting an entire subcontinent of any art that was old and portable. In the strangest of unintended consequences, this was made possible

by the officially sponsored U.N. connected Indian government's grand ideas about Central Planning.

The idea in this scheme was to "develop" India into a brand new country. This included the beloved infrastructure projects of a Soviet-style economy, with mines, huge dams, giant steel mills, harbor projects, and masses of yellowish cloud-belching concrete plants. Meanwhile, I knew who these people really were. The infrastructure professionals, in reality, were like a host of hungry picnic ants in search of cheap, bargain priced sweets.

In Bombay, I kept up with my friends, the curio dealers.

With the appearance of a whole new clientele, suddenly, from being curio dealers, they became art dealers. During a short six-month period they abandoned lifetimes previously spent selling curios to scavenging India for art. For a bit of time they rolled in newly minted rupees.

But then I began to hear disconcerting whispers from these newly minted art dealers, about their protégés, the new collectors.

In a weird Malthusian commercial progression the "infrastructure professionals" began to bypass the dealers. They started shipping from Bombay their own ton-sized crates bursting with self-discovered Indian art.

The dealers' complaints centered upon the fact that their new customers, whom they had both trained and introduced to Indian art, now made them commercially irrelevant.

With this end run around the art dealers one had to think back a bit to find out how this had happened so quickly.

In early 1960, under the new government's 5 year plan, the experts on water development, on poverty eradication and "resource utilization" arrived in Indian and they began to buy art. Being very quick studies, they'd asked around, and discovered the "source" of the art they bought from the dealers. The "source", in this case, was the 600,000 villages of India.

In the course of their work, the "infrastructure professionals" were given normally impossible-to-find Jeeps and four-wheel drive transport. And where did they go to do their work? Since their work took them into the villages, the countryside, and into every district of India they quickly located the source of all the art being sold to them by their previous friends - the art dealers of Bombay.

In next few years, during the course of their undoubted good works of cleaning up the water supply of India, and electrifying villages, the development people bought, excavated, or bartered every single piece of Indian art they came across.

India became a vacuum sucked dry of its classical art. There were no other words to describe this great, strange, and sudden looting.

The irony in all this was that it was the central-government bureaucrats in Delhi who had made this possible, and the Criminal Investigation Division who stood by and watched for previously mentioned, more serious mischief.

The new "experts" had literally Jeep's full of rupees. The strangest paradox of this moment in the art world of India was that the people who saved the greatest pieces of Indian classical art from exportation were in fact the art dealers of Bombay.

These were the same dealers who had first introduced Indian art to the creepy development people. Now, the dealers were bitter. They were broke.

"The ingratitude, the absolute ingratitude," one of my dealer friends muttered. "Here, our former customers whom we 'brought up', the people we educated and trusted with our marvelous Indian art, they have cheated us of our own prime 'sources' sir. They are cheating us out of the bread of our family!"

"Well. I told you so," was my rejoinder.

For a few brief years, 1959-1961, the markup that Bombay dealers had been making on art was mind boggling. Their cost to acquire curios, now considered "art," had been nearly zero. But then, instead of paying a pittance to some luckless peasant for what he'd discovered in a field, all the dealers could do now was watch, and fume, as cargoes of heavy crates laden with art left the Bombay docks.

They watched, and they howled among themselves, then the freighters sailed off over the horizon to distant places.

Determinedly, with rare cooperation, the art dealers commenced to protect their market from their former customers.

Shipments of art were looted. Other shipments were abruptly misplaced on bills of lading. A collector, usually our happy, parsimonious infrastructure professional, would now have the pleasure of seeing "his" former objects for sale in the shops of some of his former art dealers.

With their cost basis nearly zero, again ,wonderful Indian art began appearing in the art shops of Bombay. Nearly one in four shipments disappeared. Then it was one in three. Finally, only every tenth shipment made it "home."

Of course, what the dealers were doing was against the law, so the infrastructure people went to the police. They then discovered that the Indian police were not the cozy, sympathetic law enforcers of Europe, or the constabulary of America.

The police in India were poorly paid. Accordingly, a splendid new subset of police activity evolved. This entailed vigilante night work that might be considered insurrection. This new work, and the enthusiastic work of helping hands, was bi-coastal. The police themselves began robbing shipments of art departing from both Bombay and Calcutta.

"Did these people shipping all those huge crates think that our police were honest? Of course not, dear boy, "one of the dealers asked me ingenuously. "Whomever has heard of such a silly idea." Pausing, he patted his vast stomach and belched. He popped some paan into his mouth and began to chew contentedly.

"These people come to our country, sir. They must do things our way. That means asking us for our help in buying art. After all, what do these foreign people think we do? We are here only to help them find art. Isn't it?"

"Amazing I didn't think of this," I answered.

I learned painfully and slowly seldom were these dealers my friends. Sometimes they were your accomplices, but they were never one's friend.

The rule I discovered when I looked at the problems of the "infrastructure professionals" was this: BEWARE shipping anything out of Bombay or Calcutta. You shipped yourself whatever you wanted to send out of India to the Gulf from one of the scores of smaller ports ringing the western coast of the subcontinent.

Nothing changes. It was from these same Gulf ports, in the twelfth through the eighteenth centuries that both slaves and stallions from Khorasan and Arabia were smuggled into India to avoid octroi taxes levied by the local kings, who ruled the coasts.

For millennia, these ports had carried on the coastal trade of the subcontinent, long before the British came to India. These small Indian ports traded with Egypt in the fourth millennium BC, when a canal first linked the Red Sea to the Nile. Beyond the fog banks of time, these ports had conducted probably the earliest record of ocean trade.

192 · Clark Worswick

I discovered I could get these same dhows to carry my "things" westwards. On their return journeys to Muscat or Kuwait or Dubai, the dhows, with their Arab sailing masters, journeyed home almost empty from India. If you set up your deals with the owners of the ships, by journeying to Kuwait or Dubai and arranging your shipments, their sailing masters were scrupulously honest.

But always, always, I dealt with the ship owners in the Gulf itself. These ship owning families were all interrelated on Gulf-based Indian collateral family lines, and they had been transiting the Gulf for centuries.

And so, I developed my own little cottage export industry from India. I shipped my own goods on a modest scale. I never spoke a word about this to anyone. My favorite ports were located in the small cities above and below Bombay. They were the ancient ports of Janjira, Ratnagiri, Bilmora and the Portuguese port of Daman, still then a Portuguese possession.

In my new life as an art smuggler I felt I was a kind of commercial pioneer recreating the ancient trading routes.

* * *

CALCUTTA, 1961

Slowly I traced out, a brief sentence into one of my school notebooks which I carried around India.

"Where does this end?" I wrote.

Lately, I'd been thinking that the trouble with that all the Indian travel books I read, of the 17th through 19th centuries, was they all ended in the same place. It seemed every single journey of every Englishman I met in my books ended up behind the high brick stucco walls of the Park Street Burying Ground, the largest British graveyard in India.

In the early 1960's, there were somewhere between 20 to 30 times more people living on the broken pavements of Calcutta than the city could possibly support or accommodate. Perhaps the ultimate mystery of Calcutta concerned the millions of people, who each night occupied every sidewalk in the city. It occurred to me that the partial answer to this overcrowding could easily be the capacious interior of the Park Street Burying Ground. Couldn't the cemetery accommodate tens of thousands of indigent sidewalk people, perhaps hundreds of thousands?

Two or three blocks away from the Park Street Burying Ground was Lewandowski's house. Lewandowski was away in Bhopal, in Central India. Perhaps I should shelter two or three hundred people in his garden while he was away? As I walked across the street, either coming or leaving Lewandowski's house I pondered philanthropic questions like this while I watched the monkeys appearing in the Park Street burying ground. The

monkeys of Calcutta were shy creatures, but they loved the night.

During the day, street people moved into the cool, dark interiors of the tombs in the Park Street Burying Ground. With darkness approaching they abandoned the graveyard with fearful backward looks. In the near darkness I turned the corner, watching haunted-looking groups of human fugitives stream past me from the graveyard.

The homeless of Calcutta avoided the graveyard at night not because of the ghosts but because of the terrible things which dwelt in the trees.

In their kingdom of the night the monkeys of the Park Street Burying Ground were filled with a terrible vituperation possessing an almost demonic otherworldly ferocity. As they moved through the gathering dusk, the monkeys were camouflaged in barely seen shades of grey and black. Slipping through the trees ringing the graveyard, they appeared as shifting tones of smoke. Only with difficulty, when you stared up at the banyan trees, could you see the monkeys hiding there.

In slavering, almost invisible hissing bands, the monkeys attacked anyone they found inside the burying ground.

Among the sleeping dead, amidst the brick and marble tombs, the monkeys were the spawn of the Goddess Kali. They were the Kali vidyas, the emanations of Mahadevi, the Hindu goddess of death and annihilation.

Crossing the poor quality macadam road of Park Street, which oozed and cracked in the suppurating heat, avoiding pot holes in

the sidewalks, I walked towards the open park-like space of
the Maidan.

Dating from the period of the British Raj the Edwardian street
lights still worked at this end of Park Street. The buildings
ringing the Maidan needed paint badly. They seemed to sag with
the weight of history. Since the British had departed Calcutta.
wasn't doing too well

I wondered about a city which appeared to have been
transported, somehow, through time and to the Edwardian
period before the First World War.

In Calcutta, churches, hotels and restaurants looked like they
belonged somewhere else, in another time.

Where Park Street met Chowringhee, I reached my Chinese
restaurant. The place was a low-wattage vision of Southern
China in the late nineteenth century, and how could anyone
believe that Calcutta possessed a century-old superb, Cantonese
restaurant?

I liked this restaurant more than any other in Calcutta. It had the
simple honesty of exile and bereavement. The restaurant was
decorated in red-lacquer; the laquerwork had gold-painted
highlights marked with decades of grime. Hanging damply in
the heat were dust coated lanterns with ancient light bulbs which
seemed as old as the restaurant.

How this restaurant existed without customers was one of the
eternal mysteries of this city. Under the glass top of the table
there was a fly-specked menu. As I sat at my usual dirty table in

a city that didn't much like the Chinese, I ordered my dinner.

I opened my *Statesman* newspaper. On the front page was an article on Indian alcohol addiction and the coming of a total alcohol Indian prohibition.

In the first decade of the 1960's, I was only gradually learning that people in India were permanently addled by naturally occurring substances. At the exact moment that this whole country was being warned of demon drink, India had to be the world capital of exotic drug abuse. Out there in every street were opium, bhang, hallucinogenic Datura, and hemp products.

In the Indian countryside beyond the cities, more or less, each day and night, everyone was drugged up on something. Maybe everyone in India was trying to escape to somewhere else? I turned my mind around this idea.

They vanished into their own compartmentalized, interior unreachable spaces in broad daylight. These were the people of the crowds. They were the people who disappeared in an Indian rope trick. They hadn't managed to catch a train, a boat, or been able to fly out of an airport to escape India. Instead, they'd simply vanished into some kind of final, desperate journey into themselves. It was a place where no one could reach them. In their milling millions these were the people who inhabited Calcutta and Bombay, and every other city in India.

The one thing I knew about India by this point was that the more I learned about India the less I knew of it.

* * *

KABUL, 1961

I badly needed another rest from India.

I traveled to Quetta in Pakistan, then to Kandahar in Afghanistan.

Then I passed through the Dasht-i-Margo Desert and survived a winter passage through the freezing blank nothing of western Afghanistan.

I crossed the border to Iran and Mashhad.

The largest Mosque in the world is in Mashhad, and at the tomb of Iman Reza, the eighth Shia Imam, I tried again to take photographs. When I saw the first person picking up a rock I put away my camera hastily, but that was when the rock hit me. It was my last and only attempt making pictures in Iran.

On a ramshackle truck I bought a very cheap journey from Mashad south to Zahidan, and back to the Iranian- Pakistani border.

On a small branch train line that crossed the Baluchi desert was Quetta. From Quetta I took a 24 hour daily train to Lahore.

In the early spring I changed trains for Peshawar, then I moved into the ravaged mountains through the Khyber Pass, before I returned to Kabul.

The first time I saw the Englishwoman was in the main bazaar. It was almost dark. She was looking at a pile of thickly embroidered Pashtun winter jackets lined with sheep's fur.

The woman was already sensibly dressed for the weather of Kabul. She wore a thick, British-made Alpine climbing jacket, the kind that people wear when they spend the night on the surface of glaciers at four thousand meters. I watched as she moved through the bazaar. The woman was somewhere in her late twenties. She had a neat economical way of moving, as if everything she did was carefully ordered.

There were so few foreigners in the city, eventually, you met every firangi in Kabul. I saw the Englishwoman again two days later. I'd been moving down a sidewalk on Chicken Street and watched her pass on the other side of the street. She made no sign of recognition nor awareness I existed. For a moment I thought I might be invisible. A block further on, the Englishwoman disappeared into a kebab restaurant, one of the few warm places in Kabul. I admired her sensibility. The restaurant was one of two restaurants serving edible food in Kabul.

Inside the interior of the restaurant, I looked around. The heat of the place struck you like a physical blow. Afghan tribal textiles were affixed to the sides of the room in a halfhearted attempt at coziness. The restaurant had low ceilings. It was decorated with a few cushions on the floor. I closed the door

behind me. At the other side of the restaurant, the
Englishwoman had taken the only unoccupied table.

In the late months of 1961, most of the foreigners in Kabul were
still more or less polite to one another. We'd crossed the same
difficult-to-negotiate roads. We'd all somehow crossed the
Dasht-i-Margo to get to Kabul from Europe. The woman looked
up as I crossed the restaurant.

In the semi-darkness, the woman stared at me. Wordlessly, she
pointed at the only empty chair in the restaurant. It was across
the table from her.

Across the table in the darkness, the woman asked in an upper
class British accent, "Where else could you sit?"

"You don't mind? Thank you." I said. I sat in the unoccupied
chair.

I looked across the table at the woman as I took off my jacket.
Without her bulky Alpine climbing coat, she'd magically lost
many pounds. Her torso was thin. Her face was thin. She
wasn't beautiful, she was striking. With deep auburn-colored,
dead-straight hair, which hung straight down she was perhaps
five foot two.

Looking at me she asked, "Do any of the people in this room
know that in a few weeks the daffodils come out at Hampton
Court?"

"I don't think most of in this restaurant even knows what a
daffodil is. In my own opinion, most of the Europeans here are

so dialed out they don't what year it is." I gestured at the room and the Europeans silently slumped there in the gloom.

"I'm learning manners aren't a big item in Kabul, are they? " she asked lightly.

The Englishwoman put out her hand, holding it above the scarred table. We shook hands very properly.

 I told her my name.

"My name's Jane Seymour. Like the third wife of Henry the Eighth."

Everyone in Kabul started a conversation with the story of their travels. Lately, I was thinking these stories ended after the first half paragraph, lost forever in a cloud of drug-murdered thoughts.

The waiter appeared suddenly. We ordered our meal. After the waiter left I asked Jane Seymour if she'd come from India or was going to India.

 "Going to India," she answered with brief verbal economy.

I thought about that and offered Jane Seymour some advice.

"Try not to stay around here too long. Make sure you get out of Kabul and go to India."

"Is that an interesting question, given how hard it is to get to Kabul?" she asked.

"Look around you. Most of these people in Kabul were all more or less healthy when they arrived here. After a few months on Chicken Street the people who stay on in Kabul exist in a state of religious denial of food. That's because there are too many good drugs in Kabul. I know it's hard to imagine now, but all these people came here from somewhere else."

Jane Seymour settled on watching me. She wore one of those shapeless, eighteenth-century Afghan startlingly original chintz dresses that cost three dollars in the bazaar. It was set off with a red- and gold-embroidered tribal vest. She seemed to fold herself into long silences.

She was a tiny creature like Mary Pickford. She was one of those small people who would live forever because they didn't have to expend a great deal of energy battling gravity to remain upright. She'd definitely been a minor movie star or a fashion model, and I wondered how she got to Kabul without being eaten by road cannibals along the way.

For perhaps thirty seconds Jane Seymour was silent, then, with anxiety in her voice, she asked suddenly. "Do you know what I worry about here?"

I thought about this was question deliberately, then answered. "There are lots of things to worry about in Kabul: getting sick, where you're going with your life. Mostly, when I'm in Kabul I worry about the psychological pressures of large Indian cities. "

Jane nodded. "I worry the same thing. About getting crushed in crowds, mauled by crowds, getting lost for months in crowds. In London I worried about finding my way out of horrible crushes of people like in the tube."

There were three waiters in the restaurant. All three were named Ahmed. I always numbered the Ahmeds. From Ahmed Number Two, I waved off an offer of a sample of the new crop of Chitrali hash that he was holding.

Ahmed Three then appeared and he apologized for Ahmed Number Two and his dope dealing. He then offered me a fist full of counterfeit Indian rupees. I waved them both away. I loved this restaurant. Orders in this Kabuli restaurant had a way of arriving or more likely not arriving, but it was the restaurant owner who was very good about his customers' satisfaction. You didn't have to pay if you didn't like your meal. Tea was one price. Chicken or goat with naan was another price. The three things on the menu kept addition to a minimum, assuming they actually had any chicken or any goat in the kitchen that day.

The food came along with tea, and there were great heaping mounds of rice along with chicken still on the bone cooked with delicious saffron and spices.

Jane told me about her planned trip to India. She told me about her family. For six generations, for a century and a half during the British Raj, in India they'd been bankers and bill of exchange merchants.

They'd also been in the tea business in Assam, and the owners of a jute factory in Dacca. Her father had been in the Indian Civil Service before Independence. Jane had been born in Darjeeling, and she'd always dreamt of traveling into the vastness of the Himalaya.

"After Kabul, that's where I'm going. The Himalayas, "she said. "In an undernourished, starving post-World War II England, I grew up dreaming of the mountains of India. They were a distant, unapproachable little girl's dream of a far off paradise."

Everything about Jane seemed to have been set down in a predetermined order. The more I looked at her, the more beautiful she was. She appeared utterly self-contained. Across the table, I watched her hands move in precise and economical gestures as she ate.

"I wonder how you got from London and Calais to India," I asked. "After Calais, what happened to you?" I asked Jane. I thought she'd probably arrived in Kabul in the usual way in one of those beaten-up, ratty British Bedford Dormobile vans.

I signaled one of the Ahmeds to bring more chai to the table. After weeks in the company of world travelers-turned-dopers, I badly needed a sensible conversation. This evening was becoming very pleasant. I actually was having a lovely dinner with a smart, educated person.

"Do you really want me to tell you about my trip?" Jane asked almost offhandedly. "I actually had a very bizarre experience getting to Kabul."

One of the Ahmeds finally appeared with fresh naan and tea. I'd had too many of these conversations about trips to Kabul, but I wanted to hear English spoken. I wanted most desperately to hear intelligent English spoken, for hours and hours.

204 · Clark Worswick

Jane picked at the naan. She popped a piece into her mouth, and gave a look that said she loved the hot fresh bread.

"…in Calais, after I got off the ferry from Dover, I began walking toward the railway station with my huge suitcase. Very stupid of me; it was very heavy."

Jane paused, sipping her tea. "There was a car that must have been thirty feet long. It was one of those custom-made black Mercedes 300d sedans that pulled up next to me".

"The passenger in this enormous car unrolled the side window. He looked at me for a few long moments, as I bravely struggled with my luggage towards the ticket booth of the Calais train station, about a third of a mile away…"

Jane folded her hands around the cup. She sipped cautiously at the hot liquid and then blew gently on the steaming surface of the tea.

"And then?"

"Then, the man in the Mercedes got out and he asked me where I was going. I answered that I was going to Asia, just to blow him off. I hate getting weird rushes from strange men in places where you are between a boat and a train, and managing a suitcase that was a huge touristic mistake."

I had to say that custom-made black Mercedes 300d sedans were not the kind of cars that you saw every day. In fact, I'd never actually seen one except in magazines. They were reserved at the factory for the leaders of sovereign states, or the heads of

international criminal conspiracies that masqueraded behind Swiss bank accounts.

Jane continued, "I thought to myself … I hate this…. I hate this trip already. Why in God's name did I decide to go to India? I've just started this trip, and already this man is whacking on me. As I looked at him, I realized he was dressed in a cut-away morning coast. This was becoming unbecomingly odd, and significantly strange."

"At that moment the driver got of the car. He was huge. He was absolutely gigantic. He was the largest man I've ever seen in my life, and he moved around the limousine to the rear passenger door. The man next to me on the sidewalk gave an order in some foreign language. Then, the driver opened the rear door of the limousine. The rear seat of this car was so large it looked like an all-leather, lavishly upholstered bedroom suite."

Jane put down her tea.

"With a flourish, the man next to me pointed at my suitcase. The driver began to take it, but I held on to the handle for dear life. Everything I presently owned was in that suitcase, and I wasn't giving it up without a struggle."

"Both men watched me, then both men simultaneously burst out into gigantic rolling laughter."

"The man next to me stopped laughing and he explained. 'My dear, we were going to offer you a ride to the railway station, because your suitcase looks so heavy. But then you told us your destination and we've changed our minds. We are returning

home. On the spur of the moment, we've decided that you may come with us. If you wish.' "

"I had the feeling this was getting to be wildly manic story. A ripping, snarling con job."

Jan Seymour paused, and continued on, "Two shits from hell I thought. Both of them. Even for foreigners they were very sick, and creepy. These two men were terribly sick. God knows what they had at home? Torture racks? A snake pit in the basement filled with slithering vipers? A backyard full of murdered victims?"

"So I said to them, 'Thank you very much. I think I'll be on my way to Kabul alone.' Why I'd told them I was going to Kabul, I had no idea."

"Next to me the man drew himself up to his full height. In a booming voice he proclaimed. 'That is amazing! We too are going to Kabul! We have just come from a garden party given by the Queen, your Queen, and now we are going home!' "

"I looked at both of them. Both of them. Totally wigged out, off the scale crackpots with a big car. I said to myself, 'My poor trip. That it has to start out this way with two maniacs. Horrible.'"

"Suddenly, the giant driver of this huge car grabbed my suitcase, he wrenched it away from me o and he placed it carefully in the boot of the car."

"The man next to me smiled grandly. ' We offer you safe companionship of the road to Kabul. My companion behind the

driver's wheel is the Interior Minister of Afghanistan. For myself, I am the nephew of the Afghan king, Zahir Shah. I am Muhammed Dara, the Afghan Deputy Minister of Finance, and the Police and Justice Minister! We invite you to our country! We invite you to mysterious Afghanistan!' "

Jane turned to me and laughed in a giddy way, "Both of them were still dressed in these strange court morning coats. I realized they'd actually been *at* Court. This was so absolutely, so very preposterously untoward and strange."

Jane paused and giggled again. "So. The way I got to Afghanistan was inside the most expensive car that's ever been made in Europe. It was the King of Afghanistan's own personal high armored, bulletproof state chariot."

I simply stared at Jane Seymour.

So much for my thoughts about her slow and perilous crossing of the Afghan desert. So much for making one's terrifying way past regions of the Dasht-i-Margo, peopled by the bodies of lost European travelers buried in the sand.

Jane gave me a cool smile in the darkness of the restaurant.

"Neither of them like women, if you know what I mean. Both of them are poofters. On the trip, the prince treated me like I was his mother. They wouldn't let me pay for anything. We ate in the best restaurants. We stayed in first-class hotels. Here I'd been prepared to live with lice, and bed bugs, and food infested with little cockroach legs. Instead, we stayed in palaces."

"This is amazing." What else could I say?

"In Tehran, we were actually the guest of the Shah and his wife Queen Farah Diba, for six weeks. All the bed linens in the Shah's palace came from the George Cinq in Paris. My room had gold door knobs. Silk bed sheets. A solid silver bidet that was cold as hell on my bottom. Think about squatting over a solid silver bidet in the middle of winter in a palace with horribly poor heat. God, I can't tell you the depravations of my trip to Afghanistan!"

Jane positively beamed at me. She folded her two hands over her breasts demurely.

"I love them. They are absolutely wonderful. I came to truly worship these two men." Then, almost passionately at least for an English woman of her upbringing, she added, "We're best friends, even if they are pervs. "

"Do you know where I live in Kabul?" she asked suddenly.

I was afraid to ask. I shook my head.

"This is just a guess but you know, looking at you, I think you look like the kind of person who doesn't even smoke cigarettes. You seem very blocked up and inhibited for someone so young. Did you know that?"

I wondered where these ideas came from. At that moment I feared only what this woman was going to tell me next. Then she did tell me.

"Actually, I live in one of the King of Afghanistan's palaces but that isn't all. I do all the free dope I want. Daily. Hourly. I do

dope day and night. It's wonderful, but I don't think you'd like it, nevertheless I think you ought to learn how to relax more."

I buried my indignation, and I admitted perhaps that I looked young for my age. But as for being blocked up and inhibited, how did I get into this conversation?

As I looked across the table at Jane, I had to say that when you considered that she'd just admitted to being an accomplished dope fiend, she must take awfully good care of herself. I don't think I'd ever met a cleaner, tidier person. She almost glowed with British organizational abilities.

The more I knew about Jane during our short acquaintance, the more it seemed that, by in large, she thought mostly about herself. I decided right then that this was the only real secret of foreign travel. Maybe in Kabul I was totally surrounded by doper narcissists. Did I have to travel all the way to Afghanistan to learn this from a practiced female dope fiend?

When I thought about Jane further, she probably got all the top level Afghan drugs. God alone knew what was in this supercharged stuff? During a single day in Kabul, the drugs that a French heroin addict consumed and shot up would probably kill a village of Frenchmen. I wondered what Jane's dope habit would do. Destroy an entire English city?

I was worn out from my totally misplaced intuitions about both art purchases and the people in Indian Asia . "After Afghanistan where will you go?" I asked cautiously.

Jane looked dreamy for a moment. "You know what I did in London?"

I didn't know. I raised my hands, almost in self-defense, at the battering I was taking in this restaurant. My world seemed moored to delicate, terribly slim underpinnings.

Jane told me what she did in London. "I was a colorless little middle-class professional drone in advertising. Like every unmarried young woman working in London, I had a deeper obligation, however. That was to get married. Then I was supposed to move to a commutable country town with my husband."

"My job would be to produce a dreary dead-end family that consisted exactly of one boy and one girl. No duplicates required. One of each. They'd grow up and after they went away to their public schools, they'd come back for vacations for the rest of my life..."

In the restaurant, I turned from Jane and I watched as a zoned-out European couple rose from their table. Two of the Ahmeds came up and took their arms gently. The couple was so stoned they couldn't find the exit. Almost tenderly, the waiters led them out into the street.

Through the dirty window of the restaurant, I watched them. The couple stood there together gripping each other like they were part of a World War II naval disaster film. They looked like they were on a sinking ship. Somehow, the couple discovered where due east was. They turned and together they began stumbling toward the bazaar. Maybe they were on a spiritual errand, pressed forward by a following wind.

I motioned toward the window and the street outside.

"I know. Believe me, I know," Jane nodded. "It's terrible when you see people who can't handle their wad, isn't it?"

"Wad?" I asked myself.

God this was so heartening. Listening to someone who was British, and who was still tough as nails. Inside each of the insipid Englishmen I met they were all drones. I wondered lately how the British had put together such a huge empire in India. Then you met a person like Jane Seymour, and you saw how absolutely iron hard and brutally tough these people once were.

Jane stared down the street at the couple as they disappeared. "In London one day, I turned up for work, like the good little zombie girl that I was. I was totally fried, and I was terminated for being a dope fiend. That was that. I kissed my future wee children and my suburban lifestyle goodbye. The funny thing was my dope habit saved my life. In my new life after I stepped on my future my own relationship to hash-hish just seemed to grow and grow, like it was some beautiful interesting, invasive garden species."

"So you found paradise here?" I asked.

"Let's go for a walk in the wind and I'll tell you." Jane got up and wrapped her Alpine jacket around herself. She moved through the tables to the door.

Outside the restaurant we tripped over the broken sidewalks. We walked down Chicken Street in a night wind, and each block we walked it became colder.

Next to me, Jane wrapped a strand of long auburn hair around her finger. She was lost in thought at my question.

After three minutes she turned to me. "I've found paradise here, temporarily. Lately I worry, however. The whole scene here depends upon the Afghans, doesn't it? What happens to us, lad, when they get tired of us?"

"I worried about that. I've worried more about Pakistan, and India, and then the whole Middle East when the colonialist constructs of the last centuries blow up."

"Since I now live with two very, very smart Afghans let me tell you something from the inside, dear boy. Inside every Afghan I've met the Afghans, and probably everyone else out here in the neighborhood, seem very pissed off at the European world."

"That's the word from the palace?"

She leaned close to me now. She was wearing attar of rose and she smelled wonderful. "I'm afraid so. These people are getting very tired of us."

Marvelous, I thought.

You tried not to get sick in these terrible restaurants. You slept in hotels that had bed bugs running all over you all night long. You tried to travel to wherever you had to go without being shattered inside some ancient bus was that had been mashed to a pulp at the bottom of a deep mountain gorge. I wondered if living the way I did was worth it, despite all the interesting people I met every day.

I smiled at my former dinner companion. "It's temporarily good until it isn't good. Right?"

Next to me on the street without lights Jane seemed to wrap herself in invisibility. Suddenly, she was barely there.

After two minutes of silence, Jane seemed to gather her thoughts like she'd suddenly stuffed them into her chintz Afghan bag.

She stood there in the wind.

"The problem for me in Kabul is that who the hell knows where any of us are going?" she said as she sighed. "Where in God's name will any of us wind up? I don't know. We'll both follow our own indistinct roads Cheerio, dear boy. Keep the flag flying for us both."

At that moment there was a sudden spring snow flurry. Behind us on the dark street appeared a dark Mercedes. Presumably, it had followed Jane, and it was from the palace.

In the wind, Jane turned, and she walked back up the street toward her chaperone. In the blowing swirling snow, she disappeared. It was very dramatic. It was like we'd never met and this strange biographical conversation never occurred.

It was like I'd hallucinated her.

* * *

I kept to myself. I changed restaurants quite a bit to see if I could avoid the people I knew in Afghanistan.

All in all, however, Afghan food was infinitely better than the food of rural India and Bengal. During my most recent months in Bengal, I'd lived on watery dal populated by tiny inch-sized fish that were mostly bones. The bhat (rice) I ate invariably had rocks in it, put there by rice merchants, making it weigh more in the market.

In Kabul I searched for antiquities. For days I was lost in reveries of Afghanistan's past, populated by the ghosts of previous dynasties. The past became my own private movie I could unspool inside my head whenever I closed my eyes, as I walked through streets sodden with history.

My life now was about collecting art. It helped me greatly that the king of Afghanistan, Zahir Shah, was an avid patron of archaeology and of the Kabul museum. I spent a great deal of time visiting the museum and its collections. On the second floor, I read and re-read the long information panel offering impressionistic explanations of the country's history.

Shortly after the period of the Persian king Cyrus, in the fourth century BC, a Macedonian Greek prince named Alexander conquered the Persian Empire, which included Egypt, Persia and Bactria. In the eight short years of Alexander's conquests, Afghanistan became part of the dominions of a Hellenistic-based culture centered on the Mediterranean.

In succeeding millennia, what is now Afghanistan became part of a series of Indian-based empires stretching from south India to the furthest reaches of the Hindu Kush and beyond, to

Samarkand and the Oxus River. It was in this area that for the next two thousand years there flourished empires which had both strong Indian-Buddhist, then Indian-Muslim connections. Chronologically, these connections dated from the period before Alexander the Great, until the period of the British occupation of India in the eighteenth and nineteenth centuries.

Reading caption blocks in the Kabul Museum was a strange way for a person to learn the history of Afghanistan. Oddly, a history of the country, at least in book form, was not yet available in Afghanistan. In Kabul, the only library was the USIA Library funded by the United States Information Agency. As far as books were concerned, the USIA had tomes about the making of bricks, or on the subjects of clean water and fecal hygiene.

Arrestingly, the library also contained biographies on the lives and struggles of the American presidents. The single bookshop in the country was a market stall in the Kabul bazaar. It sold second-hand, worn-out Agatha Christie novels with fly-specked covers. Apart from this single bazaar stall, there were no English language bookshops in Afghanistan.

One of the curiosities of Kabul during the last year had been that the Afghans were now not permitted to read the magazines in the USIA Library. At one time, the USIA Library was the most popular cultural attraction in Kabul. At first, the USIA librarians were thrilled that the Afghans seemed so interested in information about America.

Only slowly did the librarians realize the real delights which they had brought into the lives of information-starved Afghan men. Week after week, the Afghans appeared at the library to

ogle the half-naked women shown in magazine lingerie or
scantily clad *coutier* ads in fashion magazines.

 Abruptly, the offending magazines were removed from the desk
by the hulking American male librarian, dressed habitually in
his immaculate pale striped seersucker suit. Somehow, in his
suit and behind his desk, this man became the official keeper of
American government smut. As for the members of a nation of
confused, and wicked sex-muddled brutes, attendance at the
library fell off precipitously.

As I made my trips from Kabul to Peshawar, and then back
again to Afghanistan I don't think I ever met a single foreigner
on these journeys. The objects I found in Kabul I took back over
the border to Peshawar, where I shipped them back to the US
through the good works of bent American Air Force sergeants.
The sergeants populated an American airbase outside Peshawar.
Happily, in the early 1960's, America was defending the
bastions of democracy in Pakistan, for all of us in the West.

Each and every time I sent a shipment out of Peshawar I thanked
the American military industrial complex which seemed to reach
its tentacles in odder and odder places in the world. Of all the
parcels I shipped out of the Peshawar American Air Force Base,
I never lost a single shipment. Shipping objects out of Pakistan,
with the aid of my crooked Air Force sergeants, was much
easier than arranging shipments from my small west coast
Indian- Arabian Sea ports. A few weeks after each of my
Peshawar shipments went off, I'd receive a mailgram stating
that each of my parcels, wrapped in stitched white cloth, had
arrived safely in the U.S.

In a very real sense, Afghanistan in 1961 and 1962 was a country that had disappeared from the rest of the world.

 Few people spent much time in the country. Few Westerners e went there. The only books I could discover on Afghanistan's history I eventually found at a bookshop called Ferozsons in Lahore, Pakistan.

In Jalalabad and Kabul, I visited the shops which sold purana chandni, which literally means "old silver." In the bazaars of Kabul and in every Afghan town I passed through I found ancient coins from the country's past. In Afghanistan I could also find examples of fantastic ceramics, metalwork, textiles and impressively wonderful Greco- Buddhist sculptures carved in the grey schist of the Karakoram drainages.

As one traveled through Afghanistan, artifacts and potsherds of previous empires were found along every stream and in every valley between Samarkand and the Ganges.

In Kabul, there were two or three shops that sold antiquities. You'd simply hang around each day for a few minutes, hoping interesting objects appeared. The Pashtuns in these shops were old men. They'd inherited their trade from their father and from their father's fathers before them. In these shops nothing ever cost more than 10 dollars or 750 Afghanis.

For the most part, I bought Buddhist period sculptures, but most of the badly damaged stucco heads of once intact bodhisattvas had been carelessly hacked off Buddhist stupas. By tradition, the tribesmen in the mountains thought that these stucco statues

contained golden treasure, and so the stuccos were decapitated. Occasionally, something truly miraculous would appear, like a perfect, standing, undamaged resplendent Bodhisattva carving in grey schist.

In the last five to seven years, the Pashtun tribes to the southeast of Kabul had also excavated entire Buddhist cities that were a millennia and a half old. They brought their looted treasures into Kabul. The tribesmen would never reveal where they excavated their mutilated stucco heads or their grey schist Buddhist statuary. It seemed to me that, for the tribesmen of Afghanistan, the only entertainments in their wretched lives occurred during those secret moments when they imagined discovering and then pounding to bits gold-filled Buddhist statues. Gold simply danced each day in these people's brains.

On the other side of the border, in Pakistan, there were similar Greco-Buddhist ruins. In Pakistan there were also other tribes similarly intent upon golden loot.

The treasure hunters of Swat and the Taxila Valley, for example, were even more "progressive" in their depredations than the Afghans. During the last few years, the tribes in Pakistan discovered that whole statues were more valuable than decapitated stucco heads that were sold into the antique trade of Peshawar.

* * *

WINTER, DELHI, 1961

Four floors above Connaught Circus in Central Delhi I sat there in the sun drinking tea on the veranda of the Palace Heights Hotel. In the morning sunlight, my whole life just then had a kind of unfathomable, effortlessness clarity to it. I was recovering again from a fever.

The morning air had the sweet, wonderful scent of wood-burning fires. In a million homes surrounding me, women were doing their morning cooking. The smell of wood smoke was the smell of four thousand years of cold north Indian mornings, never to be forgotten.

I seemed to still float a bit. Parts of my body seemed divorced from the rest of me. I wondered if could navigate the stairs. It didn't really do, tumbling down three flights of stairs onto the street.

It was at that moment I had my sudden flash of blinding intuition. The answer came to me for no reason. It was amazing. Had anyone ever had an epiphany eating breakfast in New Delhi on the sunny veranda of the Palace Heights Hotel? For the last two years, I'd wrestled my demons over this problem. The answer suddenly popped into my head.

My epiphany concerned the facts of just how awkward and out of control my Indian art collections had become. For my last seven hundred days, I'd wondered what it was in the Indian art world that you could you collect and was also highly portable. After years of transporting Indian sculptures cross country, after wrestling with sculptures which weighed literal tons and trying

to get them out of the country, my flash of intuition revealed my fascination with Indian sculpture had been dying for a long time.

A 10 foot-tall statue was hugely heavy but what did you do when you found a 15 foot-tall masterpiece weighing 15tons? I was exhausted from the paranoia of discovering buried abandoned masterpieces, then smuggling them across international borders.

I was still young, but I was rapidly growing old in muscle tone if not spirit. As I traveled around southern India, taking pictures of the gopurams and Chola-period temple cities, I'd fallen in love with sculpture. The problem with Indian sculpture, however, was that each object I found seemed to get heavier and heavier.

The second part of my morning revelation was that the weight of an Indian miniature painting from the seventeenth century was measured in ounces, not tons. Sitting there in the sun at 9:04 on a late winter's day at the Palace Heights Hotel, my entire life suddenly snapped into a startling new focus. It felt like Prometheus unbound. Subpart II of my morning epiphany concerned Indian paintings.

I left Mohan, the waiter, a big tip. I went back to my room. Carefully, I locked the door. One could not be too careful. In Delhi, thieves lurked everywhere: in corridors, in bus stations, in vacant, dangerous stairwells.

Crossing the veranda, I looked down at the street below me. A camel carrying a load of stone was being beaten mercilessly with a heavy stick by a small, apparently angry man. The sound of the leather lash flailing the camel carried upward. The camel

didn't complain. It simply collapsed on top of the man and a pile of what looked like stacked bricks fell onto the farmer who'd been beating the hapless camel.

Below me, freed of his load, suddenly the camel groggily rose into a standing position. A small circle of spectators gathered. The camel peered down at the driver. The ryot lay there apparently unconscious or perhaps dead under a pile of bricks. On the sidewalk, at least from my flattened perspective above this tableau, the camel driver was surrounded by a nimbus of low-quality bricks which both buried him and had spread out around him like the halo of Jesus in an Italian quattrocento painting.

The crowd began to disperse. As a new group of pedestrians reached the man lying on the sidewalk, without looking down at him, they detoured around the now flattened body before continuing on their way. There was a kind of awfulness about the camel driver's demise which was so random and casual. One moment he was alive, beating the hell out of his camel, and the next he was dead. The Indians on the sidewalk didn't even look down at the corpse as they moved around him. The dead man was an inconvenience. They simply erased him from their sight.

In the vague sort of way which camels have, the creature had wandered off into the Delhi traffic. A block away, I heard motorists honking crossly. I looked over the balustrade at the street below. Definitely, the man was dead.

Who knew if it was the bricks or the camel itself that had crushed the ryot? In India, the end of a man's life is so public. One morning you were alive; in the afternoon you were burnt in

the communal cremation ground. In a brief moment, a life was reduced to a puff of smoke.

In India, I'd developed an indelible caution. To the balance, always and forever, in India you lived at the edge of an unexpected extinction.

* * *

In the bright morning light, I walked several miles out of Connaught Circus in the center of New Delhi, to the tombs at Nizamuddin. Nizamuddin was one of the oldest Muslim enclaves in Delhi. It had narrow streets which wound up and down a set of low hills. In sheltered courtyards were the ancient tombs of members of the Mughal royal family. In other shaded courtyards were the tombs of saints.

I walked a half mile to the east and climbed up a steep flight of stairs upward into the tomb of the Mughal emperor, Humayun. Descending the same steep stairs I had just climbed, the emperor Humayun heard the call to prayer. By force of habit, heeding the calls of prayer five times a day for decades, the emperor bent forward. He then pitched headlong down the steep stone stairs. So perished the second Mughal Emperor of India from a broken neck.

From Humayun's tomb, I walked more miles back the way I'd come. In Old Delhi, on the Chandi Chowk, the main market street of ancient Delhi, I stopped for tea in an alleyway. Hidden in a partially darkened restaurant, I watched the Chandni Chowk with its milling crowds of thousands and tens of thousands of people. The throngs outside passed down what was once the

grandest street of imperial Muslim India. What a place to lose yourself or the demons which chased you in India.

I'd walked most of the day. I was still seized by my grand idea of collecting Rajput painting.

As I sat there in the alleyway chai shop, I thought about my future in India. I didn't need huge amounts of money to live in India but I had to have enough money to keep going. I thought about the art that I'd been buying in India. I thought about my interminable journeys around India, visiting the greatest pilgrimage and archeological sites on the subcontinent.

Watching the crowds on the Chandni Chowk, I again decided that I'd try to buy the greatest Rajput pictures I could find in India.

Few people in India then pursued or purchased Rajasthani pictures from the courts of the Rajput princes during the period 1600 to 1800. At this moment there wasn't a large market for Rajasthani paintings. It was too crude, it was thought to be too poorly formed and too poorly thought out. Most collectors now chased not very good, run-down or worn-out Moghul pictures from the grand imperial period, 1580-1700. The paintings of Rajasthan seemed to occupy some unexplored middle ground which no one was yet interested in. To most classical Indian painting collectors, Rajasthani pictures were riven with flaws, and therein lay a great collecting opportunity. My rule of thumb about buying art was that one buys art that most people haven't yet appreciated, and caught up with.

In the whole accumulated literature on Indian painting, which I'd first researched in the Royal Asiatic Society, in Calcutta

there were few books on the Rajput clans with the exception of the work of Colonel James Tod who had written a history of the Rajput's in the 1820s. Colonel Tod and his work remained an unreferenced diamond mine for any twentieth-century art collector of Rajput art. In my brand new collecting agenda, to the balance at this point, I probably knew more about the Rajput's and their schools of art than any other European in India.

In the afternoon, the restaurant began to be penetrated by the cold. I had more tea. I wrapped myself in the plain woolen shawl that I'd bought passing through the Chandni Chowk. My thoughts were about Rajput painting. When I thought about Indian painting a bit more in my half-darkened tea shop the work of the Rajput painters was possibly the most unappreciated art on the subcontinent.

When I thought about this a bit more out there in the gloom of a princely treasure room were possibly generations of Indian paintings. They waited to be discovered. Some wayward soul needed to save them from being devoured by the white ants. When you came across a forlorn Ragamala set in a maharaja's storage warehouse, called a godown, Rajput paintings had a must odor of heat-rotted paper and folic acid that was produced by white ants. When you discovered the occasional example of a Rajput miniature painting in the antique shops of Delhi or Bombay, you could first smell them.

They had the odor of abandonment.

* * *

BOMBAY, 1961

The shop was behind the Taj Mahal Hotel in the Colaba section of Bombay. I could never find a street name to locate where A.K. Essaji & Sons was on a map. In Colaba, I always stayed at the Rex Hotel behind the Taj. If I walked two blocks down the street from the Rex Hotel Essaji's shop was on the left.

Essaji was sitting on a chair outside his shop, he drank pink lemonade out of a rubber - stoppered bottle. Deliberately, Essaji leaned forwards and he looked down the street toward the shop of my least favorite dealers in Bombay, the shop of the Popli brothers. Down the street, his competitors the Popli brothers were nowhere in sight.

"Salaam barra, sahib!" Essaji rose and he waved at me. Essaji's greeting was his mordant little joke. It was an Indian greeting used on an Englishman, of an obsequiousness that the British still demanded of Indians in Bombay.

I remembered a saccharine pamphlet put out by the British military forces in Bombay during World War II.

It read: "Welcome to Bombay. Bombay's citizens are very anxious to ensure that you enjoy yourselves, so that when you move on you will have the happiest memories of their city."

"Things to Avoid: Exposure of your head to sun before 4 P.M. Eating overripe fruit or fruits not protected by skin. Drinking water from a street fountain. Walking barefooted. At all cost, avoid drinking intoxicating drinks during the day, especially spirits or soft drinks from rubber-stoppered bottles."

"BEWARE and avoid patronizing beggars, mendicants, fortune tellers and curio dealers."

Essaji gestured with his hand. From inside the shop, as if from nowhere, a chair was produced by his servant.

I glanced up then down the narrow street. None of the buildings on this street had been painted or repaired for years. The dinginess and apparent poverty of this section of Colaba was a sort of tax camouflage. Actually, the merchants on this street in Colaba were quite wealthy. In the new democratic India, people disguised their wealth from the tax man by owning dingy cars, wearing frayed clothing, and never painting the buildings they owned.

Foreigners tut-tutted about the poverty of the Indians, yet, for the merchant classes of Bombay were much richer than the English, who'd been broken after paying for two World Wars in the first half of the 20th century.

Another of the spiteful communal ironies of Bombay was that fifteen years after the British granted India independence, the local Englishmen still didn't allow Indians into their private Members ONLY Breach Candy Swimming Club.

A cup of tea was produced from inside Essaji's shop. Across the street, one of the Popli brothers came out of his shop. An overweight, chunky creature, he glowered at me and muttered to himself. Hurriedly, he disappeared back into his shop. With a huge crash, the steel shutters of the Popli brothers' shop crashed down onto the concrete sidewalk.

"Ah, you see!" Essaji laughed. "The Poplis are still angry with you!"

I was, evidently, that most traitorous of foreign human specimens. I'd proven to be a treacherous, unfaithful customer. Essaji looked across the street at his competitor's shop and he smiled beatifically.

"How are you, Essaji?"

"Good sometimes. Bad at other moments. I'm content, however. And you? How are you dear friend? Did you get all your money from the Poplis, or did they manage to cheat you again? I simply could never believe any of the objects you used to buy from them."

I sipped at my massively sweetened milk tea. There was more sugar in Essaji's cups of tea than three or four Cokes.

"I got my money. Finally. I'd never deal with those badmash again."

There were no secrets in the antiquities trade. The antiquities trade in Bombay had developed lately into a kind of silent, undeclared war amongst the dealers. What I loved about the antiquities trade in India was that everyone thirsted to know each other's business. They lived for gup, a word filled with an absolute sort of malice, that translated loosely into the words "local gossip."

"I'm in trouble Essaji," I said. "I keep running away from the inconvenient truths."

"Which are?"

"I get cheated each time I buy anything in Pakistan. My last shipment of second-century Gandharan art arrived in America from Peshawar. Instead of the sculptures I'd bought, the crate was full of rocks."

"I vow I'll never deal with a Pakistani dealer again." I then thought about my epiphany about collecting and buying Indian paintings.

"I wanted to ask you something about Rajasthani paintings," I asked suddenly.

For a long moment, Essaji looked sideways at me. His flint-black eyes glistened with intelligence and humor. I'd always felt that Essaji was an anomaly in the art trade world of India. He was the sole of discretion and it was rumored, by way of others in the trade, that he had the best Indian paintings in India. If he felt inclined to offer them. In our relationship, I thought Essaji liked me because I was his only American client and because he admired the film actress Rita Hayworth.

Essaji was an Ismaili Muslim. The head of the Ismaili sect was the Aga Khan. The Aga was a human mountain of enormous weight, and fat who appeared infrequently in Bombay to be weighed by his flock: first in gold counterweights, then in diamond counterweights. In their large quantities the Aga then donated his weighings to local Ismaili charities and hospitals. Prince Aly Khan, the Aga's playboy son, had married Rita Hayworth. Hence Essaji's curiosity about Americans.

I looked up at the sky between two incredibly dirty buildings both of which Essaji owned, then I asked Essaji, "If you could think about this for a moment. Which are your favorite schools of Rajput painting?"

Ever puckish, Essaji countered. "Why don't you ask your friends the Poplis about their favorite Rajput paintings?"

"I asked you because I don't think the Poplis even know such a thing as a Rajput painting exists."

For a moment, Essaji was lost in thought. He sighed.

"Sir. I warn you no one is much interested in Indian painting except in Mughal painting. At that, customers don't want any old Mughal painting. They only want the paintings of the inner circle of the imperial Mughal court. The Emperor. His sons. Etc, etc. My father began selling Mughal paintings in 1905. He was the earliest dealer in India to sell Mughal art. In 1915 he began to try selling Rajput paintings. I fear we have tried selling this art for 45 years with only small success."

I took that in and asked, "I was thinking of Mewari painting, then the paintings of the Rajput courts of Kishangarh, Kotah, and Bundi. Of course there are wonderful, lovely Pahari hill paintings of the Himalayan kingdom's, but Pahari paintings don't seem as strong to me as Rajasthan paintings."

Essaji looked at me for a long moment. "I don't think you've left out much on your list of Indian painting schools."

"Do you have any of these paintings made for the Rajput princes in stock?"

"Do I have Rajasthani paintings?" Essaji repeated. He appeared to think about this.

"A week ago in Delhi, I had an inspiration: that I had to speak to you about Rajasthan. Do you have paintings of the Rajasthani schools?"

"Did you know that the Poplis have their agents scouring the lower Himalayan kingdoms for Pahari paintings?" Essaji answered.

After giving my question some more thought, Essaji continued with his misgivings about Pahari hill paintings, "No one has ever gone up there to look for art except the Poplis. Could either of the Poplis know anything about art, or whether any art whatsoever was produced in all those little northern mountain kingdoms in the shadow of the Himalaya. Basohli, Kangra, Manali and even Kulu."

"Couldn't one be surprised about Pahari hill painting?"

Essaji considered the question then waved it away.

"They are too contrived, sir. They seldom stray from the grand epics of Hinduism. These paintings always appear in sets of 144 paintings in the Gita Govinda or the Baramasa of Keshavdas. In most of the Pahari paintings, the texts of the Hindu epics were always favorites. The Hindu hill rajas simply swooned and became all wet over depictions of love in the form of Krishna and Radha. These paintings are like indigestible Indian sweets."

Essaji stood suddenly. He waved me in front of him. "Come, I shall show you some grand Rajput paintings."

In the dim light that spilled in from the street, the shop was perhaps 60 feet deep and 20 feet wide. I followed him.

Halfway down the width of the shop was a 20 foot-long, glass-topped display case inside which antiquarian objects were displayed. I noticed a particularly fine Tanjore eleventh-century bronze under the glass. Next to the bronze was a court painting of the high Mughal imperial period of the mid-seventeenth century. It depicted an epic battle in progress. There were finely drawn elephants, huge cannon spitting fire, and a cavalry charge. Overseeing the battle, upon a hill, there was the great Mughal himself, either Jahangir or Shah Jahan.

I bent closer to the painting. The emperor was mounted in the howdah of a huge war elephant. The elephant was girthed by thick, quarter-inch steel armor. It was a truly extravagant beast. I wondered if elephants that big had ever actually existed.

The painting was a masterpiece. On the other side of the glass case, Essaji leaned toward the painting. In the gloom, he stood there looking down.

"Do you think that foreigners will ever understand Indian art?" he whispered. His voice was sad. "I pray they do."

"Generally, Indians are almost insensate to their own art. They have absolutely no appreciation of how grand our art in India once was. It is a scandal, sir, and a national tragedy. They are complete fools and philistines."

The servant brought us both new steaming cups of tea. He set them on the glass case. I sipped the sugary-sweet, boiling hot liquid.

Essaji looked up and he sighed. "I've offered every Indian collector I know art from the Gupta period. These sculptures are possibly the greatest art ever produced in this country. They date from the sixth century. They are 1,500 years old. They are in absolute perfect condition."

Essaji paused, then continued his lament, "From the Tanjore, during a period in the tenth century, below us in this other case is simply the finest Chola bronze I've ever seen. It's a mere 500 hundred of your dollars. I have the best south Indian bronzes in the world, but in Bombay, Indian collectors gather art that is rubbish. They stay away from my shop because of my prices. Dear sir, what to do? My countrymen avoid the greatest articles of Indian art in droves, sir. "

Over the last two years, I'd seen this strange contradictory style of collecting develop divided between west and east. The problem with Indian art wasn't that there was a lack of collectors, because, by now, most foreigners in India collected Indian curios and sometimes Indian art. It was becoming the chic thing to do in the expat communities of India.

The problem was that there were very few Indian collectors, and what could any of the Indian antiquities dealers like Essaji do to change this? Soldier onwards, I supposed. You could only sell to clients who came through the door then made a purchase.

"Do you have any Kishangarh paintings, Essaji?" I asked the question quietly.

For a long time the dealer looked at me, then he decided something.
From below the glass-topped cabinet, Essaji withdrew a three-foot-square black portfolio. Carefully, he undid the string ties which bound the portfolio. He took out the first painting in the portfolio.

"How could I not buy this when I first saw it?" he asked.

In front of me was one of the most electric and magnificent Indian paintings I'd ever seen. It was the picture of a Rajput maharaja with a golden halo behind him. Rays emanated from his head as he greeted his queen. Below him, and off to the side, the queen sat on an orange velvet-looking couch. The queen was staring beyond the raja at a huge blue-green lake that made up much of the background of the painting.

In the background, the sky was blue-black and it was lit by flashes of lightning over the lake. Beyond the lake was a city of palaces. The city stretched toward the horizon. The picture was simply stunning. It was remarkable.

"Kishangarh?" I asked.

Essaji nodded, slowly.

"Would you think . . . someday . . . that you might sell this?"

The picture stopped your breath it was so magnificent. I was overcome by a collector's lust for this picture.

234 · Clark Worswick

"This is the finest Kishangarh painting I've ever seen. No one knows from what source it came. I was afraid you'd ask this. They are very hard to find. They simply appear," Essaji said.

It would be a kind of sacrilege and a betrayal of our acquaintance to ask the price. It was Essaji's picture to keep or to sell.

"Since you are the first customer of the day . . . actually, you are my first customer this week, and I've been here two days already . . . for you, I will make the price of this picture . . . $350, in American currency."

I looked at Essaji for perhaps 10 seconds. He had set the price unbelievably high so the picture would not be sold, at least to me or anyone I knew. I could live in India for four and a half months on this much money. "Done," I said.

"Are you sure you have $350?" Essaji's voice was full of worry. The worry was then replaced by shock. "Done?" he repeated in dismay.

I pulled out a wallet of travelers checks. I tore off three $100 checks and a $50. Across the shop counter, Essaji looked devastated. Whoever it was who said Indian dealers lived only for money was wrong. Essaji looked stricken.

The checks were unsigned and didn't bear anyone's signature. It made them totally negotiable. With very bad humor, Essaji studied the checks. Essaji's hands were shaking with barely suppressed emotion. He slipped my checks into his shirt pocket, and with his index finger shoved his painting toward me.

Essaji didn't look at me when he said, "I think I will close my shop and take complete rest. Mohan will wrap up your painting. I am very tired. I must take total rest, sir. Goodbye."

With that, Essaji disappeared out the front door of his shop. Outside the shop, Essaji angrily shouted directions at his servant inside the shop. From behind a curtain in the shop, his assistant appeared. Almost in slow motion, he wrapped up my new painting in cheap brown paper. Next, the parcel was tied up with flimsy jute string. Mohan the servant handed the painting over the counter to me.

This was very curious. I'd never witnessed an Indian dealer who was attached to any object whatsoever that he'd sold.

Behind me, the steel shutters of the shop crashed down onto the sidewalk, and as I made my way up the street back toward the Rex Hotel, I whistled tunelessly. I thought about the painting I'd just bought for much too much money. It was the finest Rajasthani painting I'd ever seen. Five minutes later, as I climbed the stairs of the hotel to the sixth floor and my room, I thought how very strange it was what you could learn if you simply asked the correct questions. What I'd learned first that day was that great Kishangarh paintings were out there, somewhere.

Next what I'd discovered was that they were being sold by a person or persons unknown. Whom were they? That was the only question.

* * *

NORTH INDIA, 1961

I reached my room at the Rex Hotel.

I unlocked the door then passed through the room towards the balcony with its view of the ocean. Looking at the ocean, I thought about my immediate future. I had to go to Rajasthan. But first I had to check a few more bits and pieces. I thought back to Junagadh.

At the Auto Club of India bungalow on Malabar Hill I'd met a cousin of the Maharaja of Junagadh. The man had said anytime I was near Junagadh, he'd have the doors to the maharaja's treasure house thrown open to me. By this unlikely route, I'd first gotten into a maharaja's treasure house.

The town of Junagadh is in Saurashtra, near the borders of Pakistan and India. It was not easy to get to. Two days after I arrived in Junagadh, through the introductions from the cousin of the Maharaja, I entered the Maharaja's treasure house.

In the heat, I looked around the godown. I peered into the deep shadows at the broken palace furniture which, a century before, had been abandoned here. In the gloom and dust, there were abandoned elephant howdahs. There was a gigantic seventeenth-century Persian carpet of colossal dimensions, which once were used for princely durbars. Once priceless, it was now eaten away by the white ants, a ruin of one of the most magnificent carpets in the world.

In the great heat of summer, when temperatures sometimes reached 125 degrees, the remains of seven gilded princely

coaches, imported from Europe, had collapsed into heat-shattered heaps.

In a recessed room was a pile of huge, brass-covered wooden Katiwhar treasure boxes. Now abandoned, they'd held the kingdom's treasure, but it appeared they'd been smashed apart by hammers.

Everything in the prince's godown was in ruins.

In the greatest heat of the afternoon, I found an abandoned closet full of Indian paintings. The paintings had been done in the late seventeenth century. They had been created by some unknown genius, both in great animation, and great detail. Princes and courtesans danced across the surface of these paintings, but, below a topping of pigeon shit, each of the paintings had a coating of damp and mold. I was a century and a half too late.

In Junagadh, I walked out of the restaurant at dusk into the surging crowds of the street. In the last heat of day, I decided there had to be other palace treasure houses left by the Maharajas. I had to find more princely collections. But how?

Night came and Junagadh shrank down to isolated pools of light populated by indefinable, shifting shapes traveling through the darkness. I wondered at that moment if there was such a thing as fate. The paintings I'd found that day, ruined as they were, appeared to me like a vision of my own future.

* * *

Two months later in Delhi I climbed into a third-class rail carriage of the Down Bombay Mail. From inside the vastly crowded compartment, I watched the slums of Delhi slip by. A half hour later we were in the desert. The city disappeared. I reached up and swung myself upwards into the luggage rack above me. I spread out my cotton dhurri. I needed to sleep.

In the 100 degree heat of the compartment, I felt one of my fevers coming back. I thought back to Junagadh and to the maharaja's treasure house. I'd thought about these abandoned princely godowns for the last 60 days. Out there, somewhere, were seldom entered buildings filled with treasure.

In the heat of the now speeding train, my mind ratcheted over and over as the engine sped down sections of track. In my now growing fevered delirium, I made a list of the known dealers on the whole subcontinent who dealt with Indian painting. The list was very short: A.K.Essaji & Sons, Bombay; C.L. Nowlakha, Calcutta; Ram Gopal Vijaivargia, Jaipur.

I thought of the Indian Arts Palace, Connaught Place, Delhi, and a dealer named Bharani. I disliked both Bharani and the Indian Arts Palace people. When I'd first gone into their shop they'd ignored me. And so from 1959 onwards, I'd ignored them.

In the heat somewhere beyond Delhi, and now racked by fever, I passed out. The last thought I had, as blackness closed over me, was that in Bombay, the Popli brothers weren't on my list.

* * *

NOTEBOOK 4

1962

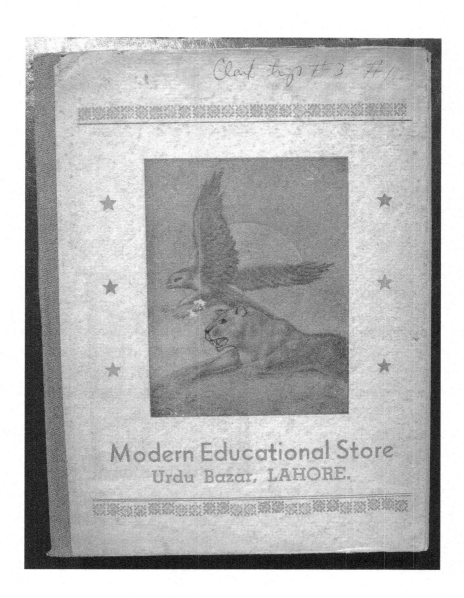

KABUL, 1962

Beyond the restaurant, it was another day threatening snow.

I pulled my sheepskin-lined jacket off, and waved to one of waiters for chai. An even greater cold had descended on Kabul.

Ten minutes later, in a gust of ice cold air Jane Seymour entered the restaurant She looked around. She saw me, and I pointed to a chair against the wall opposite my side of the table.

"Is it becoming a habit? Meeting like this in dirty restaurants?" I rose gallantly.

Jane laughed. "You look very peaked and cold and underfed."

She took off her coat and sat down. In the faded light of the half-dark restaurant, as usual she looked gorgeous.

Jane had adopted the de rigueur European fashion of the Afghan street. As she'd come into the restaurant, she'd been wearing a thick, richly embroidered coat of black and gold. Her vest was of a splendid purple damask pulled up tightly over her breasts to her throat. Today, she had pulled her hair back and you could see her long neck.

I hadn't actually seen a European woman for weeks. The Afghan women of Kabul, when one saw them at all on the street, dressed in a sort of fabric sack which covered their bodies from head to toe. Inside these terrible sacks, the Afghan women peered at the world through a single, index card-sized, lattice-work mesh in the front part of their burkas. In the years I'd been

in and out of Afghanistan, I'd never heard a burka-clad traditional Afghan woman speak or laugh.

With long, delicate fingers, Jane reached into her vest and withdrew a packet of Players cigarettes. She shook out a fag and offered me one. I shook my head. Jane lit up. She inhaled deeply, then exhaled languidly.

The waiter appeared with a kind of thin, gruesome soup. He put it next to my chicken. There was a large grease spot, like a Rorschach object, floating on top of the soup.

I reached for the stale, board-hard naan and broke off a huge piece. I offered it to Jane. She shook her head. I began to east as Jane took a sip of tea.

"I suppose you think you're unique and vulnerable and well-traveled. Is that it?" Jane asked suddenly.

I looked at her. Never try and start a conversation with lone women in the East.

Jane was going to ask me something else, but she didn't.

"At last, I've found someone who thinks I'm vulnerable." I laughed. "The last two people who thought I was vulnerable were two German SS soldiers who turned into successful gold smugglers when they got to India."

Jane reached in her purse, taking out a bill which she dropped on the table. "For both of us. I'll call a taxi, because I don't want to eat here anymore."

242 · Clark Worswick

Jane smiled brightly at me. In the dimness of the restaurant, she looked very fragile and out of place. In the semi-darkness, she gave me a faraway look, then Jane stood abruptly.

I stared up at her trying not to be angry. "There are only three or four places firangi go in Kabul. The bazaar. Two restaurants. Then, the United States Information Agency Library to read month-old newspapers. It's nice to see you again, Jane."

She turned and left without speaking, not even saying goodbye. I wondered what in hell I'd done to her. Perhaps I'd dented her *wa*, as the Burmese called their hard-won inner spiritual peace.

"Shit and shit again. Desolation," I said to myself. "What is it with this otherworldly creature? Hot and cold. No god damned reason. Except way, way too much dope."

* * *

It had been a year and half since I gave up the idea of smuggling black market Indian rupees back into India. Yet, here again, I was in Kabul.

I needed Indian rupees to buy art in India. I didn't see any way around this. I had to return to Kabul to transmute dollars into Indian rupees.

The jails in Delhi these days were populated by the citizens of virtually every nationality of Europe. In India the government was waging a full-fledged war against illegal money exchange. The jails also held currency smugglers from most of the newly liberated, post-colonial African countries, from South America

and every country in the Middle East. In the summer the currency violators broiled slowly in the heat. During the winter inside these Indian jails, one ran the risk of either freezing or expiring of starvation after a meal of rice and a single chapatti which had been rolled in the dirt.

As I stood outside the restaurant, Kabul appeared out of the snowstorm in front of me. A moment later Jane appeared with a taxi.

Through the icy rear window, with a wave of her hand she gestured toward the backseat of the taxi next to her. In a sudden gust of snow, I bent against the wind and I ran down the street towards the taxi. I slipped inside. Was this a détente in the new part of our relationship?

There was very little room in the back seat, as the taxi was filled with cloth bags full of Jane's recent purchases. In Kabul apparently the single place Jane visited regularly was the central bazaar, where she could buy yet more clothes. This evening, out of her jacket, she was more lustrous and better dressed than I'd ever seen her. She looked, as usual, dazzling. I thought about this. In Asia during the last two centuries, Englishwomen had had the unpleasant experience of living in difficult to lethal places with fashion the least of their worries. How did anyone manage to look this good during a winter snowstorm in Kabul? Jane seemed to be making up for two centuries of lost fashion appearances.

Jane motioned to the driver. The engine started. I looked over at her. She never used cosmetics. She had pale, perfect skin. Around her neck was a silver necklace of the Mughal period, set with silver mohur coins from the seventeenth century.

Jane's black silk cheongsam dress was set off with red Chinese dragons, while her thick, chestnut hair was covered by an embroidered black and yellow Persian princess' headdress.

I thought about how Jane always managed to appear beautiful and eerily composed. Maybe women should never use cosmetics or even try to keep their weight down. Perhaps every morning, like Jane, women should simply wake up and smoke a quarter of a kilo of well-cured hashish before breakfast.

"I thought you were leaving for India?" Jane asked. Women dope addicts seemed to blow hot and cold in manic mood swings. Jane, with her concern about my wellbeing, I supposed was now blowing hot.

Conversation with Jane was like falling abruptly into a river. There was never much of a preamble to her conversations like "How are you?" or "Isn't the weather beautiful?"

"Bugs," I said touching my lower stomach. For the last few months I'd been plagued by worrisome intestinal problems. For the last week I'd been sick. Again.

Jane reached out a cool hand and placed it on my forehead. "You're better now aren't you?" She studied my face.

I nodded. I'd always dreaded getting dysentery and I worried that I might have it now. My English tutor at Santiniketan University had had dysentery. He'd had it for years. His name was David McCutcheon. Each night during an attack, he sweated through his mattress. Drugs could not shake it. The drugs that then currently existed couldn't mitigate this terrible

thing, which was literally devouring poor David McCutcheon alive.

Jane produced a long Czech scarf which she wound around her headdress like a kind of turban. She held her hands, palms up. I smiled. She looked fantastic.

"You look ravishing." I answered.

The taxi stopped. "Come with me," she said.

Jane grabbed my arm and began pulling me out of the taxi. When I was extricated, she reached back. Through the door, she handed the driver an Afghani currency note.

I grabbed a handful of bags, at least the ones she hadn't taken with her when she'd exited the cab. I followed her down the street into the storm toward another street, then around the corner.

At the end of this next street was the largest car possibly in all of Kabul. It was the highly polished black Mercedes 300d sedan. As we approached, a uniformed chauffeur left a shop and he hurriedly opened the door of the car.

Jane giggled as the chauffeur bowed to her. She tugged at my arm as she dragged me toward the car. "I forgot to tell you. Selim was sending a car for me, before we get to the difficult part of our journey."

Jane slid into the back seat of the huge car first and then waved me inside.

The car looked absolutely new. It was an unbelievable automobile. It was the first time I'd actually seen a 300d Mercedes Sedan. For the rest of the world this car was simply a rumor. Perhaps this was the largest car in the entire Middle East. It was the car in which Jane had traveled from Europe to Kabul. To think when I first met Jane, I'd thought she was a serial exaggerator who's stories had been warped by too much cold and certainly way too much dope.

The Mercedes started with a throaty roar. I ran my hand over the carefully worked walnut burr of the interior coachwork. I settled back into the lushly padded red leather seats.

As the car moved forward through the crowds in central Kabul, it was almost impossible to hear the engine as we moved up streets which became increasingly narrow. For twenty minutes we climbed upward toward the old Bala Hissar fortress.

Through the windshield, the snow was coming down more heavily now. Above us, the old fortress of the Durrani rulers dominated the skyline of Kabul where so much intrigue and death had awaited too many members of the royal family.

We made a turn and we moved upward into streets I'd never seen. There were only a few houses as we entered a section of the city where, perched high above the city, every house was surrounded by huge fortress-like walls. In the weak light of evening the passage ahead became a single long corridor lined by easily fortified walls.

At the center of the last, and largest, wall I'd ever seen in Kabul, the street dead-ended at a closed gate.

As we waited, slowly the heavy gate was pulled open by two Afghan soldiers in uniform. The huge car moved past a saluting uniformed lieutenant of the Royal Guards into the grounds of the palace.

I was thinking just then that Jane seemed a particularly literal person. I reflected that I'd never actually met a truthful dope addict before. It was a completely new experience. Jane had said she lived in a palace.

The car pulled to a stop under a porte-cochere. Beyond the driveway leading up to the palace was a huge garden, decorated with the trelliswork of now frozen vines and long-deserted rock-covered paths.

The building in front of me looked like it had been dropped from the sky, then magically levitated. Somehow this building had been materialized on the side of a barren mountain under the glowering scarp of an Afghan medieval fortress. Below the garden was a blasted desert landscape and far, far below was Kabul. Looking down at the city from this great height, Kabul was like a city of miniature building blocks, haphazardly strewn about .

Out of the palace rushed three liveried servants who hurried toward the huge car to fetch Jane's bags from the Kabul bazaar. In a sisterly way, Jane patted my back.

I turned. At the front of the palace stood a man. He didn't move, and he stood there staring at me.

Before Jane disappeared into the palace behind the servants, she turned to me, "Dear boy. Drinks at seven. Dinner is at eight. Dara will get you a room and some clothes. Ta ta."

The man moved towards me. Dara was immense. He had hands the size of serving platters. In front of me, he completely blocked the roadway. The huge man's voice actually rumbled, "Miss Seymour says that we are to treat you well. We've put you up in the guest suite used for visiting royalty. I hope that suits you."

Dara towered over me. "Perfect," I said.

The thing that was most striking about Dara was his perfect resemblance to a gigantic version of one of Alexander the Great's Macedonian legionnaires. This massive man could have been part of the army which had conquered the known world exactly 2300 years before. He had absolutely perfect, classical Greek features. He looked like a Macedonian commander in Alexander's legions. The hairs stood straight up along my arms.

I had not yet made the transition to this place. I was still covered by dirt and my clothes were rumpled from too much travel.

Dara was easily three times my size. He gave me a slight hint of a smile. Then, in a clipped Roya Military Academy British upper-class accent he asked, "Do you have your luggage with you?"

I shook my head.

"Well then, I suggest, old man," Dara suggested brightly. "That you simply buck up and claim the moment as your own.

With this strange message, the huge man confided suddenly, "We think planning Jane's life is impossible, and she is quite beyond calculation. We think that this is the very best part of her. She is possessed by an absolutely untypical British charm. Don't you think?"

With real doubt, I nodded.

Dara led the way toward a set of huge metal-bound double doors. The doors looked like they had been built to impede an attack of howitzer fire. They appeared to have been snatched out of one of the Third Reich's last redoubts, or even possibly out of one of Hitler's personal Austrian mountain fortresses at the end of World War II. That fit. The Afghans loved Germans. The Germans had trained the Afghan army in the 1930's.

We turned down dark corridors. We climbed a darker staircase as I padded along after the giant.

The palace itself looked like it had been built at sometime in the nineteenth century. It was finished in dark woods with heavy, overstuffed Victorian furniture that filled every room we passed. In an elevator, one of those caged affairs you used to see in older French hotels, we moved toward the third floor.

Beyond the elevator on the third floor two servants waited in blinding white livery. They wore huge Afghan turbans. Passing the servants wordlessly in procession, we moved down another long corridor in lockstep, like a miniature military formation.

At the end of this third floor passage was open door. Dara stood aside. He waved me into the room beyond. "Drinks at seven. Make yourself at home. Toodle-oo."

The immense man disappeared soundlessly, and I moved into the suite alone. I hadn't yet caught up with the fact that I was actually here, in a palace. It was all terribly odd. I wondered for the first time why I was here.

Around me, the suite looked like it had been stripped out of the Hotel Ritz in Paris during the 1890's, and then, like the palace itself, it had been sent into exile as a museum exhibit on the side of an Afghan mountain.

Beyond one of the doors leading off from the suite was another door. Beyond that door was a high-Victorian-style bathroom, constructed of white marble. At the sink, I washed my face then my hands. The porcelain caps on the taps in the bathroom read "froid" and "chaud." The suite contained six spacious rooms: there were two bedrooms, a sitting room, a dressing room, a formal living room and the bathroom.

I went through the suite for perhaps five minutes, studying the details carefully. I came to the conclusion that this whole palace must have been crated up in Paris, then shipped by sea through the Suez Canal to Karachi, the nearest port to Kabul. It had then traveled upcountry by train a thousand miles, to the end of the railway at Peshawar. By camel load up and across the Khyber Pass, it had probably been transported into Afghanistan. After a few hundred miles of narrow rock defiles, and the high Afghan desert, it had come to rest on this mountainside above Kabul.

In the dressing room, they had left me a set of my own freshly laundered clothes that, in my disoriented state, somehow fit me exactly. Finally, in a state of amazement and exhaustion, I took a nap in my new bed. As I fell asleep, I had the thought that each of the rooms in the palace came from a period which had disappeared everywhere in the world before the advent of motor cars.

A Kabuli palace was certainly a nicer place to live than my bug-infested hotel. I looked at my watch. It was 4:30 on a short dark winter's afternoon on one of oddest days in my life.

* * *

An hour and a half later, a hand shook my shoulder. Looking up groggily, I saw one of the servants dressed in blinding white. I wondered if I was dreaming, as I looked up around the room.

A quarter of an hour later, I finished soaking in a gigantic black marble tub with brass legs. I dried myself with what seemed a three-quarter-inch thick Ritz Hotel towel. Dressed in my new clothes, I made my way back down the corridor the way we'd come.

As I descended to the second floor I remembered that once I'd attempted to count the rooms in an Indian palace. I think I gave up at 277. I'd thought at the time that the number of rooms in any given Indian palace was an affectation of a prince who'd built a palace. I'd realized only later that the people who owned such palaces probably never even knew how many rooms there were in their own buildings. They were like children lost in a trackless forest.

Finally, I descended a last long formal staircase and reached the first floor. In the distance, Jane was waving me towards the library where we were going to have drinks with Prince Selim in a country which discouraged drinking alcohol.

Prince Selim had a pencil-thin moustache. He was immaculately turned out in a tailored Savile Row suit. He was of medium height and in his mid-thirties. The prince looked ethereal, he was so good looking.

"Prince Selim begs you to sit, sir."

Next to the Prince, the enormous Dara introduced us. He waved me toward a high-backed Queen Anne chair opposite a sofa.

Prince Selim spoke in a rapid burst of Pashtun. Dara smiled. "Prince Selim asks what you would like to drink?"

It seemed, in the library, as if from a great distance, the prince was studying me. Around us, prints of British hunting scenes were stacked three deep, as they climbed up the walls in expensive golden frames. Priceless Persian carpets covered the floor.

I asked, "It is probably very boorish to ask, but I'd die for a beer."

"And would that be German beer? British? Or, would you like a Urquell Pilsner from Plzn, Czech, which you seem to favor?" Prince Selim asked. Like Dara his voice had a clipped, Sandhurst trained British officer's intonation.

"I'd choose Urquell. Thank you. My god, I've forgotten what it tastes like."

At a sideboard Dara poured out two half full glasses of single malt scotch. What else would one suppose that people like this drank in Afghanistan except the most expensive scotch in the world?

Dara moved out of the room and returned with a cold Urquell pilsner on a tray. I simply couldn't fault their background research on my life and tastes could I? In the cozy library, we sat back and went to work on our drinks.

By the time dinner was ready, both the Afghans and Jane were well lit, after three double scotches each. My god. Even that was impressive, the way this group held their liquor. The prince explained that he was a doctor with a medical degree from Heidelberg.

However, somewhere in the progressively jolly conversation, he announced that he was also a spy and the minister in charge of the Interior Ministry.

I knew only too well in eastern countries that the Interior Minister supervised both the police and spies. The prince and Dara got up and then went off to search for a book the prince wanted to show me.

Jane stared at the door leading out of the library. She turned back to me. "Dear boy, as far as I can determine, Selim is the chief of everything important in this country. The king has

absolute trust in Prince Selim. The king, Zahir Shah, is Prince Selim's uncle. I think, by the way Prince Selim quite likes you. Not to worry though about the way he likes you."

I absorbed this information nervously. At the very best, this was all very strange.

The prince returned with his book. It was bound in very aged, red morocco. It was folio size perhaps 18 inches wide and vertically 24 inches high.

I rose. Prince Selim held the volume out to me.

Carrying the book over to one of the tables lining the left side of the room, under a large hanging art nouveau lamp, I opened what appeared to be an illuminated manuscript.

As I turned the pages, I saw page after page of most carefully worked paintings. I leaned closer. Staring down at the paintings, I saw that they appeared to be Mughal court paintings executed in the beginning to the middle of the seventeenth century.

I turned the pages more slowly. I moved back to the beginning of the volume at the rear of the book. Upon second look, it occurred to me that this was a Jahangiri period manuscript done in the imperial atelier at Agra. To be precise, it had been done in the decade of the 1620s. I took a deep breath.

The prince watched me. "It is a Shahnama," he said. "The Book of Kings", written by the Persian poet Firdausi, who spent thirty-five years, or all his youth, composing the Shahnama.

Firdausi completed his epic work in AD 1010 of your calendar. The Shahnama begins with the creation of the world. It ends with the conquest of Persia by the Arabs in the AD 633-641 period. In its entirety, the Shahnama contains sixty thousand lines of one of the greatest epic poems ever written."

I felt profusely thankful for my curiosity about India. I thanked my inquisitiveness about all things in Indian art history relating to the last five hundred years. I silently thanked the moments I'd spent in reading rooms of British libraries and the Asiatic Societies of London, Calcutta and Bombay. Strangely, on my first visit to Calcutta, I'd become fascinated by one of the Queen of England's greatest treasures, which I'd discovered in an article I'd read in the Asiatic Society Library.

I therefore knew the history of the Shahnama in front of me.

In Windsor Castle, the queen's manuscript was very much like the manuscript in front of me. The queen's manuscript was produced in 1648 for the Mughal emperor Shah Jahan, and it was Shah Jahan who built the Taj Mahal. The queen's manuscript was created in the imperial painting ateliers of Agra. It was called the Padshanama, and it was considered by expert opinion to be the next to greatest manuscript in Mughal Indian painting.

The greatest Mughal manuscript to exist, or rumored to exist, was a Shahnama very much like the manuscript in front of me.

After looking at the paintings in Prince Selim's Shahnama, I observed that the paintings in this manuscript were executed perhaps 15 to 20 years earlier than those in the Windsor Castle

manuscript. The prince's volume appeared to have had been painted during the reign of Shah Jahan's father, the emperor Jahangir.

In my research, the lost manuscript of Emperor Jahangir was referenced with something close to blind reverence. It was illustrated by court artists in the *atelier* of the Emperor.

Repeatedly, it was spoken of as the greatest manuscript of the Mughal period. In one of the last articles that appeared in The Transactions of the Royal Asiatic Society (London), it was referred to as "the great missing Shahnama of Jahangir." Yet, so splendid was this manuscript that, centuries after it had disappeared, it was still thought of as the holy grail of imperial Mughal court painting.

The prince looked at me for a long moment. "I've heard from my spies in the Kabul marketplace, and others in Bombay and in Peshawar, that you're interested in antiquities and paintings. For someone so young, my informants tell me you are quite knowledgeable about Mughal period paintings. Could you hazard a guess as to when and where this copy of the Shahnama was made?"

A cold chill ran down my back.

Dealers in Bombay? In Peshawar? Spies of the Afghans?

The problem with Asia was that when governments took an interest in your activities, their interests were long term and tended toward the encyclopedic. Carefully, I set down the manuscript. I considered the prince's question like I was walking across quicksand.

The prince moved across the room toward me and his deep-set eyes watched me carefully. "And?"

I didn't answer.

"My spies are very reliable group. They are actually full of admiration about your knowledge. Come, come. Don't be shy about your talents."

I took a deep breath. I began tentatively, "By rumor this manuscript, was begun in 1622. It was finished by perhaps 1628. It was executed under the close personal observation of Jahangir, the fourth emperor of the Mughal emperors to rule Hindustan."

"From the style of the paintings, it appears that it was rendered by a court master. Jahangir's Persian-trained painters came to India from the Persian Imperial Court in the late 1590's. Thereafter, the greatest of these painters changed the whole course of Indian art. "

The prince was silent for a very long ten seconds. There seemed to be something like uncertainty in his eyes or perhaps it was surprise.

"And so? If you could, please tell me. Who owned this manuscript and where it has been?" the prince asked slowly.

"In 1739 the manuscript became the loot of war. In that year, the Persian king, Nadir Shah, sacked Delhi, and transported treasure of India to Persia. No one has seen a trace of this manuscript since the looting of Delhi in 1739. Like the great

Koh-i-Noor diamond, once owned by the Mughal Emperor, I think the manuscript went traveling as well. "

"Someone so very young," the Prince said. "Amazing. I've wanted to meet you. In Peshawar, were you successful buying art from the Pakistanis?"

Thinking about this question I wouldn't say it was unlucky. I'd been totally mauled in my impossible dealings with the Pakistanis.

"The Pakistani has no izzat whatsoever. They are mongrel Indians," the Price said. "You're lucky you didn't wind up dead in a ditch dealing, and being murdered by art in Peshawar."

The prince stared at me in absolute silence.

I ventured. "Returning to the paintings in Padshanama made for the Mughal Emperor Jahangir, after the Persian king Nadir Shah was murdered himself, they must have come into the possession of the Afghan kings. Where it still remains until this moment.,"

"Someone so very young. Amazing," the Prince said with awe .

I tried to get the Pakistani's out of my mind. My acquaintance with these monsters were my greatest failure as an art smuggler, and art collector.

"You're lucky you didn't wind up dead in a ditch dealing with art dealers in Peshawar. They have no izzat whatsoever." The Prince waved his hand. "Come we will have dinner."

Prince Selim rose and he led the way toward the an ornate dining room snatched out of 1890 Paris. With the wine and with this marvelous company I began to get a feeling of hazy wellbeing. As we ate I lost count of the number of courses.

After dinner, we moved back toward the library and Jane threaded her arm through mine. The two Afghans walked ahead of us.

"I think Prince Selim likes you. A lovely sign around here," Jane observed.

As we walked toward the library, I watched the two Afghans. The more I saw of them the more they behaved with each other like an elderly couple who'd been married for decades. Dara started a sentence and then Prince Selim would complete the paragraph. There was an easy kind of gentleness between these two men I'd never seen in India or Afghanistan.

In the library, we had more to drink. When we left the library after eleven, the prince gripped my arm then gave me a hearty British public-school-like whack on the back. "Delightful evening. Positively delightful. We must have this sort of dinner again soon. Certainly."

I'd had much too much to drink. Jane again linked her arm through mine, as the two men moved off into the darkness of the huge palace.

The building seemed an unending maze. Somewhere along the way, Jane departed for her rooms with a chaste peck on my cheek. With too many unintended detours, I finally found my suite on the third floor of the palace.

Sometime during the evening, I'd switched to single malt whisky. A terrible mistake. A wretched, terrible mistake. In my room, I sank down into a horsehair mattress on the huge bed. I had alcoholic, if surreal, visions of this mattress being carried over the Khyber Pass by an unending chain of camels. I passed out and descended downwards into a spiraling, spinning chute of oblivion.

* * *

BREAKFAST AT THE PALACE, KABUL, 1962

The next day held a vivid fresh new Kabuli sunrise. Across the room, Dara was piling food onto his plate from a sideboard. Across the table opposite Prince Selim Jane sat there watching me.

Prince Selim was smiling. "So, my guest how are you?" the prince asked brightly.

"I'm just splendidly tip-top," I managed, somehow.

I felt absolutely dreadful from all the single malt scotch of the night before. The cold flat winter light streamed through huge French windows..

"If you could, tell us where you've been in our splendid country," the prince asked. He looked up at me over his long, perfect nose. "Or are you just a visitor to Kabul who comes for a bit of a full stop here?"

There was malice in his voice this morning. Definitely, it was malice. I'd come lately to think that underneath their considerable charm, the rulers of Afghanistan had a natural predatory place in the scheme of politics. They were remorseless homicidals from another simpler age. Behind his charm, Prince Selim was showing his fangs. But then I'd realized beneath the charm of all Afghans, they seemed filled with an unknowable rancor.

Evidently the prince was not ready to abandon our conversation. "In our strange and wonderful country, where have you been besides Kabul?"

Jane leaned across the table. She looked stunning today. All of her drugs must have been good for her complexion. She was giving Prince Selim a long, steady look.

My head felt about to crack. I wasn't up to an interrogation before breakfast with the head of all the spies in this country.

With immense difficulty, I smiled.

"Lately, I've been in quarantine. I was in Persia, in Zahedan. There was an Indian cholera epidemic spreading westward, so I spent two weeks in Persian quarantine. Somehow they expected you to feed yourself, even though you couldn't get out of quarantine to buy anything to eat. For 10 days in quarantine there was nothing to eat except stale naan, and dal bhat. The breakfast looks wonderful." I pointed down at the buffet spread out across the sideboard.

I surveyed silver toast racks, silver pots of two different kinds of tea, with a third pot of what smelled like coffee. I filled my plate with food. The only thing missing was bacon, which was totally forbidden, heretical and haram in Afghanistan, because it was pork.

"So . . . How did you get to Kabul?" the Price asked.

Trying mightily to be chirpy and bright, I continued onwards, narrating my travels. "On my trip to Iran I got a ride from

Zahedan to Herat on a lorry. From Herat I went to Mazar. Then went to Bamiyan and, finally, I returned to Kabul."

"It seems you've been all over our difficult country. And this means you did all these journeys in Afghanistan riding on top of cargo lorry? My god." The prince sighed, "Someday in my country, in the far distant and bright future, I promise we will have regular bus services."

The switch here, apparently had been made by the prince from hostility to kindness. I'd noticed over the years that people in Kabul veered violently from a position of kindness to passions of absolute hostility for reasons I never knew.

Across the room Dara loomed over his end of the table even though he was sitting. He leaned his huge bulk toward me. "Tell us our new friend . . . what do you think of our country?"

With my art buying and my Indian currency smuggling, I was spending definitely too much of my time on the edges of the law. These types of questions were not promising, particularly with two men who represented the Afghan Interior Ministry and Afghan Police. I had a hazy memory of a very strange evening the night before.

"I spend much of my time in Kabul looking at Afghan art in your museum." I assiduously avoided the question of what I thought of Afghanistan. I was ambivalent about Afghanistan, and this morning, starting breakfast, I was in a even fouler mood as I thought of trying to change money at horrible rates in the bazaar.

At the table I took a bite of egg. I slathered a piece of toast with butter. Then I gave my toast a coat of the best orange marmalade in the world, produced by James Keller & Sons, Dundee, Scotland.

The Prince watched me. His dark eyes were hard and intolerant. "If you could tell both of us we wonder why exactly you are in Kabul?"

Three bites of breakfast and it was crunch time. Just then my head actually felt like it could be unscrewed.

"Additionally we'd like to know where are you going after Kabul?" Prince Selim asked.

Where did I want to go? Anywhere but here, and first I wanted to escape this conversation.

"I'm going to south India to start with. Then, I want to see the ruins of the late Muslim kingdoms of Golconda, Bijapur and Seringapatam…"

The prince sighed heavily. He turned to Jane, he clapped his hands and asked in a sudden manic way, "Why don't we all go together? A happy trip to India! A trip to Southern India to see historic remains of the once great Indian Muslim kingdoms. Forgotten by everyone, the last great Islamic kingdoms in the world. Why didn't we think of this Dara?"

Jane smiled brightly. Dara smiled.

Deliberately, the prince put down his cup of coffee. Again, he was suddenly serious, "You've explained your travels. Now

please explain to us what you are actually doing here young man. No one comes to Kabul in the winter. I'm sure you've noticed it's very cold and there are very few foreigners here."

I didn't answer immediately.

In the distance, beyond the breakfast room, was the ticking of a huge grandfather clock. We were high above the Kabul Valley. Up here, there was not a vestige of shelter from the wind, nor could I find again any shelter from Prince Selim's question. Beyond the windows it had begun to snow, and I was again thinking furiously.

Out of verbal subterfuges, I tried honesty. "The reason I'm in Kabul is quite practical. I buy Indian art, and I've come to Kabul to change money. In the bazaar I can get 40% more changing my dollars into Indian rupees than I can in Bombay. That means I have 40% more to buy my Indian art in India."

"Ah . . . now we see . . . the dreadful admission of a crime! The crime of importing Indian rupees into India, which violates a number of Indian laws doesn't it."

I took one last deep breath. "I collect art just like you do. There's a huge difference between dealers and collectors," I protested.

Across the table, the giant Dara was staring at Prince Selim. The huge man then gave his opinion for the first time.

"Remember, Selim, the peculiar behavior our spies reported in Peshawar? In Peshawar, he went through hundreds of Gandharan pieces in six separate dealers' shops in order to find

a single sculpture that he wanted to buy. No dealer or even collector I know of is that careful buying art."

I looked over at Jane. I was now working on a horrible headache. Jane had brought me here, and now she wasn't even interested, apparently, that over breakfast she'd thrown me to the wolves. I imagined myself in the sub-basement of an Afghan jail, looking at possibly years in an Afghan prison.

The only way I'd salvage this terrible conversation was to throw myself completely on these two men's probably non-existent mercy.

Right then, Jane was worse than useless. She was staring off into middle distance, as if she wasn't connected to anything happening here.

"Is changing Indian money illegal in Kabul?" I asked. "There are no local Afghan victims of my crimes, are there?"

"What you're doing in Afghanistan is very dangerous," the prince said in a prissy way. He reached up a delicately manicured hand. He smoothed his hair carefully.

Dara's stood up from the table to his full height. He was handsome, Greek god handsome and he towered over me.. Gone were any feelings of doubt about my crime, apparently.

"You have certainly, by your own admission, engaged in suspect currency exchange. You admit that. Yes?"

"The Indians have protested to us about illicit currency

exchanges in our bazaar, and about foreigners like you operating out of our country. Soon I imagine you will be digging up Afghan cultural treasures as well! Allah! Such a badmash, Selim."

The prince leaned across the table. He looked up at the Dara man and he nodded.

"So young," the Prince said heavily. "I think we've found ourselves a master criminal in training Dara. Such a pity."

The huge man pointed a massive finger toward me, the thickness of a pool cue.

"In the Finance and Interior Police Ministries, we possess thick dossiers of your activities passed on to us by the Indian CID. They know you. We have expert knowledge of people like yourself!"

I wanted to crawl under the table and hide. Absolutely horrible. Oh, God. Horrendous!

The huge man, however, seemed to be simply warming to his subject. "I think . . . a few years would do it, don't you Selim? Perhaps five years, or even ten years in jail will slow him down. That would send a message to his firangi cousins, who might be tempted to make Kabul a center of international art smuggling and crimes of finance. Yes?"

I was sheet white. I was about to disappear from the world for a decade. In the past few minutes, my palace breakfast had definitely turned into a disaster of unimaginable proportions.

"We've known about you all along, you see," the prince confided. He leaned over towards me and almost whispered now.

"What we don't quite understand yet is how you proposed to make your escape from Kabul to Peshawar? In Peshawar, what will you do? And if you reach Pakistan, they are all thieves. They suck crime in with their very birth milk. In your depredations here, you certainly must have had Pakistani partners, yes?"

I was sweating. I didn't answer.

"And please, add this to your indictments, if you will," Dara said to me.

Both of the two men were silent as they watched me. Finally, the Prince offered an opinion about his neighbors.

"You are a total fool to trust any Pakistani. When the Pakistani is learning to crawl, he is also learning to be a thief. Could a Pakistani ever live even one day as an honest man? That is their izzat. I've seen this in Hyderabad, Peshawar, in Lahore, and Karachi. You saw this in Peshawar. After the British left they became an entire nation of thieves."

As I studied both of them in an absolute cold sweat, some reason, I thought back to my own boarding school. I thought back to the outrageous pranks, and the pummeling's school boys gave other boys. Life in a boarding school was about respect and learning to stand up for yourself. A light suddenly switched on inside my head. You never gave in. Ever. And where had both

of these men gone to boarding school? Probably, Harrow.

This interrogation, coming out of apparently nowhere, seemed like a sudden ambush, a tribal tactic in which the Afghans excelled. But I had the thought that it seemed too terribly bent even for an Afghan. Here I was accused of being a master criminal over breakfast.

If they were anything at all, the Afghans were insane upon— they were absolutely demented upon the point of respecting a guest's honor. Were both Prince Selim and Dara simply overgrown school boys executing some terrible prank out of boredom?

Then, both the prince and Dara hooted with laughter. They almost screeched with laughter, so delighted were they with their provocation.

"Izzat . . . he knows about izzat and honor! I told you so," the prince said pointing to Dara.

They pounded the breakfast table. They threw their heads back crowing with laughter like this was the most amusing and clever thing they'd ever done. The tears were running down their cheeks.

Dara wiped the tears from his eyes. "Just look at him. I thought for a moment we'd scared him to death! He was terrified, I tell you! My God, did we jump him! But what spirit! Allah, what spirit! Anything for a joke though. To the balance, Selim, he certainly needs our help in Kabul, doesn't he?"

I smiled bravely.

Right then, I learned you never wanted to be on the receiving end of either an Afghan joke or Afghan rage. Right then, I felt nothing but barely contained anger at this unprovoked, heartless stunt. For themselves, they looked like very naughty boys who'd just gotten a special treat.

The prince turned toward Dara. "Absolutely. He needs our help desperately."

The prince wagged a finger at me in warning. "I think that you are remarkably fortunate, my young American friend, and you should thank Allah you met us. In changing money the bazaar wallahs will cheat you unmercifully."

I nodded slowly. I wasn't thinking about the bazaar wallahs. I was thinking about an Afghan prison full of spiders, poisonous insects and ten years in the dark of agony.

Jane was totally unraveled by their weird humor. She looked at both of them with alarm.

Then like the proper British woman she observed, "Oh, dear God! Selim, and Dara. Both of you are so absolutely heartlessly tedious, aren't you? "

Tedious? God damned cruel, heartless, and merciless. Horrible wasn't even a word to cover this - I was thinking.

* * *

That morning I rode in the back of his Mercedes with Dara and Prince Selim. They had to attend a tribal jirga, a meeting of the tribal elders.

As Dara explained in the car, during a tribal jirga, everyone sat around drinking interminable cups of sweet tea. Everyone smiled at each other, and the jirga they had to attend that morning had been called to deal with a high-level tribal murder in the mountains near Ghazni.

The jirga was held in the Ministry of Internal Affairs building which was a colonial-style building with wide arcades from the 1920's. Dara explained first that blood money would have to be paid to the family of the murdered man. The prince and Dara first would drink tea with the heads of the aggrieved tribes.

I supposed the next vendetta always had to start with a clean slate. No long lasting result was ever resolved by these jirga's. A month or two later, the murders, and assassinations and revenge killings would begin. Another jirga would be called to address the new homicides. I thought perhaps all these jirga's were something like Central Asian bon voyage parties.

We dropped the prince and Dara off at their meeting place. It appeared neither Dara nor Prince Selim considered taking any chances with their fellow countrymen. The moment Dara and Prince Selim stepped out of the Mercedes, they were greeted by armed bodyguards equipped with Soviet made AK-47 machine guns with folding metal stocks.

The prince leaned into the car and invited both Jane and me to the ministry the next day for a meeting. We both nodded.

I needed to sleep for a whole day and night to recover from my breakfast conversation. I was dropped off at my dingy hotel. As I lay in my bed, listening to the wind outside my room on the third floor, I decided that the only thing the Afghans did in a first-class way was murder one another.

My recent contacts with the Afghan sense of humor didn't make me any happier, either. In my ratty hotel, I slept 16 hours.

* * *

KABUL, THE FINANCE MINISTRY, 1962

One approached the building cautiously down a long, deserted, snow-swept street. Behind me the wind howled and it almost tipped me over.

The clerk guided me down the third-floor corridor of the Finance Ministry to Dara's office. On a long couch Jane sat there . She was dressed in her usual fashion-plate assembly of local clothing in optimistic scarlet and yellows. She wore damask Ali Baba pants.

"When are you leaving?" Jane asked abruptly. From her bag she extracted an oval tin of Players cigarettes and put one to her lips.

"A day. Two days."

I dreaded my exit from Kabul. I dreaded my trip back across the Khyber Pass in the cold. Afghan trucks had a way of breaking down in the cold.

In the semi-darkness of the room Jane lit up and took a deep lungful of smoke. "Now I'll be all alone in my palace won't I? Dara and Selim are always busy with work. You can't stay on?"

It was the first time she'd ever admitted human feelings like loneliness. At that moment, the prince and Dara both materialized in the darkness. Both of them looked angry. Across the cavernous room, Dara fell into a chair behind the desk. He placed his hands on top of his head and stared at the

ceiling trying to calm down. The prince settled on a second sofa directly across from Jane.

The Prince himself was incandescently angry. "Simply murdering all of them would be by far the simplest solution to my problem meeting with these hellish jirga's. Savages. I don't even think any of them even know yet how to tell the time."

Prince Selim leaned forward and put his hands deliberately upon his knees lost in thought.

A servant padded silently into the room. In the semi-darkness, he poured out four cups of tea. Silently, he placed each of the cups before us. Wraithlike, he withdrew as silently as he'd appeared.

Jane passed her tin of Players cigarettes to Prince Selim, than Dara. she first, to the prince and then to Dara. From a lighter tucked into the recesses of his cloak Dara lit all three of them up. Soon the darkness of the room had a purplish cast of thick cigarette smoke.

"Do you know what a hundi is"? the prince asked me, quite suddenly.

I didn't know if a hundi was a person, or a species of local rumor? I shook my head.

"Allah . . . I can't believe this," the prince was suddenly exasperated. Things didn't seem to be going at all well for him this morning.

I had the feeling this conversation was out of out of control and it hadn't even yet started.

"You've actually never heard of a hundi. A bill of exchange? Don't they teach you anything about finance in America? Truly tell me again that you don't know what a hundi is?"

The prince waved at Dara through the smoke. "Dara. Tell him a brief history of a hundi.."

"A hundi is a single-use monetary instrument," Dara began. "You can cash it only once. Across international borders payment is made in a your country of choice, by brokers of a transfer network called hawaladars."

Outside the windows, the world was blotted out in a carpet of freezing white ice.

"I don't understand," I said.

"Let us say in Kabul, in the bazaar," Dara continued. "You approach an exchange merchant, a hawaladar. In India the official rate of Indian Rupees to the dollar is 4.50 per dollar. In the Kabul bazaar, however, the world free market for rupees is 9.16 to the dollar. The question is: 'How do I take my free market rupees from the Kabul bazaar, and circumvent the Indian foreign exchange rules, and receiving my free market rate rupees in Bombay?'"

"In the Kabul bazaar you pay a small commission for the services of a hawaladar . Then Jack Snap! No messy messiness with governments, or the inconvenience of tedious currency

controls. You collect your money via Kabul hawaladar agent in Bombay ! Voila!"

 Dara rubbed his massive hands together in delight.

The prince smiled, and then he added, "In our system of money transfer, the hawaladar operates completely beyond the jackals of the judicial world. The whole transaction takes place as a matter of izzat ... of honor!"

 "But the most unique aspect of the hundi is that the only trace of your transaction is a disguised record of the amount one hawaladar broker owes to another. You give this to the hawaladar contact in Bombay. Presto! Free market rupees!"

Amazing. Here I was with the Minister of Justice of an entire nation, who was sitting with his chief deputy in his Justice Ministry, with both of them hatching bank frauds.

As I thought about this, in the hawala system money simply wafted across borders like smoke. This money was impossible to trace.

Jane smiled. The prince smiled. Dara smiled.

Such a marvelous place. Asia. Just imagine the future.

* * *

BOMBAY, 1962

After the impenetrable cold of Kabul it was warm in Bombay. At the end of a narrow street with sickly diseased-looking buildings was the carefully studied, purposely derelict looking shop of the faux-poor Popli brothers.

The Poplis' shop was a block from the ocean, and behind the Taj Mahal Hotel in Colaba. As I moved down the narrow street I thought of that first Popli, the unnamed progenitor of all the Poplis.

Was he fleeing his debts? Was he chasing a quiet dream of palm trees and golden-colored full-breasted maidens? Did he come to India perhaps in order to spawn?

The Poplis claimed descent from a long line of Greek traders. Had the first Popli arrived in India 500 or 600 hundred years before, when this coast was 100 foot wide strip of sand amongst ill-sorted, low-lying malarial islands.

Inside his shop, the last descendant of the Popli dynasty was sleeping on a dirty, bare marble floor. At my feet, Popli was suddenly afflicted by nervous palsy and he began to shake in his sleep. He seemed unconscious. He started panting like some overweight species of dog. In his sleep, he made whimpering noises, while his feet made bicycle-like, erratic pedaling motions, as if he was being chased by his creditors or his clients.

Popli had put on a large amount of weight since his brother had died last year.

I nudged Popli with my foot.

 The man on the floor opened his eyes. He stared up at me without saying anything for a moment. I confess that once I'd had a brief, but bitter, altercation over money with Popli. It was a moment of bile in our relationship.

Without moving, Popli lay on the floor looking up at me and he finally spoke. "You are my least favorite customer. Go away."

Our problem had risen over the purchase of a group of small bronze statues that I'd bought. In a fit of kindness, Popli had insisted that he wrap up my new little fifteenth-century bronzes with the helpful suggestion that once wrapped up the bronzes would be easier to carry back to my hotel.

My specially wrapped parcel appeared. It was a huge ball of newsprint wrapped around and around with string. It looked like the servant had wrapped a human head in the ball.

"Just a little quick peek. Simply can't restrain myself, Mr. Popli." I began to unwrap my parcel as I was about to depart his shop . A look of alarm had appeared on Popli's face. Popli's complexion shifted from dark brown to battleship grey.

When my purchase appeared from its wrappings my statues looked like they'd just been run over by a municipal Bombay double-decker bus. My lovely bronzes had been reduced to tiny amputated legs. Mangled torsos. Little squashed heads.

"Mr. Popli. Oh, dear. What's happened?" I exclaimed. "An untimely munition's explosion at the back of your shop?"

The argument that ensued was brief and angry. Reluctantly, like he was giving up one of his own arms, Popli gave me back my money.

On the floor underneath me, Popli closed his eyes. It was an unpromising beginning to the renaissance of our relationship. Popli appeared to be asleep, or perhaps he'd lapsed into unconsciousness.

I bent over and, close to Popli's hairy ear, in my most theatrical whispered voice, I said, "I would like 54 statues of Christ."

Popli's eyes flew open. They started out of his head. I'd never noticed it before, but Popli had golden eyes, just like a Pekinese dog.

"You want 54 statues of the holy Christ?" he repeated.

"Precisely, I want 54 statues of the holy Christ. Exactly! Guaranteed upon delivery upon of this message, and I've just delivered the message!"

Popli was galvanized into action. Abruptly, this international finance criminal jumped up.

"Sir. This will be very difficult... but I will try from my very best being, sir. Even remembering our last very sad-making commercial exchange. YES! YES!! You can be rest assured, sir! Popli is on the job. Popli is trying very fast for you ... even though I am feeling fairly stagnant seeing you."

Without another word Popli bolted out of his shop and I watched as he ran down the street barefoot. He had remarkable speed for such a fat man. Stagnant?

A block away, he disappeared into another art shop. Doubtless it was a shop of another of his financial criminal accomplices. All these people were related to one another. Colaba was full of these "Greeks" who claimed a remnant Greek ancestry. Each of them had his own hand in his cousins' pockets.

In Popli's absence, I considered that perhaps being "Greek" was merely a social upgrade from having been previously an Anglo-Indian, or a Goanese, on the western Indian social scale. When the British left India, everyone seemed to move up one notch on the Indian social scale.

I heard distant shouting from the shop into which Mr. Popli had disappeared. Was this a positive sign?

After a brief 10 minutes, Popli padded back up the narrow street clutching a thick, dirty chintz bag to his bulging stomach. Somehow, Popli and his fellow currency exchange criminals had rustled up 54,000 rupees. Breathing hard, Popli moved into his shop clutching at his cloth bag as if his life depended on the contents. Waving me back toward the darkest back part of his shop, Popli produced three 12 inch stacks of 100 rupee notes out his bag.

I began to count the first stack. Popli's face glistened with sweat. "Please, sir. This is highly illegal. You must hurry."

I looked up and continued counting. In the back of his dimly lit shop, Popli watched me count. The humidity was absolutely

oppressive. Popli's eyes never left the piles. After 12 minutes, there were 54 piles of one-hundred-rupee notes. I then counted each pile a second time.

I nodded. "Marvelous."

Popli held the chintz bag out toward me and I placed the notes inside. In a conversational way, I told Mr. Popli that I loved Bombay because the people here were so personable and lively. I left the mystery of my hawaladar connections unanswered.

My business with this awful man finished by means of a half-hour long circuitous route, trying to loose anyone following me, I returned to the Rex Hotel. No sense getting it on the head by one of Popli's criminal relatives.

On my circuitous journey, I stopped off at the American Express Company and checked my mail.

When I returned to my tiny, sixth-floor room at the Rex Hotel I closed the door. My room was level with the tops of the palm trees outside my window. Light streamed into the room. As the sweet scent of the sea wafted over me I.

I decided that night I'd go to Gourdon's, the best restaurant in western India. I thought of Monsieur Gourdon's excellent sauces. Just the thing, a wonderful French meal created from western Indian lobster at my favorite restaurant in Bombay.

At Gourdon's that night, I had the best meal I'd eaten in a year.

* * *

TRAVELS, 1962

Two and a half years after I'd given up studenthood, I still had my Indian university railway discount ID voucher. I'd come to be a devotee, and then a fanatic user booster of Indian third class railway journeys. I loved them. They were the greatest travel bargain on earth and they opened up a whole sub continent that few Europeans knew, or had ever traveled.

By means of my generous Indian student train ticket scheme, a thousand-mile, continent crossing trip from Bombay to Calcutta, which lasted 54 hours, cost less than $. 55 in Indian rupees for a third class railway ticket.

My first journey in an Indian third class train compartment, with 30 to 40 other travelers stuffed into a 20 foot by 25 foot space on very long journeys, taught me about *rishwat dena.*

I learned that if one arrived early at any Indian railway station, however, with something called *rishwat dena* placed discreetly in the hands of a railway attendant, one could obtain near perfect, early arrival third-class accommodations.

In practical terms, this meant that by means of a bribe, you first occupied a previously locked 3rd class compartment. Then, you took up your own private sleeping accommodations above the ungodly multitudes, on one of the public overhead luggage racks, which ringed every 3rd class compartment.

Before the train left Victoria Station in Bombay, I took Arturo Barea's unbelievable book *The Forging of a Rebel* from my bag.

It was a gigantic volume that, in fact, contained three separate books. It was a thousand-page book for a very long journey.

For comfort on the luggage rack, I put my down filled Korean War period mummy bag. A railway attendant lubricated with *rishwat dena* opened the compartment door, and pushing and crowding my fellow passengers arrived.

As the train began to slowly move out of Victoria Station Bombay began to slip by. I was young and in a foreign country. I was surrounded by the chaos of 490 million Indian souls each living out an unfathomable story of secrets, evasions and dreams.

In central India, a day into my journey, the train ran over a herd of goats. Out of nowhere, chai sellers appeared as the little, inert goat bodies were cleared away from the track. Somehow, in the middle of a desert, with not a single habitation for 20 miles in either direction, tea sellers had appeared. I was always amazed by these ever entrepreneurial country vendors. How long did it take to brew up a pot of hot tea in the middle of nowhere? How did these chai sellers suddenly develop this impromptu commerce? I wondered if they had an inexhaustible supply of goats, with which they waylaid passenger train traffic.

Fifty-four hours after the Howrah Express left Bombay, the train pulled into Calcutta.

Groggy from war and revolution, dispirited by the Spanish Republican defeat, or reveling in the mysteries of espionage, I was satiated by 54 hours of reading. I staggered into the chaos of Howrah Station, down the long station platform. After bargaining with three different rickshaw touts, I managed to find

284 · Clark Worswick

a reasonably priced rickshaw that would take a foreigner to the Red Shield Hostel, on Sudder Street across the river.

Calcutta was cold. A rain squall suddenly enveloped the city. As the rickshaw moved toward the east side of the river, the coolie reached back and, still running, pulled a black canopy over the front of his rickshaw. Inside my rickshaw I viewed Calcutta through an eight inch milky window, through the eyes of an ancient man with cataracts.

The unnatural gait of the rickshaw man created a kind of floating sensation. It was as if I'd been wafted into eastern India on smoke, while outside the rickshaw, Calcutta was a place of soft pastels and muted colors.

We circled trams and passed cars marooned in traffic. We turned off Chowringhee at the India Museum in a hot despondent rain that fell in sheets now.

At the Red Shield Hostel, a long block down Sudder Street, I got out of the rickshaw. I stretched out my cramps. I paid the poor rickshaw man three times what my agreed price had been. The man smiled beatifically. I asked where the rickshaw man came from. He answered Bihar. He had an absolutely lovely smile. Bihar was one of the poorest places in India.

The rickshaw coolie told me the rains had failed in his village for the third year running. He had no choice but to come to Calcutta to try and feed his family. Lucky the rickshaw wallah who made it back to his village alive. On the streets of Calcutta generally rickshaw coolies lasted five years before they died of

TB. Their existence was a terrible lottery that these poor men gambled with their lives as their only asset.

<div align="center">***</div>

Lugging the rucksack I now used on my travels, I trudged from the street into the courtyard of the Red Shield Hostel. In the foyer of the hostel was a desk which had been set up to block the entrance From under her white nurse's cap, a sour-faced, middle-aged matron stood there staring at me. She folded her thick, bulging white arms across her chest barring my way.

Clearly, from our past acquaintance, I was not high on her list of people she liked.

"You are back?" she sniffed. It wasn't a question, however. It was more like an accusation of my continued, unfortunate survival in India.

"Can I get my usual room?" I asked this starched monster.

"You need a room?" the matron asked, as if this was a complete surprise to her.

"I think I'd like my room at the back of the hostel, away from the monkeys."

I was dizzy. My head spun. When I thought about it, I hadn't eaten many good meals lately.

"We usually require a reservation. But now we also still require certificates of good character. Introductions. A deposit. Can you produce a deposit?"

To the disgust of the matron, I took out a fistful of rupees and placed them on the desk.

I smiled. I hoped it was a happy smile. I hope my smile communicated that I appreciated how difficult it must be for all the Red Shield people. Out here they were surrounded by hundreds of millions of heathens, so bravely they carried the flag of Christ into an unforgiving darkness.

With her rimless glasses and her thin, beady face marked with heat splotches, the matron studied me carefully.

Perhaps she was seeking signs of debauch, or alcoholism. Perhaps she sought clues of devious or repulsive sexual orientations. These days in Calcutta, without the steadying hand of the British, anything was possible.

"You're not sick, are you, with some repulsive leaking disease, or a plague-like waterborne disease, which Calcutta is rife with in this season." Her voice was seeded with suspicion.

The matron's eyes drifted down to my rupees. Perhaps she remembered I'd been a guest of the Red Shield Hostel on and off for the last three years. More likely, she needed a paying guest in a month that was most likely barren of traveling missionaries.

I picked up my rucksack to leave. This was getting tiresome. I knew another hotel, five blocks away beyond Park Street. Of all these people who labored in the distant Bengali vineyards of Christ, this creature was the absolute worst of them.

"I do have a room," the matron said hastily.

 Then she added in a chirpy, optimistic voice, "We can't take care of sick people though. As per usual you must not allow loose women of the street, nor pets into your domicile at the Red Shield Hostel. How long do you require?"

"A week. Two weeks." I was exhausted by my train trip. I was worn out by this absolutely rancid insincerity.

The matron adjusted her terrible little cap. Primly, she added the admonition, "As a final word, I might mention, young sir that if I catch you drinking spirits in your room, we'll simply throw you right out on your ear into the street. Without your earnest money."

Suitably chastened by all this Christian charity, I took my passport and then my Indian residence permit from my rucksack. Next to the passport, I sorted out my 200 rupees from the pile of money. Rooms were ten rupees a night. I paid for two weeks, then gave her my earnest money for room damage.

The matron picked up my passport carefully. She opened it and stared at my name. Perhaps she was checking to see if I'd changed my name? Through the layers of her Calcutta martyrdom her look never softened.

Abruptly, she snapped the passport shut, then she dropped it into a cubicle under the desk with her other guests' passports. Each week, all over India, the police registered every foreigner traveling in India, and staying in every hotel in the entire country. It was a practice begun during the dark days of the

First World War when Asia was overrun by German agents in disguise.

The matron picked up the bell to summon the porter as her skinny, meatless body shook with curiosity. "And what have you been doing since you were last here? Are you still going to that dreadful Communist university near Birbhum?"

I sighed heavily. "I've left university. I decided to try and see a bit of India before I have to return to America for my military service."

"I see. Military service? Are you headed out to Vietnam?"

I bravely shrugged. "No matter where I am called to go, like you sister, my life is now in God's hands. If my country calls me to Vietnam, who am I to say that the price of my own blood is not too great a sacrifice for my country?"

The matron pursed her lips tightly in approval. She nodded her head vigorously at my ideas of an early death and martyrdom in the jungles around Chu Lai.

Reaching out, she rang a bell and one of her emaciated Christian starvelings trotted up to the desk. Few people knew this but these creatures inhabited a horrible four-foot-by-four-foot area actually under the stairs. Hunkered there, day after day in the darkness, they waited for customers of the Salvation Army Hostel as their only occupation in life. I liked to think of these unfortunates as perhaps Christ's soldiers.

The man had an emaciated, bony face, with protruding teeth and a pronounced permanent stoop, perhaps from being imprisoned under the stairs.

The porter wrenched my rucksack away from me. He fled from the matron into the rain.

As I moved away down the corridor, suddenly the matron cried out, "I say . . .Welcome Back to the Red Shield Hostel on Sudder Street! And bye bye! Cheerio bye, for now!"

Pivoting in a military-like maneuver, she moved quickly into an adjoining room.

"Simply fucking terrible." I whispered.

Outside the building, the porter padded across the courtyard at the back of the building as I followed. At a low outbuilding adjoining the rearmost wall of the Indian National Museum, the porter unlocked the door's padlock. Inside the door was a spacious room. I gave him two rupees.

The porter smiled. "Beer, sahib? Gin? Whiskey?"

I shook my head.

"You want young girl? Bright teeth? Big bosoms? Yes?"

At the door, the porter ran through a list of more suggestions.

"Two young girls? Together?" the emaciated porter asked hopefully. "Mens and womens bumping together? And you are watching, sahib, as they go jig, jig, jig?"

In anticipation, his tongue stained with areca nut paan darted like a small red snake between his black teeth.

I began to close the door. Again, I shook my head. One could scarcely imagine the depravity of this place.

"You like boys, then? Ah, boys . . . one . . . two . . . three... four together."

"Bas hoggia," I said. This meant, "stop here." It was a direction you gave rickshaw drivers. In this context it was an insult.

"Karaab, firangi!" The porter hissed as he slammed the door.

Amazing. The small cultural gifts you got from travel and learning foreign languages. At least the porter hadn't forgotten his native Urdu.

* * *

In Calcutta, I went over my purposes in returning to east India as I ate my lo mein lunch at the Nanking Chinese restaurant on Park Street.

After seeing Essaji in Bombay, I decided to hunt down my leads in the Rajasthani eighteenth-century painting world. The reason I'd come to Calcutta was to visit the shop of Mr. Nowlakha, who was one of the two possibly greatest Indian painting dealers in India.

I took a tram down Chowringhee, the main street of Calcutta. The tram ran alongside the Maidan, the huge central park of Calcutta that had originally been cleared of houses to affect a

clear field of fire around the British-built Fort William. During the eighteenth century, the fortress had anchored the English presence in Bengal on the borders of the Arakanese Kingdom of Burma.

On my tram ride to the left, was the Ochterlony Monument, built in 1819 to the memory of the hero of the first Gurkha War, Sir David Ochterlony. Ochterlony had been born in Boston. He had later taken up the British service in India. At the beginning of the nineteenth century, this curious American expatriate had risen to become the richest and the most powerful British official in northern India.

 It was my particular fascination about Ochterlony that in Delhi, this American expatriate promenaded with his Indian ladies each evening.

Amidst a romp of carnal abandon, during his time in India Ochterlony had so thoroughly immersed himself in Persian-Mughal culture that unlike many of his guilt ridden sin obsessed Christian British contemporaries, he'd become thoroughly "acculturated" and Indianized.

Apparently, Ochterlony had prodigious sexual appetites, and to assuage his long eastern exile he had supplied himself with 13 concubines, each of whom he equipped with a retinue and 13 individually painted elephants.

 Fluent in Persian and Urdu, he was also a military genius. Ochterlony's epic achievement, after a half century of battles in Northern India was the conquest of the Gurkha Kingdom of Nepal. A major general in the British Army, Ochterlony died in Delhi in 1825 of a broken heart, after his service to the British

government was unjustly terminated by the governor general, Lord Amherst.

I stepped off the tram. I moved down Old Court House Street toward the Great Eastern Hotel, two blocks away.

At the entrance to the hotel stood a durwan dressed in a martial Punjabi uniform of stiffly starched, khaki cloth. The durwan whipped back the door with a "salaam". He saluted. He looked like some martial angel from another century.

Nearly blind from the sunlight outside, I banged my shins painfully on a low-lying table that was invisible in the hotel lobby. Only with difficulty did I avoid planting myself face first onto the lobby rug. Hobbling along, I navigated past two sets of matching sofas.

The rear of the hotel lobby was a vast, dark pit, lit only by a single feeble light which came from a shop window display.

Posited at the far end of the lobby, the window seemed to hang there in space, unaffected by gravity. Above the shop front was a sign which read: "The New Art Emporium. Prop. Mr. C.L Nowlakha."

Along with A.K. Essaji & Sons in Bombay, Nowlakha was one of the two most knowledgeable purveyors of antiquities and paintings of the classical periods of Indian art. Of course, the shop was filled with the bread and butter of the Indian curio world: carved ebony elephants, walnut Kashmiri boxes and brightly polished Banaras brassware.

Through the glass window of the shop, a man with thick glasses and a dark, black European suit seemed to be sitting, waiting for customers who never arrived. Presumably, the man dressed in the black suit was Mr. Nowlakha, and I pushed my way into the arcticly air-conditioned shop.

Across the shop, the man in the dark suit and carefully pressed shirt studied me carefully. He examined me through thick black plastic spectacles without speaking. The man was perhaps fifty years old. He was immaculate.

"Mr. Nowlakha?"

Cautiously, the man nodded.

"I've heard so many nice things about your paintings from Mr. Essaji in Bombay."

"And which paintings would those be?" The man's voice was just a whisper.

"I'm trying to find a Hamzanama page, if you have one of those? Alternatively, perhaps I wonder if you have any seventeenth-century Mughal or Rajasthani paintings, as well?"

The Hamzanama was perhaps the first and the most famous manuscript done for the emperor, Akbar, in the imperial painting atelier of Agra. Pieces of this manuscript and the paintings it contained had been dribbling out of India for the last 50 years or so. I'd never seen one but why not ask?

Quite blankly, Mr. Nowlakha looked at me.

294 · Clark Worswick

Improvising, I tried something else. "Perhaps you might have a few Rajput paintings from Udaipur or Kishangarh in the eighteenth century? I'd be happy to see these."

"And you are?"

I gave him my name, and my country of origin. I told him that I collected, and was interested in Indian paintings, particularly late 17th-to18th century Rajput paintings.

Nowlakha took this in. He moved along one of those ubiquitous glass-topped counters that the antiquities dealers of India had adopted from what I supposed were once-British-owned cake and pastry shops. From under the glass countertop, he extracted a black folio. Quite precisely, he placed the folio on top of the counter. With a small, and I must say an almost languid, unenthusiastic flourish, he opened the folio boards for my inspection.

From inside the portfolio I picked up the first painting.

With great care, as if I was handling a vastly precious object, I placed it carefully aside. My God! The picture was absolutely awful. It was simply terrible. This was going to prove to be an excruciatingly tedious visit.

Reaching down to the center of the pile, I picked out another painting. This second picture was in lamentable condition. In the quality of the painter's vision, it was only slightly better than the first. Carefully, I placed it on top of the glass case next to the first painting I'd seen.

"Perfect," I said. "They are very special, aren't they?"

Nowlakha looked at me with a sour expression. "A man who knows about Akbari and royal Rajput painting should do better than that. Those are awful paintings. I am so very tired of Americans who know nothing. I'm sorry I showed them to you. I apologize."

Nowlakha seemed irritatingly bereft of small talk.

"Then why did you show them to me?"

"Force of habit. I am so very tired, sir of dealing with people who know nothing about art. It breaks my heart." The dealer shook his head, then he looked up at me bravely through his glasses.

"As a fellow countryman to all the people I see week in and week out, I want to ask you a question. How did America come to control all the money in the world? I don't understand this. Perhaps we should all simply become Americans?"

The Americans in Asia all dressed identically in drip-dry clothes. The Americans you met in India were interchangeable. They all had this depressing, wide-eyed naiveté, which they took to be a kind of terrible trustworthy sincerity. There were only two versions of Americans: one was male, the other was female.

I saw Mr. Nowlakha's point. It seemed to me lately that the American worldwide cultural mission was dedicated to spending gigantic amounts of money, buying up every portable object on earth.

"What can I say about my countrymen? What I think they love best about traveling on airplanes is telling people how they got to India," I said.

"I too have also noticed this. Americans always speak about flying, don't they?" Deep in thought, Mr. Nowlakha frowned, then he nodded.

For moment the dealer was lost in thought, then he continued, "To us, Americans seem so solid. You are so very, very strong. If I may say, sir, as a people, all Americans seem to appear to be so very durable, so permanent. Indians die and what happens? Poof! At the burning ghats, we simply disappear in a small cloud of nasty-smelling smoke. Here today. Tomorrow a little cloud of ashes and greasy smoke. Sir, let me tell you it is a very ephemeral thing being an Indian."

Without another word, Mr. Nowlakha reached down under the counter and he produced a second folio from under the glass case.

When the dealer opened this second folio, I had the feeling that Nowlakha deserved every single bit of his reputation as one of the greatest art dealers in India. The paintings in this second folio were extraordinary.

They ranged from early Pala manuscript pages painted on palm leaves from the twelfth century, to Jaina pages from Saurashtra in the fifteenth century, and they were the lineal descendants of those first Pala paintings in the folio.

There were Decanni paintings, and paintings from the Kingdom of Bijapur. There were a score of wonderful Mughal pictures from the 1590's to 1710. Every picture was breathtaking.

The last paintings in the folio, however, were four Rajasthani Kishangarh paintings of the early eighteenth century.

Each of them showed a lake with low mountains in the distance. In the foreground was a palace courtyard with the figures of the gods Krishna and Radha. In each of the paintings, Krishna had the distinctive elongated eye which characterizes figures in Kishangarh paintings.

These Kishangarh paintings were astonishing.

"Do you have many of these?" I asked diffidently.

"They are very hard to find, sir. They are from the Rajas' *atelier*. I have only these four paintings. They come from a set of paintings made for the maharajas of Kishangarh."

"And how many do you find in a set?"

The dealer eyed me speculatively. "There are usually 144 paintings in a set of these pictures."

"And how many of these pictures of Krishna and Radha from this particular set are known?" I asked.

"You see them here, sir. There were four of them. The rest of the set was destroyed by white ants. As I have said, they are very rare."

Nowlakha took a deep breath. He shook his head. "It is so terrible that so much has been destroyed, sir. The climate of India is very hard on paintings. Of this manuscript by the master of Kishangarh, for instance, these are the only ones I've ever seen, or heard of."

I placed the four paintings in a row, looking at each of them.

The eighteenth century in India was a period that witnessed the breakup of the Mughal Empire. This, in turn, allowed the smaller courts of northern India to become independent military and political powers.

In the deserts of Rajasthan, and presumably in the Himalayan foothills, the newly empowered princes of these states devoted themselves to intrigue, politics and war, but they also became patrons of musicians and painters. Formerly, these artists had been part of the imperial Mughal *ateliers* of Delhi and Agra.

In many ways, the paintings of Kishangarh were a perfect fusion of the Mughal and the Rajput styles. Both of these styles had met and interacted upon each other in strange and wonderful ways. The pictures in front of me were simply dazzling. I studied the paintings and selected two of the Kishangarh works.

Nowlakha, the dealer, looked down at the two pictures sadly. Both Essaji and Nowlakah seemed upset about parting with these Kishangarh pictures. Then, the dealer priced each painting at five times more than any other Indian painting I'd ever seen.

"I am afraid to ask, but I need to get 25 hundred rupees for each painting."

Much to Mr Nowlakha's surprise, I didn't bargain. From a chintz shoulder bag I carried, I paid with a stack of Afghan-sourced 100 rupee notes. The pictures were taken to another counter. They were wrapped up by Nowlakha's peon.

I paid his asking price of approximately $550 American in Indian rupees for each painting.

"Did these pictures come from Kishangarh directly?" I asked.

Nowlakha opened his arms. He shrugged. "A runner brought them. He said he bought them from another runner who probably bought them from another runner, so on and again so on. These people tell no end of lies, sir. Who knows who got them first? Who knows where they came from? If you're looking for a source of paintings like this, it is a hopeless task, sir."

The dealer peered at me through his thick glasses. He stood there in his immaculate black suit, studying his two remaining pictures. "These pictures are heavenly, aren't they? Perhaps it is fate that brought them to you."

I made my apologies and said I had an appointment. I didn't want Nowlakha to question me about what I collected. Lately, I was developing the idea that anonymity was the best armor against the world a collector had.

I exited the shop with Nowlakha's eyes following me. If what Essaji had shown me in Bombay was the first proof of the greatness of Kishangarh paintings what Nowlakha had just sold me was confirmation of the greatness of these pictures. These paintings were beyond exquisite.

As I walked back through the miasma of Calcutta toward my dark ten-rupee-a-night room at the Red Shield Hostel, I was thinking about the Indian art dealers. Usually, nothing escaped their clutches. They were covetous and greedy. They were progressively getting better and better at what they did. Lately, I had to say that, from what I'd seen, the Indian art dealers were absolutely vacuuming up the classical art of an entire subcontinent.

 I didn't know of any country where this had ever happened before. How did you loot an entire continent of its art? No one had as yet discovered the source of these paintings. I had the first glimmerings of a way I could somehow find their source. Perhaps I could get the matron and her eight rice Christians employees at the Salvation Army Red Shield Hostel to pray for me and my art collections.

* * *

I spent another week in Calcutta on Sudder Street. Each day I visited art dealers on Park Street, then I went through the auction houses to see what things the British residents of Calcutta were selling up that week.

These auctions were startling.

As they gave up the last pieces of empire the furniture, and possessions of the British were dumped into the auction rooms. Generations of objects once owned by British residents were being liquidated for the little ready cash they'd bring. Did any of these people have a future of finding any work after they went "home" to the gloom of England?

I was mightily tempted by lustrous twin, black stone Pala ninth-century statues, once British owned, at a Park Street auction. In the land of art bargains, these statues were exemplars. You could buy these huge statues for between $50 to $100 each. Unfortunately, the Pala period statues weighed between 1,500 to 2,500 pounds, and if you bought any of these incredible statues, you then had to somehow get them out of India.

I reconsidered my new vows of sculptural art celibacy. I loved Indian sculpture, but I couldn't do the work of getting sculptures out of the country. I hoped someone who'd care for them, and eventually give them to a museum would buy them. When I thought about it, every Indian collector I'd met in India bought art as a passionate act of salvage. When so much was being destroyed by neglect, singularly, and importantly these collectors were saints.

My new lasting rule about collecting Indian art still pertained: Weighing only a few ounces, shipping paintings out of India in the post, interleaved between the pages of a book, was the most elegant way to smuggle art I could imagine.

* * *

It was two days later, after the last auction I attended that I was walking down S.N. Banerjee Road, in the business district of downtown of Calcutta. I passed a six-story building from the 1920's in the Beaux Arts style, then on the sidewalk I turned back towards the building.

What struck me was not the Beaux Arts building itself, but the photograph inside the foyer.

I moved off the sidewalk into the building.

I stood in front of the picture and was transfixed.

The photograph was of the Jag Mandir Palace, which had been built in the middle of Lake Pichola, in the Rajput Kingdom of Udaipur. In the picture, five men rested in a boat upon the lake bank. It was haunting and almost surreal in its beauty. In the background was the palace itself. The picture was like no picture I had ever seen before.(See: Cover Photograph, *The Orchid House*)

For five minutes, I stood in the foyer of the building staring at the picture, and try as I might, I could not understand how this picture worked.

In my mind I took it apart and I put it back together again.

I could find no explanation for the utter magic of this picture. It was the ultimate summation of the lost, and now vanished glories of the Rajput princes of India and their world. As I stood there silently for the last minute, a man had been standing ten feet behind me in the building doorway, watching me look at the picture.

The voice had a soft British accent. "It is indescribable, isn't it?" the man said quietly.

I turned. In the doorway was a late middle-aged Englishman dressed with a carefully knotted tie, set off by a rumpled, tropical white suit.

"Let me tell you about this picture . . ." he rubbed his hands together. "It is a photograph of Udaipur and the Lake Palace of

the Maharana. It was taken by a man named Colin Murray in the year 1871 or 1872. Murray was the chief photographer of the firm Bourne & Shepherd of Calcutta and Simla. Today, Bourne & Shepherd is the oldest surviving photographic firm in India."

I looked back at the man. "I'm a photographer and I think this picture is one of the most extraordinary photographs ever taken."

"I agree. I've spent my own life taking photographs, and I totally agree. Come with me upstairs. I'll show you some more photographs of Samuel Bourne and Colin Murray. Take the stairs, not the lift. Damn lift has been broken for the last eight years. The new India. Impossible to get parts to fix the damn thing anymore."

The Englishman moved around me.

He climbed the stairs, and that is how I met Arthur Musselwhite, the last British owner of the photographic firm Bourne & Shepherd, Calcutta.

Arthur Musselwhite had built the six-story building. He still owned the building and he'd paid for it himself in a most unlikely and exotic way. For a period of 15 years Musselwhite had been, apart from a British appointed political agent, virtually the only foreigner allowed into the then forbidden Kingdom of Nepal.

During that 15 year period, from 1921 until 1936, Musselwhite had been, "By appointment, Court Photographer to H.R.H. The King of Nepal." During that period, this unprepossessing man

had also been perhaps the highest-paid photographer in the world. For his work in Nepal as the court photographer, the king paid him tens of thousands of pounds in British gold sovereigns. From his earnings, Musselwhite had bought the Bourne & Shepherd firm. In addition, he maintained an elegant house in the fanciest section of Calcutta, a few blocks off Park Street.

On the fourth floor of Bourne & Shepherd, I began a three-day process of going through the firm's "order books". These were the company's nineteenth century original photographic proof books. They had been compiled by Charles Shepherd and Samuel Bourne in the 1860's, then carried on by their successor, Colin Murray, from 1871 to Murray's death in Calcutta in Calcutta from typhoid fever in 1886.

In a Musselwhite-produced catalog of 1941, based upon the firm's work, the 89page catalog began, "In introducing this catalog of negatives . . . they present the work of one hundred years of effort. . . . Here is presented a unique collection found nowhere else in the world."

The catalog itself was titled "A Permanent Record of India. Pictures of Delhi Durbars, Temples, Mosques, Palaces Cities and Himalayan Scenes."

In terms of vision and of acuteness, few photographs today rival these photographs. The pictures of the proof books themselves were made in photographic process that had disappeared in the late 19th century.

These pictures had been created by two totally forgotten 19th century Indian photographic firms, which today were still operating in Calcutta in 1962.

The firm of Johnston & Hoffman, where I'd first bought my film and had it developed in Calcutta, had been founded nineteen years after Bourne & Shepherd. Both firms created work which was, the more one looked at it, astonishing in the scope of its ambition.

These two photographic firms photographed literally everything in India. The difference today was that Bourne & Shepherd, was run by Arthur Musselwhite who was the last lineal descendant of the nineteenth-century photographers who crafted this staggering art document of a now vanished place.

In the next days, Arthur Musselwhite pulled out anything I wanted to look at except for Samuel Bourne's photographs of the Himalaya and, frustratingly, Colin Murray's unbelievable Lake Pichola Palace picture made in Udaipur. The print I'd first seen was a copy print of a copy negative of not very good quality. The original plate had been broken in the 1880's.

In the course of my now frequent visits, I kept asking to see the pictures of Samuel Bourne's three epic journeys into the Himalaya during the years 1863-1866. In that period, Bourne's longest photographic journey lasted ten months. He had 60 native coolies to carry his equipment into the most inaccessible reaches of the Indian Tibetan borderlands of the highest mountains on earth. On my last day's visit to the studio, Arthur Musselwhite admitted reluctantly that he couldn't show me the Bourne's Himalayan negatives.

In early 1951, he'd thrown out the negatives of these journeys, because they took up so much storage space. He told me that he would have given me every one of Bourne's negatives if he'd met me earlier. Between the years 1916, when Arthur Musselwhite had first come out from England on contract to work for the firm as a photographer, to 1951, not a single person had ordered a print of these Bourne negatives.

On my last day in the studio, Arthur Musselwhite, the last British photographer of Bourne & Shepherd, gave me prints from his own personal collection that he'd made in 1915, of a few of the now lost Himalayan Samuel Bourne negatives.

I thanked Arthur for his many kindnesses. He told me to return to his shop whenever I was in Calcutta. On that last day, one final time, I walked down the stairs of the Bourne & Shepherd building. As I gained the street and walked up S.N. Banerjee Road, I thought of the world of the future.

I wondered if the work of this firm, and of the photographers of the nineteenth century in India, wasn't one of the greatest bodies of work extant in the world of art. These artists had gained absolutely no credit for their achievement of making extraordinary art documents, which documented an entire now vanished, subcontinent.

In a country now called India, a country that was free and democratic, the cities from the British period on the subcontinent would inevitably be renamed. After the British had departed, the names of the states, the cities and even the mountains would be changed. I wondered what tracks through the sand and dust of India the British had left behind them.

In their democratic alterations, both British India and India of the princes would disappear. Of a place impossible to return to, only these photographs remained.

A day later, I boarded a train for north India.

A COLLECTION OF INDIAN
PHOTOGRAPHS OF THE
19th CENTURY

The following photographs are a small selection of pictures from a larger collection begun in Calcutta in 1959. The pictures were made in the last half of the nineteenth century during the period of the British Raj in India, when England directed the destinies of what are now five different Asian countries. In this same era, India was divided into 569 different independent states, only one of which was the self-appointed British "paramount power."

Virtually uncollected and still unrecognized today in any serious collections outside of Britain, these photographs present mysteries of character and place which scholars will spend future generations unraveling.

Each of these photographs are sealed and individually, in work consuming days, from the ravages of time with a delicate wash of pure silver or gold.

"THE DILWARA", JAINA TEMPLE, MT. ABU.
COLIN MURRAY, POSED DURING A 45 MINUTE
EXPOSURE, 1872. PHOTOGRAPHER
COLIN MURRAY/ BOURNE & SHEPHERD

YOUNG GIRL, COLOMBO, CEYLON. 1870S.
PHOTOGRAPHER, CHARLES SCOWEN

LEPCHA MAN, DARJEELING, 1890'S.
PHOTOGRAPHER, A. HEFFERAN

JASWANT SINGH, II THE MAHARAJA OF JODHPUR
WEARING THE JODHPUR EMERALDS, 1890'S.
PHOTOGRAPHER, JOHNSTON & HOFFMAN

KASHMIR, THE MAHARAJAS STATE BOAT, 1872
PHOTOGRAPHER, FRANK MASON GOOD.

TIRUVANNAVALI TEMPLE GOPURAMS, 1870'S.
PHOTOGRAPHER, FRANK MASON GOOD

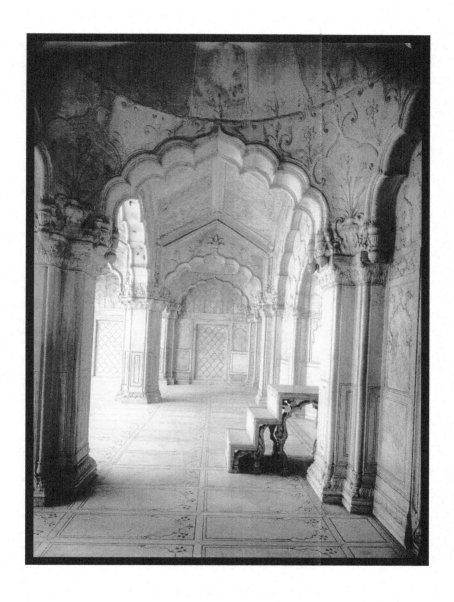

THE MOTI MASJID MOSQUE, RED FORT, DELHI,
1890'S. PHOTOGRAPHER, JOHNSTON & HOFFMAN.

ACROBATS, CHATRI'S CIRCUS, HYDERABAD. 1890'S.
PHOTOGRAPHER, RAJA DEEN DAYAL.

COURT OF THE NIZAM OF HYDERABAD, TWO
PRINCES & SERVANT BOYS. 1890'S.
PHOTOGRAPHER, RAJA DEEN DAYAL.

BORA BAZAAR, BOMBAY, 1871.
PHOTOGRAPHER, COLIN MURRAY/
BOURNE & SHEPHERD.

KYBEER SHA, BYRACHEE LIVING GOD &
FOLLOWERS. 1862.
PHOTOGRAPHER,CAPTAIN W.W. HOOPER.

THE YEARLY MAGH MELA , AT ALLAHABAD, IS ONE OF
THE MOST SACRED HINDU FESTIVALS. DURING *SANGHAM*,
A CONFLUFNCE OF THE GANGES AND THE YAMUNA
RIVERS, THE HOLY WATERS PURIFY THE SOUL
PHOTOGAPHER, G.W. LAWRIE.

FAKIR, IN YOGIC ASANA. 1880'S. PHOTOGRAPHER,
ROBERT HOTZ.

THE FIRST FASHION PHOTOGRAPH.
BARONESS OLGA DE MEYER WITH
THE ELEPHANTS, CEYLON, 1899.
PHOTOGRAPHER, BARON DE MEYER.

BURMESE PRINCESS, MANDALAY, 1890'S.
PHOTOGRAPHER, FELIX BEATO.

LOWER PYKERA FALLS, SOUTH INDIA, 1869.
PHOTOGRAPHER, SAMUEL BOURNE

BUTTERFLY SELLERS. DARJEELING, 1890'S.
PHOTOGRAPHER A. HEFFERAN

HYDERABAD, THE CHAR MINAR,
PHOTOGRAPHER
RAJA DEEN DAYAL, 1886

DELHI, 1962

The only way to get to Kishangarh from Delhi was to board a bus at the central Delhi bus station.

From Jaipur, one caught another Rajasthan State Transport bus to Ajmer, the largest town near to Kishangarh. I had an appointment in Jaipur. It was a stop I had to make.

I remembered the summers in Delhi after the city heated up. At midday, the streets were an oven. Shimmering waves of heat rose off the roads. Birds dropped dead in the heat as they fluttered weakly from one place to another, trying to find shade. Beyond the outskirts of Delhi, trucks clogged the narrow two-lane road that moved southward toward Jaipur. These two-lane twenty-foot-wide strips of macadam connected every city in India.

The Sikhs who drove the behemoth Tata Mercedes-Benz country trucks always took the right of way. The rule of the road was that any oncoming vehicle meeting one of these huge trucks had to veer off the tarmac onto the desert. The approaching bus, or the hapless passenger car, then disappeared into a huge cloud of its own choking dust. The third time this had happened, I looked down at my arms. It looked like I was covered in dried red paint from a coating of ocher. It was five and a half hours after the bus left Delhi that it slowly moved into Jaipur.

In the dusk, the city was just coming to life. Cooking fires illuminated low smoke-filled houses. The bus passed down the wide roads of the carefully planned city. At the city center, near the maharaja's old palace, the bus stopped. Inside the bus, the

passengers climbed groggily to their feet. I was dizzy from exhaust fumes and I felt drunk as I exited the bus. In my dazed and confused state, I wandered off to find a hotel.

Twenty minutes later, I was shown a third-floor room. I'd found a hotel down a narrow street. The room had a washstand and a single window that looked out over a lovely view of Jaipuri houses with their ornate, whitewashed eighteenth-century roof lines. The smells that wafted from the city upward into my room were delicious. I smelt curry and cardamom and the sharp tang of mustard oil being fried.

There was no bulb in the small lamp on the bedside table. I locked my door with a padlock I carried. I went off in search of a restaurant and a light bulb.

In a restaurant near the bus station, I ate a lovely dinner of curry murgh with dal bhat. My penetrating headache from the carbon monoxide began to recede. After dinner, I went in search of a 25-watt bulb.

In my room, I screwed the only bulb I'd been able to find into my lamp. It was a feeble and quite dim 10 watts. Spreading my thick cotton dhurri over the bed, I settled back and read the jacket blurb on the back of my book that described the text. The book was "Immensely engrossing . . . Trollope's 1875 tale of a great financier's fraudulent machinations in the railway business. His daughter's ill-use at the hands of a grasping lover are a classic in the literature of money and greed."

Where else in the world these days could one actually buy a copy of *The Way We Live Now* by Anthony Trollope? In Calcutta, in the New Market, I always found amazing books left

behind by the departing British colonialists. In abandoned piles, these books appeared to be the sole literary evidence of a now defunct empire.

Quite glad to have the company of my antique Penguins and armed with my books in their old green bindings, I stormed into Rajasthan feeling intellectually inoculated against India. What more could anyone ask? But I was suddenly not sure whether *The Way We Live Now* fitted my present mood. Was this the right book to read after eating a meal of chicken and rocks in Jaipur?

Against my fly-specked wall, instead I selected another Trollope Penguin. This one was titled *The Last Chronicle of Barset*. The rich jacket blurb said of this volume, ". . . the moral dilemma of the protagonist seems to belong more readily to the world of Dostoevsky than to Victorian England. *The Last Chronicle of Barset* concerns itself with an indigent but learned clergyman, the Reverend Josiah Crawley, curate of Hogglestock, who is accused of stealing a bank cheque." Goodness. I loved the Victorians. They were absolutely obsessed with money. I plunged into my new Trollope with barely controlled enthusiasm.

Later that night I lay down on my lumpy bed.

Had I slept? A faint tinge of dawn touched the ceiling. Then like they always did, the terrible roosters woke me up before dawn. My eyes were gummy. I think I'd slept. I lay there in my cramped room in a coma of exhaustion.

* * *

As my tenth grade teacher had always advised, "Always visit the town library first to find out what is happening in a town." It was simply splendid what things you could find out local libraries if, of course, the town had a local library.

My first stop the next morning was the City Library. My Murray's Guide said the city's only library, like much else in Jaipur, had been endowed by the Maharaja of Jaipur, where it contains much of the history of the former princely state.

Twenty minutes later, I was set down by my cycle rickshaw in front of a neatly kept, whitewashed Georgian-style building with stone steps. Behind the library was an elaborate garden.

In the poorly lit gloom, once inside, the building was similar to every library I'd visited in India. The longevity of any library in this country was a race between the quick white ants and their immobile victims, row upon row of books. Judging from the piles of whitish dust on the floor of this library, the ants kept on winning.

From the back of the library in the darkness, an older man moved slowly toward me. As he got closer, I saw he wasn't an old man; he was an ancient man. He was dressed in a pair of well-pressed white Jodhpur-style pants tucked in at the ankles. In a few moments, the old man stood in front of me, stiffly erect, like a retired military officer. The librarian wore over his chest a tight garment that lately had been called a sherwani coat. The sherwani coat had thirteenth-century Central Asian Persian-Indian antecedents. It was the court costume of the Mughal emperors.

The old man's face was a face from the Indian past, the likes of which appeared in Mughal paintings. He had deep-set eyes that held pools of unfathomable distance and reserve.

"May I ask what are you searching for? And who might you be, young man?" the old man inquired softly.

"I'm a student, sir. A student of Indian history at an accredited Indian university. Are you the person to ask if you have information on genealogical research of the Kingdom of Udaipur."

In the darkness, with all his books rotting away, I presumed this old man was the sad keeper of this place.

The old man gestured at the rows and rows of moldering books. "All of what you see here is my kingdom. I welcome you to the unique and marvelous history of Udaipur, and to clansmen of the Rathore. Welcome to my empire."

The old man pulled himself up to his full six-foot-four height. I noticed only now that he was a giant, and he carried himself with an unbending authority. He was a specimen from another century, from another time. The more I studied him in the darkness, the more I changed my opinions about a still formidable man.

The librarian turned abruptly.

In the darkness, he slowly made his way deeper into the darkness of the library. The rear of the library was lit only by the dimmest of flickering neon bulbs. There was another corridor of books and yet still another. With its turns and twists,

the building, as it was constructed, was much larger than one suspected. Finally, we arrived at the distant absolute rear of the library.

The librarian pointed upward. "That largest book. There! Take it down. I am too old to reach it anymore."

From a side stack of books, I took a ladder. With two hands I gripped the book, backing down the ladder. The volume I held weighed 60 to 70 pounds.

Following the huge man I was covered with blackish dirt from carrying the heavy book toward the front of the library, and put the large and very dirty book down on a table.

The old man came up behind me and looked down at the opened book. "Of course you don't read Brahmi, do you?"

I shook my head.

"No matter. It doesn't matter." He waved absently at two chairs. "I shall be your cicerone, and your amanuensis. I shall be your slave of knowledge and your secretary."

The old man chuckled at this thought.

"Let's start at the beginning young man. With a short but emphatic history of the Rajputs. Is that satisfactory?"

I pursed my lips tightly together in the spirit of academic inquiry.

"Our history goes back perhaps three or four thousand years. Do you know anything at all about the Rajput clans?"

" I've read every single word of James Tod's book *The Annals and Antiquities of Rajasthan*. It seems the single book in English, that covers this subject."

"So we begin with your known limits here. We begin with the fact that you know nothing about this subject, except for the colorful inventions of Colonel Tod and his fables done six generations ago."

He raised his hands above his head. He clasped his hands together then stretched backward with his hands behind his neck. "To begin with . . .it was the sin of the Rajput clans that they were utterly possessed by the idea of valor. For millennia they fought every invader of India. But in their time off from fighting foreign invaders, they did something infinitely more amusing: they spent their lives fighting and killing each other.

"The Kachwahas of Amber and Jaipur; the Hara of Kotah and Bundi . . . where does one start to define this spectacle of blood, valor, revenge, and dementia? The Rajput warrior is utterly ferocious. He is infinitely more violent and vicious than the blood-maddened tiger, which is the only other species to kill for his own pleasure."

The old man hadn't reached the genealogy of the greatest of the Rajput clans but one.

The old man leaned forward. His deep-set eyes held some terrible unknowable ferocity. "I now mention is one other clan," he whispered, almost silently. "It is a clan of the desert wastes . . . and they are the greatest of all the Rajput clans."

I didn't breathe.

The old man's voice exploded in the darkness. "They are the Rathore! They are the Rathore of Udaipur who never gave a princess in wedlock to the Mughal emperors. They are the Rathore of Marwar, of Bikaner, and of Jodhpur. They are the proudest, the most resolute of all the Rajputs, and finally, in the genealogy of the Rathore, there is Kishangarh.

The hairs stood up along my arms. My hands were sweating. I let my breath out slowly.

"I am a Rathore of Kishangarh," the old man said.

For a very long moment the librarian was lost in thought. He ran a finger up and then down his long nose. "You are a student of which university in India?" he asked.

"At Santiniketan I was a student of Indian history."

In the gloom, the old man nodded. "You are an odd sort of American. How very strange it is, that an American of all people, has come to study this subject. I think you are the sole person I've met in decades who is interested in our past. You are the first westerner to have this interest of the Rajput clans, since our dear Mr. Ratliffe, our state librarian, who died of cholera in 1923."

The librarian perched there on his chair in the darkness. His eyes were focused somewhere in the past. He suddeny slapped his hand on the table in a decisive gesture.

"Yes! To begin your research on the Rajputs, you must start at Kishangarh. I believe Kishangarh is where you must begin young man. Kishangarh is a mere one hundred miles from Jaipur."

I had the feeling, suddenly, that a man like this didn't exist anywhere else in the world except in the now politically ruined Rajasthani princely states. He was a man from a time that had gone missing in a new kind of India.

"I shall skip over the boring details. It is so very tedious to outsiders. The Suryavansha or 'Race of the Sun.' Descended from the God Rama, etcetera, etcetera."

Slowly the librarian rose and then he moved through the gloom in front of me.

At a wide desk near the back of the library, the old man came to rest. He snatched up a pen, and next, he dug out a piece of heavy-bonded writing paper from a desk drawer. For five minutes, the librarian worked at a letter. Perhaps he was setting up appointments for me in a tour of other princely libraries of Rajasthan. I could only hope that was the case.

As I waited, I thought about how unhappy the maharajas and princes of India and Rajasthan must have been when the British quit India. For generations, the Rajputs had put their complete faith in the British. Then, one day, the British left India. I couldn't imagine the feelings of the princes of Rajasthan about

the treachery of the British. Poof, and with a fizzle of stink, they dematerialized themselves.

The old man looked up at me and he issued what seemed to be a preemptory command.

"You must go first to Kishangarh. You should work in the Royal Library there, such as it is. The entire history of the Rathor clan is in that out of the way library in a now forgotten state of no consequence. Of course, you should also arrange for someone to help you with your translations. I will put that in my chit as well."

"Thank you so very much. Thank you, sir."

The huge man sat there for a long moment in silence, thinking.

"It is no matter." The old man waved his hand. In the darkness he considered. "And you can thank your fate that you're an American, not an Englishman."

The librarian sat for a long moment, staring at something far away in another time.

"They were so very certain of everything. What I miss is their certainty. I miss their belief about their whole presence in India. It turned out, however, that in the end, the British were filled with an empty, utterly faithless conviction of their own superiority, and nothing else. Look what happened to them after 1947. Their reward was that they had to live their worst nightmares. They became a nation of bankrupts with the morals of auto salesmen."

I had to wonder just then, in the dim interior of the library, what fate it was that I'd stumbled upon in the innermost soul of this old man. I wondered who he was. He was like no librarian I'd ever met.

The librarian sat there at his desk. He finished writing the last bit of his letter. He put down his pen.

Looking over his shoulder I studied the pen. I'd never seen any pen like this that was owned by a librarian. Librarians possibly earned 80 rupees a month, and they did without lunches because they were so poor. The pen was a gold-cased, old-fashioned Cartier fountain pen.

I wondered what was in the chit the librarian had written. One would never be received in the period of the princes without a chit. One was quite literally denied a hearing with the higher orders in India. Alternatively, on the receiving end of such a document, the person addressed rendered almost mandatory assistance.

The librarian looked up at me, and continued,. "Could I point out the current state of civility in my country?"

"I see only merchants and civil servants without honor subservient only to money. In the new India, it will be immensely difficult to replace a working civil authority, and judicial system that, for all its faults, the British left us. With the magnificent patrimony simply handed over us, to guard and protect, we've destroyed ourselves."

I didn't answer.

The old man paused for emphasis. Then, in the gloom he continued quietly, "Every Indian is drowned at birth by his obligations to his family, to his community. He inherits a loneliness that is unbridgeable. No one is free of his unrequitable obligations in this country. That is the most terrible secret at the center of every single Indian soul."

"After a very long life, I shall tell you something else about India. I have come to think that at the center of every Indian is an almost savage, unbridgeable loneliness."

There was no answer to this. I didn't try. The old man seemed inconsolable.

Slowly, the librarian rose. Carefully, with a shaking hand he placed the letter he'd written into a heavy envelope.

"In Kishangarh, present this letter to the maharaja's ADC. This will eventually take you into the state library of Kishangarh."

The old man pointed me out of the library towards the entrance.

Without another word, he turned and retreated slowly back into the gloom and into the semi-darkness of the moldering library.

I walked and thought about the librarian's parting words.

In 1947 the new democratic government of India had stripped the Maharajas and Princes of their armies, their judicial powers, their railway systems, their police spies and constables. Some of these princely families had ruled for millennia. In the last 15 years the Indian princes had retreated behind their castle walls. They saw no one and the only remnants of the past were their

palaces and libraries. Inside their walls they curled into a cocoon of the past.

A half mile from the library, I engaged a pedal rickshaw. We swept past ownerless holy cows wandering aimlessly garlanded with necklaces of decaying flowers. Young boys darted through the traffic.

I took the envelope the librarian had given me out of my pocket and I turned it over. As I rode through the streets of Jaipur, I looked down at the envelope with disbelief.

The envelope was addressed personally to the Maharaja of Kishangarh, Shri Umdag Sumer Singhji Bahadur. The envelope was not sealed. It was de rigueur with such letters as this, addressed to high personages, that the sender never sealed his letter. It was a communication between equals. The protocols of these letters called attention to a service that should be given to the bearer of the letter.

The idea was that the person to whom the letter was addressed knew that the bearer of letter knew the contents of the letter, because the letter had been left unsealed.

I stared at the note the librarian had written. It was written in English and it said: "Bunny, be so good as to give this young American gentlemen, who is interested in our history, every facility you can. This includes allowing him to take anything away from our library in the form of my manuscripts or paintings which illustrate or relate to the history of my clan."

The letter was signed, "Shri Yagya Narayan Singhji Bahadur, Kishangarh."

This letter slid past the question about whom exactly Shri Yagya Narayan Singhji Bahadur of Kishangarh was?

A thin piece of paper fell out of the envelope into my lap.

The paper was addressed to me. It read simply, "Young man please tell Bunny that you met the writer of this letter in Pakistan. You met him while he was on an extended, difficult pilgrimage to Mount Kailas in Tibet. You might also say, and this is very important to me, that this old man's state of health was such, you didn't expect him to survive a four month march in the dead of winter across sixteen thousand foot mountains. This hastily concocted story will protect you from further interrogation by Bunny's brigadier, the Rottweiler."

This was an exceedingly strange letter. The Rottweiler?

* * *

KISHANGARH, 1962

Out there on the cold road which stretched in front of the ancient bus, northern India was a world of millennial red ocher dust.

The night before, the cold had moved down from the Himalaya. It had dropped the temperature of Rajasthan.

It was one of those mornings where the ryots huddled in their thousands and tens of thousands inside their heatless villages. The sun came up. As the bus passed through the countryside the ryots one saw looked like mummies wrapped in earth colored linen shrouds. In the backlight, the landscape looked seeded with ice crystals.

Moving through small towns, there were whole walls painted in inconceivable, astonishing paintings that lined whole streets. There were paintings of princely court retainers, of elephants, of mahouts. They were done with amazing naturalism, and with great exactitude of character. In the paintings were bright oranges and dazzling azure blues. The paintings had been done by the descendants of the great court painters of the Rajasthani courts, who had lived 15 generations before, in the seventeenth and eighteenth centuries.

A half hour later, the town of Kishangarh appeared.

Above the town, the Roopangarh Fort dominated the skyline. The town rested on the banks of a large man-made lake called Gundalao. Like many of the towns of Rajasthan, small whitewashed buildings rose upward from cramped, crowded streets below the fortress.

My ramshackle Rajasthan state transport bus came to a stop by the central market. Climbing off the bus, I felt beaten and worn. I had a carbon monoxide headache.

In a chai shop near the market, I drank two cups of thick, hot Indian tea and felt almost human. Like most of the country towns of India, there were no hotels in Kishangarh, and one stayed, if it was possible, in the government run dak bungalows. I hired an ever-present pedal rickshaw and I told him in Hindi to take me to the dak bungalow.

In previous princely times, if one wanted to get a room in a dak bungalow, you had to initiate the protocols of petitioning the local government engineer of the public works department. For 150 years, these modest buildings were spread across the whole expanse of India, from the Himalaya to the tip of Cape Cormorin in south India, and they'd housed generation after generation of grateful travelers. The Kishangarh dak bungalow was a shopworn specimen from the distant past.

A garden had once been planted in the forecourt. Century-old empty ringed an entrance road of sunbaked dirt. I descended the rickshaw and passed inside the musty, almost dark building.

Inside was the main communal room of the bungalow. It was populated by chairs with exploding springs and stuffing. A table nested by a wall. Along the far wall was a tottering sideboard set with ten tea cups and six chipped saucers. The dak bungalow seemed empty, both of a full complement of saucers and cups, as well as guests.

"Ho, chowkidar!" I called, as I went through the building trying to find the caretaker.

Ten minutes later, after distant door slamming a diminutive man appeared. He was small with a neat, intelligent face.

"Sahib, salaam." He bowed. Then he directed me through a set of doors backing off the rear of the building.

I followed him into the office of the bungalow. I asked for the registration book. Then, there was a drama of the complicated protocols of these dak bungalows.

The routine of these places was that you always signed into the book before you took up your room. You then wrote your name, the place you came from, how long your expected stay and, finally, the destination that you were "reporting to," as was described in a special "official column" in the dak book. At the end of your stay, you always wrote down what you'd paid the chowkidar.

Tips were "off the book," a phrase that was English, which had entered every language on the subcontinent, then everywhere else on earth. I checked to see what people were paying to stay in the bungalow. The rate was 35 cents a night. I signed in the book and I ordered up breakfast and "bed tea." I badly needed pots and pots of extra-sweet milk tea.

With the book under his arm, the chowkidar disappeared to arrange my breakfast.

In times past travelers, moved around the subcontinent with their baggage tied to either an elephant, or to a long row of 40 or 50 camels. A traveler today always traveled around India with huge bedrolls, which contained sheets, blankets and a thick cotton-stuffed mattress. Such bedding was proof against communities of bed bugs and other, even nastier Indian "things" which lurked in locally supplied mattresses.

I opened the bungalow windows in an attempt to rid the room's musty smell. As I stood at the window, I thought of the eighteenth- and nineteenth-century British travelers to Kishangarh.

The impedimenta of a traveler of the last century included bedframes, tents, tables, chairs, tinned food supplies and huge brass or earthenware vessels for storing hard-to-find water in desert regions like Rajasthan. In the mofussil (the countryside), a traveler's train of baggage animals, and his equipment, required a retinue of ten or more servants to set up a camp when no dak bungalow was available.

I placed my single cotton dhurri over the bedframe of my room. I then spread out my two thin cotton sheets from my rucksack. The drill in dak bungalows was that each room provided a basic bed platform, a bed frame. In the mofussil, I'd long gotten used to sleeping on thin sheets overlaid on my dhurri, placed over plain wooden rough rope charpoy bed frames.

I always checked the bathroom for nasty things that crawled or slithered. Before you did anything in a dak bungalow, you did that. You checked. Immediately.

In the bathroom, there was a Western-style toilet bowl without water in it. An earthenware pot, which came with every room, rested under a steel tap set into the wall. The only water in the building came out of this modest tap. To take a shower, you poured water over yourself from this earthenware pot. This pouring operation was usually affected with bitingly cold water. 1962 was no different than 1862 or 1662. Nothing had changed in the Indian countryside for centuries.

It was always important to find out if there were biting, slithering or crawling visitors in your room.

Very carefully, I looked at the hole cut into the wall where the water drained out of the bathroom into the garden behind the bungalow. You always checked to see if this opening was screened. If you didn't check, possibly at some inopportune future moment, you might find a five-foot, regular sized cobra, or quite unhappily you might discover a behemoth 14 foot completely lethal king cobra as your collateral bath mate.

Snakes seemed to like cool, damp places and dark corners. A 15 inch krait, for example, was an infinitely worse discovery than any Cobra no matter what its size. This small snake possessed venom that was 16 times as deadly as a cobra bite. With a lively little krait embedded in your thigh, you hardly had time to say "adieu" before you fell down dead.

As you traveled around India there were other sorts of "habits" connected to Dak bungalow living. At night in a dak bungalow, if you needed to pee, you always used the chamber pot next to the bed. Dak bungalows only rarely had electricity. At night, if you had an intestinal attack, you lit the bungalow's kerosene

lantern, or your flashlight, *before* you entered the bathroom.

As I studied my room a whole family, or perhaps an entire clan, of wonderful green gecko lizards stared down at me from their positions on the ceiling. In bright, quick movements, they skittered back and forth. I wondered how I appeared to them in their topsy-turvy world, as they stared at me upside down.

Breakfast came and I had my fried eggs as the chowkidar presented two pots of tea.

I asked the chowkidar that, if one wanted to meet the maharaja, did one go either to the fort or did one appear at the Phool Mahal Palace? The chowkidar frowned. He gave his labored and slow opinion that the maharaj was living in the fort, as the Phool Mahal Palace was undergoing extensive repairs to the royal suites.

A half hour later, I waved down a tonga, a horse-drawn taxi from another era. I asked the driver "Quetna palace, hai?" The driver gave me a price.

"Siga jaldi," I said.

I then jolted along uncomfortably in a conveyance that probably wouldn't last another 20 years in India, but which had been part of India for the last two millennia.

* * *

KISHANGARH, THE PALACE LIBRARY, 1962

What unfolded that morning in Kishangarh's palace was completely strange.

Upon receipt of my chit from the librarian of Jaipur, which I presented to the Prince's ADC, the aforementioned Rottweiler, ten minutes later I was informed that the Maharaja of Kishangarh had granted immediate permission for use of the state library. Not only that. I was told to gather whatever research materials I required, and carry away from Kishangarh anything I wanted.

Given my request, and that this was India where people need days, weeks and even years to reach a conclusion about anything, my research seemed to gather forwards momentum with an unearthly haste. I couldn't help wondering who the kindly ancient librarian of Jaipur was, then what kind of hold did he have on the Maharaja of Kishangarh.

I was led through acres of abandoned palace rooms, upwards into a complicated set of narrow staircases, then finally to the high ramparts of the palace. Across the hundred yard terrace, high above the town was the lake. and above the lake were towering cumulus clouds floating in a clear blue sky.

Slowly I moved across the terrace and beyond the terrace was the library.

Wetting my hand I polished a five-inch circle of the dirty glass in front of me. I pushed open the unlocked door back onto its hinges, with effort. It appeared no one had been inside the

building for decades. Pieces of ceiling and plaster had fallen onto the tables and floor beyond. A thick coating of grime and pigeon gunk covered every surface.

At that moment my new assistant appeared behind me and he announced his presence by stuttering his name nervously. His name was Mokesh.

He was a man with a wall eye, a slight, insubstantial build and thick bottle-end glasses. He was of indeterminate age, but I judged him somewhere in his late forties. Mokesh came equipped for battle in the library with a large Sherlock-Holmes-style magnifying glass, that never left his hand. To aid me in my work he announced he could translate Brahmi script, the ancient script of India.

Presumably, to my detriment, Mokesh was also certainly a palace spy assigned to watch over my activities, on my adventures of "genealogical research."

Mokesh also apologized during our first meeting, "Sahib. Key is unobtainable. For aforesaid library. Lost from ancient epochs."

Lining the walls of the library were steel tables that held heat-burst bundles of documents tied up with rope or string. Hanging from the ceiling were two inverted bell-shaped electric lights from the Victorian period. I switched on the lights. They didn't function.

For six hours, Mokesh and I worked trying to sort out the mess in the library.

In the evening through open veranda doors of the library, in the last minutes of the light, I glanced across the terrace at the astonishing views across the lake below. The distant hills, the clouds at dusk, the lake. Each of these individual pictorial elements were dramatic, and in the paintings I'd bought each was painted with great care.

Reluctantly, in the near darkness, I left the palace and went back to the Dak Bungalow.

During the succeeding week, I fell into a quiet, if remorseless routine. Each day I went through scores and eventually hundreds of records and manuscripts. I was assisted by my new, nearly mute assistant, my reader of ancient Brahmi script, Mokesh.

Each day, Mokesh insisted on calling me zemandari sahib. "I am your slave of knowledge. I am at my best assisting you every day, isn't it, *zemandari sahib*."

Each day as we worked, he appeared dressed in an immaculate white sherwani coat, which, after 15 minutes of lifting manuscripts, became the color of red desert dust. Unhappily, he seemed as allergic to dirt, as he was exhausted by his work of translation. As the days wore on my new spy-partner had sneezing fits every 15 minutes or so, in addition to appearing more and more almost congenitally untrustworthy in his obsequiousness .

In the library each day, Mokesh would enumerate what each manuscript detailed into his notebook with tiny squiggly-looking Devanagari script, while I looked for paintings.

It was Mokesh's job to instruct our hapless peons to lift, then carry hundreds of Kishangarh library manuscripts to our long inspection tables. Each day, I took a growing and perverse pleasure in seeing exactly when Mokesh would quit his work and leave for an important errand in the palace. Usually this was around 1 p.m. and or, lunchtime. My lunch was brought to me in the library. By habit, I then retired to a charpoy bed in another room, to read through a box of yellowed Penguin reprints of 19th century British novels I'd discovered in the library.

In the late afternoon, Mokesh would reappear at three thirty or four. After all his labors were "government work" that he appeared to undertake at his leisure, even though this was his sole employment.

On other early afternoons, I walked around Kishangarh.

I took long walks to the periphery of the town. I was in no hurry to go anywhere. Each day that faded into the next, Mokesh worked at translating long rambling passages of script from the earliest parts of the sixteenth century. For me, the life of the princely families of Rajasthan began to come alive.

First assembled during the early years of the sixteenth century anything that related to the history of the Rathore clan, and Kishangarh was placed in the archive. Or, perhaps, more accurately, it was abandoned in the archive.

I became fascinated by Mokesh's translations. The archive was the final resting place of the passions, and the betrayals, of the

abandonments and the murders, which continued throughout generations of the royal family of Kishangarh. There were wars, regicides, and queens who poisoned their husbands. Seemingly, in their own turn, the maharajas murdered, in wholesale batches, 10 or 20 brothers and uncles.

This was the poisoned bouquet of Rajput life.

Alternatively, the princes of the Rathore clan choreographed elaborate family-oriented suicides, as gruesome endings of impossible-to-win wars, and their consequent final battles. The maharajas, rajas and Thakars who were involved in an index of violence that seemed almost predestined to end in the acrid vapors of their funeral pyres.

During the course of these well-attended public burnings, the perpetrators of this violence were accompanied on their last journeys to the next life by hundreds of women gathered up from their *zenanas*. It was the fate of these luckless women to suffer the honor of *sati*, an elaborately choreographed act of self-immolation.

In a ghastly progression, the ladies of the palace, their servants and the prince's concubines, would join their maharaja on his funeral pyre. They burned with their dead prince. Whole cities of Rajput women committed *jauhar*.

I discovered that Mokesh, my companion in the discovery of the dangerous and uncontrollable past of the Rajput princes, was fond of chewing betel nut and then spitting his paan into a small brass lota. His reaction to this vaguely narcotic stimulant was

almost constant sweating, and he seemed riveted to his betel nut fix. Every day, all day.

I had observed lately, to my dismay, that Rajput painting, at least in the state library at Kishangarh, had not survived well. Elsewhere in Rajasthan, coming onto the art market were large numbers of seventeenth- and eighteenth-century paintings from Jaipur, Udaipur, Kotah and Bundi. Happily, one found them in a well-preserved state. But in Kishangarh there had been hordes of hungry insects. Apparently, they thrived on eating this art, wolfing it down.

In manuscripts wherever Krishna appeared, the painters of Kishangarh had worked up particular vibrant-blue pigments. It appeared that the white ants loved Krishna, particularly they had a fondness for both *Ramayana* and *Ragamala* paintings. The ants seemed to be absolutely ravenous for blue pigments.

During the last days in the library by far the largest percentage of manuscripts we'd found had been devoured by these dreadful ants, which had devoured centuries worth of early eighteenth-century Krishnas.

I sank into a chair and covered my face.

"We will be working harder, *sahib zemandari.*" Mokesh spat a huge wad of chewed-up red juice from between his paan-blackened teeth into his horrid pot. "We will work harder than white ants!"

I looked up as Mokesh popped some more paan into his cheeks. With his wall eye, his glasses askew and now with his stuffed

cheeks, he looked like an over-energized manic squirrel. What was I doing here with this indescribable assistant?

Across the room, I surveyed the wreckage we'd made of the library and its contents. Along a 66 foot stretch, on a long table, was a stack four-feet high of the ant-eaten remains of what had once been priceless illuminated manuscripts.

I had a headache. My eyes were gummy from dust that covered the whole library. In the morning, the only light that filtered into the library came through small, dirty windows set at the front. In the distance, young boys were shouting and giving a herd of cows their morning bath in a shimmering backlight.

We'd exhausted the contents of the library and its shelves.

Along the walls of the library, piled onto every floor surface, were the rotting manuscripts that we'd gone through.

I rose slowly. I walked toward the rear of the library until I reached the rear of the almost darkened library. Then I reached out, and with an angry yank, pulled some of the now empty steel shelving away from the wall. In frustration, I struggled with a 10 foot section, and finally wrenched out a long 15 foot section of shelving.

At an angle, I put my head into the space in front of me that I'd just cleared of shelving.

Behind the steel shelves was a single rusted iron door. It was buried into the center of the wall, and on the front of the door was a six-inch circular, rusted steel ring.

Wedging the shelving further back into the room behind me, I gripped the ring. I put all my weight pulling at the door. With a squealing of rusted hinges, the door opened a crack.

After seven minutes of pulling, I'd made a six-inch-wide crack. After a struggle of another twenty minutes with a steel bar Mokesh produced, I wedged the door open.

From beyond the door there was a sudden whooshing sound, and I tried to step back.

A huge pile of bundles cascaded out of the room behind the door. The torrent of bundles broke over me like a wave, and I went down with my back smashing into the stone floor. When the rumbling ceased, I was trapped under mountains of documents along with dirt, cobwebs and pigeon shit from the floor.

Flakes of broken manuscript paper stuck to the small portion of my face which stuck out from the pile that had buried me.

"Mokesh! Help me!" "Dig me out!"

As Mokesh began lifting bundles of documents that had broken their fastenings, he said over and over again, "All will be well I assure you! *Zemandari sahib*! A moment, sir. A briefest moment. *Zemandari sahib...* "

Even for his diminutive size, Mokesh seemed particularly weak and slow at digging me out. In addition to Mokesh being horribly underweight, he was small boned, and exceedingly puny. Apparently, Mokesh was not used to physical exertion of

any kind. With great pantings, mewings and moanings about his unaccustomed efforts, finally he pulled me free.

"Sir, I am trying. Be of good cheer! I think we have won the battle!!"

As I lay on the floor of the state library, surrounded by new research materials, I felt like I was leaking away my last pools of vital juices. My hands were numb with prickling. I wiggled my toes. I flexed my fingers. I tried my neck. What the hell was I doing here in this godforsaken, hellish library?

"Sahib. I am so sorry, sahib. Are you damaged permanently, sir?"

Mokesh was still panting from his exertions. "Even though a temporary situation, our new discovery has most clearly overwhelmed our researches isn't it?"

Had Mohan suddenly discovered irony? It was an appalling thought.

Sitting up I sat with my back against the wall of the library. Slowly, I raised an aching leg that felt like it had been partially crushed. I stood slowly on the protesting leg, approaching the door, limping and bruised.

From the room beyond came a strange odor. The huge room had been built as part of the fortress centuries before. Stone shelving covered each wall and apparently from the smell at one time the huge room had been an ammunition depot for the upper works of the fortress. It was the stink of ancient saltpeter and sulfur that filled the air.

The only exit from the room was through the heavy steel door, and broken bags of now inert ancient gun powder lined the walls of the entire eastern side of the fortress inside this great room.

The room was perhaps 50 yards deep and 100 yards long. This huge place was lit by a single shaft of afternoon light that leaked into the darkness from a broken stone high up near the roof. Sometime in the past, the room had been given over to the storage of thousands, perhaps tens of thousands of now forgotten state records. In the far corner of the chamber were piles of 200 year old cannon balls.

"My God, don't believe this." I whispered.

Once your eyes adjusted to the darkness, shelf after shelf of orderly paper bundles marched down the length of the gallery. The entire vaulted gallery was filled with books and, I hoped, illuminated manuscripts.

* * *

In the gloom of the forgotten library, which no one had seen or touched since the last years of the eighteenth century, I turned slowly in the darkness.

In the huge room buried within the fortress walls, I moved toward pile after pile of neatly stacked state documents. After a quick look at the piles, Mokesh determined that the documents in this archive dated from the fifteenth century to the mid-eighteenth century. With a bit more research, Mokesh determined the documents and paintings in the manuscripts had been entombed here during the period of the Maratha Wars. It was during these vicious no-quarter given wars, with their

unending battles, that the Mughal Empire disintegrated, during the middle to end of the eighteenth century. In a holocaust of dissolution, an entire continent was reordered, and the British emerged as "the paramount power" in India.

It seemed the everything in this huge room had been forgotten. Perhaps we were the first men to step through the door of this library since the time of the American Revolutionary War.

How in God's name did anyone even start digging through this many documents? It was a vast project.

I stood there. My discovery was a miracle beyond calculation.

Opening a manuscript at random from a shelf set against the walls, in the dry desert air of Rajasthan the manuscript seemed in perfect, miraculously preserved condition. I picked up a second and third manuscripts. Each was equally startling and each of these two manuscripts was, likewise, astonishingly preserved. How bizarre this was, given the condition of the manuscripts we'd found in the state library beyond the door, that had been irreparably destroyed by white ants.

I went outside and stared down at the lake.

It was nearly sunset. Fire clouds covered the hills beyond the lake. In the sky billowed gigantic towering cumulus clouds, while in front of me the lake went from gold to red then gradually toward black.

Mokesh appeared on the ramparts next to me. He looked dirty and tired. There was not much of him. He stood barely four feet three inches tall, and I am sure he weighed less than eighty

pounds. It suddenly occurred to me that everything I wanted to do in Kishangarh in this new archive depended solely upon this single small man. I towered over him. In the semi-darkness, Mokesh looked even more diminutive.

"Mokesh, we will need help getting these manuscripts behind the wall out. This task is absolutely beyond us."

"Sahib. Tomorrow we will fix up tables. Tomorrow we will set our discoveries out under a shamiana on the ramparts." Mokesh paused. The Rajput's and the local princes of India used this kind of huge tent, a shamiana, as a kind of forecourt for their durbars and for formal gatherings of state.

"It is my responsibility, charged to me by himself the prince, to do the complete work *Sahib Zemandari*." Mokesh drew himself up to his full height. " I will get ten not so smart palace peons to help us with our discovery. We start taking out manuscripts. I want to chase up four smart peons, sorting said manuscripts to find said paintings, and illuminations!"

I reached out and put a hand on his small shoulder. *"Shabash, risalder sahib!* Well done! A wonderful idea Mokesh! Indeed. Thank you."

Mokesh looked up and there were tears of gratitude in his eyes. "Sir, I thank you. This being a wonderful adventure. If pictures of princesses and maharajas are discovered I will tell no one, because you trust me now! I have your complete trust now. Isn't it?"

I wondered about the old librarian in Jaipur and whom he really was. I avoided the subject completely.

I think Mokesh had been miserable in his role as a spy. He was a terrible spy. He was a person without intrigue. And now he had a new and gigantic task in front of him that only he could accomplish. Fiercely and unexpectedly determined, this diminutive man had pledged to help me in every way that he could. Mokesh actually glowed.

Turning and limping from legs that had been almost crushed, I tottered towards my room. On my *charpoy* I stripped off my clothes. Both my calves and thighs were bruised up to and beyond my kneecaps. I felt like a water buffalo had rolled on me.

In the bathroom, I took a bath in the tin bucket provided by the palace. I laid on the bed and began to read. I wasn't hungry and didn't send for my dinner. I feel asleep thinking that yet again the maharaja neglected to send a set of the dancing girls to my section of the palace.

* * *

In the next month, my life was a blur of discovery. It was unbelievable what we'd unearthed, and yet the Maharaja who certainly knew of our work, remained uninterested.

One week slipped into the next. My work, previously, had been a doomed foot race between the white ants and historical discovery. But in the new library, as I called it, the strange effects of disintegrating munitions and saltpeter had proved too much for the dreadful white ants. Every day now, I was winning my race with the ages.

Gradually, with almost painful slowness, piles of manuscripts were transported onto the ramparts of the fortress. Under the tent-like shamiana Mokesh was inspired. He was like a diminutive, whirling dust devil. He must have been jet-fueled by hundreds and hundreds of pounds of the palace-supplied betel nut he chewed. Mokesh was everywhere. Pointing, spitting, stacking, reading and directing.

After four weeks of work, I counted hundreds of paintings which I'd extracted from the forgotten archive.

The paintings were sorted and then moved to into my ever growing stacks of paintings on the tables. These were the crème de la crème of Kishangarh painting.

In each painting where Krishna appeared, he stood out in the dazzling blue pigments of his nakedness. Individually and collectively, the paintings of Kishangarh during the height of the classic period of the eighteenth century were simply dazzling and in near-perfect-to-mint condition.

In the piles Mokesh also discovered the earliest manuscript in the library. It was in Nagari script from the late ninth century. I opened carefully. This was one of, if not the earliest manuscripts in Rajput history, and it was engraved on small metal plates.

On one of my tables, I'd made a pile of the greatest, the most spotless and perfectly preserved, almost new-looking illuminated manuscripts.

There were a half dozen of these which I was determined to carry off. The manuscripts, and the paintings inside the manuscripts, covered the critical period of Maharaja Sawant

Singh in the mid-eighteenth century but they also included the earlier reign of H.H. Umdai Rajahai Buland Makan Maharaja Shri Raj Singhji, 1706-1748. In the six manuscripts, there were masterpiece after masterpiece of Kishangarh.

I compared these new paintings from the archives to the paintings which had been once owned by Essaji and Nowlakha which I'd previously bought. They were perfect matches in both style and color. But my new pictures generally, were far, far better in execution, observation and condition.

Many, if not most of them, were characterized by genetic markers of the Rathore Rajput's of Kishangarh. It is a hallmark of Kishangar painting that the figures in such paintings have an distinctive elongated eyes. It remained, of course, how to get these paintings out of India but I didn't think that this would be much of a problem. In India during 1962, unlike the export of Indian classical sculpture, no one on the subcontinent seemed to bother about the export so called "Indian miniature paintings."

To the Indians at this point they weren't art. Amazingly, at least to me, Indian paintings existed as some kind of still diminutive, decorative art of negligible importance. In Kishangarh itself no one in the palace apparently had the vaguest interest about their own significantly important art.

I knew that as a great art collector you had to be early. You had to always be early, and you must have a great "eye."

Perhaps I was too early, but no one on earth would ever find, or be able to assemble a Kishangarh collection like this again.

* * *

I commissioned Mokesh to buy four nondescript tin trunks in the bazaar. In the market, I bought eight brightly colored thin cotton quilts. These cotton blankets, in gay colors, would make simply splendid packing material for my four tin trunks full of paintings. I had Mokesh wrap the quilts around the paintings, then pack up my trunks.

On a late afternoon, I made a final trip along the colossal parapets of the fort.

I saw the Maharajas ADC, the brigadier, that last day. I met him in his office and thanked him for the maharaja's hospitality. The brigadier nodded and remained seated behind his desk. He favored me with a single sour smile. I asked him to present both my thanks and my leave-takings to the maharaja.

The brigadier stood abruptly. He shook my hand once, mumbling a few sentences that were unintelligible. Then I was looking at his back, as he made his way out of his office without saying goodbye.

Two days before, I'd made a single request of the maharaja. I had asked the brigadier, as a reward for his difficult and important work, that Mokesh be made the state librarian of Kishangarh. In our mumbled final conversation, the brigadier had told me that Mokesh was already the state librarian. The collapse of kingdoms was indeed sad. Mokesh had never been allowed inside the library by the maharaja.

On my last night in Kishangarh, I watched my last sunset over Gundalao Lake. I stood on the castle parapet. A cold wind had sprung up and I wrapped my arms around myself. It was simply incredible to me that this family had let so much of the greatest

art ever done in India simply rot away. What I left behind were several thousand paintings, and it was certain there were further caches of painted manuscripts. These paintings would come from cabinets in distant parts of the palace where they had been forgotten.

As the sun sank into the desert on my last night in Kishangarh, I had a feeling that the days of palaces and princes had drawn to a close in India. Perhaps one day the palaces would become hotels for foreign tourists and rich Indians. A forlorn hope I suppose. I hated to see these incredibly grand buildings rot away and collapse.

The next day, I left Kishangarh. It was cold and nastily damp.

A thin rime of ice lay on the roads. The bus I rode traveled north along the same road I'd come down two months before.

The peasants outside the bus, on the outskirts of the town moved toward the sunrise and I hoped a better future. In Ajmer, at the bus stand next to the market, I changed buses and I boarded the bus to Udaipur. That morning, I was filled with a terrible feeling of lethargy and anti-climax on my journey toward Udaipur.

* * *

Three days later, I finished the final arrangements with my shippers. I was in the Gujarati city of Surat, on the flanks of the Arabian Sea. I arranged shipment of my trunks to Kuwait. From Kuwait, I paid for air shipment to Berkeley, California. The address I gave was the house where my parents lived with a view of the San Francisco Bay.

Four weeks later, in Delhi I received a cable from my father.

In the cable, my father asked me why I had taken so much trouble shipping, by very expensive air cargo, hundreds and hundreds of weird little paintings. The question involved a very long answer, and I couldn't give an immediate reply. My father also said he was baffled, and didn't understand my continuing attraction to Indian art.

How could I describe a mania for collecting Indian art in a three-sentence cablegram?

* * *

NOTEBOOK 5

1963

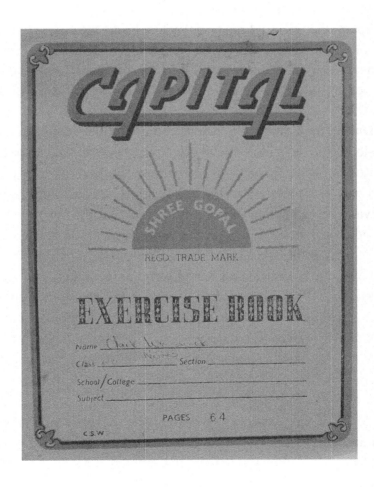

KABUL, JANUARY, 1963

That January, Kabul was stuffed with resident freaks.

In the capital's streets, the whole world seemed to have descended upon Afghanistan. There were junkies from Japan, Mexico, Sweden, Canada England, Holland, Italy, Greece, Spain, the US and France. They had heard the call. Afghanistan was it. In Kabul, individually and collectively, they loaded up on a huge buffet of drugs and, of course, in a riff of sartorial excess, clothing from the period of *Ali Baba and the Forty Thieves*.

During the last week in Kabul, things had been going at a very slow pace, absolutely nowhere. I was trying to find antique Russian Bokhara carpets. My carpet "connections" in Kabul had a way of promising magnificent carpets, then disappearing. It was as if, with their impenetrable medieval rug negotiations, these dealers were developing mysterious, brand new epic fictions. I felt like a figure in a Kafka-period story. At the best of times, the rug dealers of Kabul were faithless and Machiavellian. On the other hand, perhaps the semi-nomadic rug dealers of Kabul had vanished into the mountains to be with their loved ones. What possibly could be more fun than a week or two tending the goats and camels, beating their wives and children?

The day was warm, but you knew the winds of Siberia were out there, waiting. I telephoned Jane and we set up a day and a place to have lunch. I wanted to eat again at Manhood's off Chicken Street near the bazaar. It had become the place to go. In the orbit of her princely friends, Jane, by rumor, seemed to have become a social fixture in Kabul.

Two days after we had spoken, I approached Jane's table in the small, smoky restaurant. Jane looked up. She smiled sweetly. I bent over the table and kissed her cheek like Europeans had started to do in Asia. I studied her in a hopeful way. She didn't appear to have yet completely given up food for dope.

Jane brushed away a long strand of blonde hair which had fallen down in front of her face. "Where have you been?"

I leaned forward and smiled. "India. Pakistan. Europe. And for now, here I am."

Jane stared at me for a long moment. "These days in Kabul, all the people who come here are so zoned out on scag and God knows what else, they can't walk in a straight line. I've missed talking to someone who isn't a walking zombie."

Settling back into her chair, Jane produced her inevitable tin of Players. She seemed to have an ever-present supply of these impossible-to-obtain cigarettes. I decided she must get these tins through her friends, the South American diplomats, who had set up in Kabul, producing their incomes through use of the diplomatic pouch, and supplying difficult-to-get consumer staples like Johnny Walker Black Label, European cigarettes, and New Zealand butter to the locals.

Jane lit up then waved the match out. "Such a treat. So nice to see you again. A friendly face. I missed you. Prince Selim and Dara have been out on tour in the dusty hinterlands for weeks. I'm all alone in my palace. More and more they are 'out of station,' dealing with the recalcitrant natives, as the British were wont to say during our bygone era."

Jane seemed thinner than when I'd last seen her, but it was
difficult to tell. She was dressed in a *soigné*, shapeless smock
sewn from random calico patches. In her calico sack, she looked
very British mod. Jane was one of those singular women who
could wear anything and look as if she'd just stepped out of a
copy of *Vogue Magazine*.

After not seeing Jane for months, I decided, somehow, she was
one of those rare people that were whole and complete inside
their own skin. When I thought about it, I came to realize, in
the years I'd known her, that Jane didn't need either love or
emotional relationships. Perhaps she lacked something inside
her which caused her to need other people.

I ordered chai and murgh. "So what have you been up to?" I
asked.

"You won't believe this . . . I am becoming an international
sensation."

Sitting there in a heat haze of smoke from the kitchen, I asked
what an international sensation was. "You see all the freaks
here? They've created a distinctive kind of roadie, exhausted-
Asian sartorial appearance. Right?" Jane paused. She took a
deep drag on her cigarette.

"As you well know I love to shop. So I started a business where
I can shop every day, all day long if I want. Now with Selim's
help, I have boutiques in San Francisco, New York, on Carnaby
Street and Portobello Road in London. I also have shops in
Paris and in Amsterdam. I'm exporting everywhere *the Kabul
look*. I'm the toast of the New York and Paris fashion industries.

I started out with the idea that I was determined to change the way the British dress. The men in Britain look like they are sewn into used oatmeal sacks don't they? And the women! Oh, my God let's not get started on the absolute drab, dull, haggard women of Britain, with their sallow pudding- like figures and their beastly complexions."

"How is it going?"

"I'm winning beyond my wildest imagination." Jane looked over at me and smiled sweetly. "All of those years in advertising . . . those dreadful terrible years of excruciating boredom . . . none of it went to waste. I'm soon a millionaire if I'm not already. I have been described in the New York Harper's Bazaar as a person who has caused an 'earthquake of fashion' exporting *the Kabul look*."

Jane studied me. She smiled her long-distance smile. I realized as I sat there that she and I had known each other for years. In Kabul, we had something that passed as a friendship. As I considered this, I'd probably never know how difficult it was for Jane to have a friendship with anyone. She was British. English people seemed to be shy creatures, who only made friends with great personal struggle. Perhaps Jane's parents had never actually touched her.

My chai came. Twenty minutes later, our murgh and naan arrived. I'd ordered a whole chicken and we made a feast of it.

After the meal had been cleared away, we watched the freaks shuffle in and out of the restaurant. There were more Germans in Kabul those days than anyone else. Every one of them had

perfect Nordic looks. They looked like the children of the Aryan gods, they were so beautiful. Then, you looked again, and under the perfectly formed features, they were filthy, emaciated and strung out. When these northern gods spoke, it was only haltingly. They had difficulties of both focus and concentration. I turned my attention back to Jane. God! When I looked at her, she was so striking. She was going to absolutely tear up the fashion worlds of both Europe and America.

Out of her Afghan calico bag, Jane produced a two-inch-by-two-inch object. She held it in her hand. She looked down at it for a long moment. Then she slid it across the greasy tabletop of Manhood's toward me.

I looked down at the object and my heart skipped a beat. It was an ivory object from Begram. The small ivory plaque had the patina of old book leather.

The object was very old. The ivory had been discolored by age and I held it up to the light spilling in from the doorway to get a clearer look at it. The ancient plaque was carved with two cavorting elephants that had their trunks wrapped around each other in an elaborate, almost Arabesque pattern. Across the table, Jane watched me with a detached, if habitually cold, curiosity.

One of my lesser crimes these days was reading. My lasting failure in academia at Santinikitan had never affected my taste for research. My interest in Afghan archeology had first been sparked by the pieces like this that I'd seen in the Kabul Museum. Lately, I'd too spent much time reading up on the French Afghan archeological expeditions begun in 1922. For some reason, these expeditions fascinated me.

Under the direction of a polymath named Jules Alfred Boucher, the French mapped hundreds of ancient Afghan archeological sites. For almost 30 years, until World War II, the French had Afghanistan as a virtual archeological preserve all to themselves. It was the French who had excavated a site at Begram in the 1936-1939 period.

Oddly, for the last week in Kabul, I'd spent my time reading about the French-Afghan archaeological expeditions. My reading distracted me while I waited for my peripatetic rug merchants to show up again in Kabul. The most fascinating part of these archaeological reports concerned the greatest Afghan finds in the country.

These finds had occurred at Begram. They were made by Joseph and his wife Riau Hackin, who seemed to have an otherworldly knack for finding superb objects. Tragically, after they joined the Free French Forces fighting the Germans in World War II and in 1942 the couple were killed. Since then, their work had been largely forgotten as they'd never had the chance to either collate their discoveries or publish them extensively.

I turned the plaque over and over in my hands. It caught the light on its different facets.

"Extraordinary," I said. My only thought was that this had to be one of the Hackin objects. I must be. Only a few objects in the Kabul Museum were this good.

The hairs rose along my arms. I think I knew where Jane had gotten this object, but was that possible?

Definitely this object came from the Hackin's dig in the ancient royal city of Begram. Definitely it was a find from Site I or Site II from the first century AD. According to a brief catalog of the Hackin objects published by the Musée Guimet in Paris, the only other known examples of art from the Begram dig were in either Paris or the Kabul Museum. Somehow this piece had broken loose.

It didn't take me long to think about who owned this piece. The ivory had been intended for the Afghan state collections but it had been "withheld" from the state collections by the king of Afghanistan, Zahir Shah. I didn't think a single first century AD Afghan-sourced ivory Kushan object from Begram had ever appeared on the market before. I wondered how long Prince Selim had owned this object.

Jane's eyes moved down to my hands where I held the plaque. "I want to sell this," Jane said.

I was abruptly wrenched from my thoughts about Begram back to the present. "Besides you, who wants to sell this?"

"I can't say."

I'd been worried about this happening to me. For years, I'd been worried about finding the impossible object which could get me into a huge amount of trouble. This object was absolutely impossible to resist, and attached to great objects like this there were also great dangers. In Kabul particularly, one had to be very circumspect about things possibly "appropriated" from the king.

In a place like Afghanistan, an object like this could possibly get you killed. I raised my eyes to Jane's face, and studied her before I asked, "I'm wondering if this object comes with a free pass out of Afghanistan?"

Jane smiled beatifically. "Actually, I think you know that already,"

I took this reaction to mean that the "authorities" in this case were probably themselves the sellers of this object.

Jane continued, "Perhaps Prince Selim will even drive you up to the border in a large automobile. Then you'll walk out of the country into Pakistan with an armed escort."

I took this in. It was too soon to plunge but I began to have vague hopes about this unbelievable object. This brought me back to my researches.

The French had amassed a huge cache of archaeological objects. In total, the discoveries around Begram amounted to approximately 2,500 objects. This included Bactrian gold objects and Kushan-period ivory statues and plaques, as well as Roman and Egyptian brass statues, a collection of coins, and Chinese lacquerware from the time of Christ.

The conquests of Alexander the Great had carried the art of Greece to Afghanistan during his conquest of the country. This Mediterranean invasion was to have indelible, millennial impressions upon the arts of India and upon the art of Far Asia. The art of Afghanistan was the direct lineal descendant of the classical period of Greece.

In Afghanistan, wherein comprised the spine and watersheds of the Hindu Kush and Karakoram mountains, a series of forgotten two-thousand-year-old Greco-Buddhist kingdoms arose. The art of these kingdoms was transformational.

This was the art of the great transcontinental caravan and pilgrimage routes which came in time to be known as the "Silk Roads." It was along these roads that the arts and culture of Buddhism traveled from India to Asia. On a map, the Silk Roads stretched from the Roman Empire across central Asia to Far Asia, and still further eastward to China.

"Are there other objects where this came from?"

Jane smiled distantly. "Think about that possibility while you finish your dinner."

I thought this over. How often in one's life does one see any art the quality of this object?

"Do you know what this is?" I asked slowly.

"I think this must be your lucky day. Or perhaps your lucky month or even lucky year."

I left my dinner on the my plate. "Do you know of more objects like this?"

Jane touched her lip and picked a piece of tobacco off the corner of her mouth. "It's a small ugly plaque. It is very old. I'm more of a textile person myself. Essentially, I'm not much interested in art objects. Show me an early eighteenth-century brocade and you know I get all hot."

Jane looked at me distractedly. She wound her hair around and around her index finger.

I placed the plaque on the table between us. I edged into this very cautiously. "How much does the seller want for this?"

Jane stared into the distance. She rubbed an index finger against her cheek while she was lost in thought as she considered the answer.

Jane's eyebrows lifted. "I think the seller wants 50 for that. That would be US $50,000."

"I don't have $50,000. I don't have anything like that."

I felt sick. Right then I had about $4,250 to my name. I looked down at the plaque on the table. I sat back and I felt this unbelievable object slipping away.

"How old are you?" Jane asked.

"23."

"Well, how about $23,000 then?" she suggested brightly. She looked across the table at me.

Evidently, what she saw convinced her that I didn't have $23,000 either.

"Just a joke," she said. "Didn't mean to taunt you. I'm going through a nervous patch myself."

Jane leaned across the table. "I wonder if you can understand why I left London? Do you know or do you have the slightest inkling what I survived in London? Before I came out here where I presently spend my time facilitating international art criminals like you. Every day— each and every day—I went *mano a mano* against seven rampant, bull advertising bitches. Each of them had bleached streaked-blonde hair. Each of them dressed in identical Liberty print dresses and all of them originated from good addresses in Knightsbridge."

More tea came. I warmed my hands on the hot cup. I took a sip of scalding liquid and thought that definitely this whole thing was not meant to be.

Thank God for Gautama Buddha. I had learned in the East that there were things that went your way and other things that would never probably happen. Buddhism came to my rescue. My *wa*, my inner being, told me this was not going to work out.

Jane reached out. She took the plaque from the table. She dropped the plaque into her cloth bag and looked up at me. Right then, she looked totally manic. "This is very sad isn't it? About the money part? Oh, God. Money shouldn't fucking ruin a splendid friendship, should it? Let me make this up to you, ok?"

I sipped half my tea without speaking. In my estimation, it was money that seemed to ruin every business deal. I almost laughed at my joke but I refrained.

Across the table, Jane folded her hands in front of her and then rested them on the table. She looked like she had simply erased

the whole negative part of this conversation from her memory. Drugs did that to you.

In truth, right then I felt like I'd been kicked in the stomach. I tried not to show pain. This plaque was the miracle object the likes of which I knew I'd never see ever again in my life.

Across the table, Jane fished around in her purse again for her Players tin. She dipped into the tin and produced another of her dreadful cigarettes. She lit up, taking a deep drag down into her lungs. Slowly, Jane exhaled smoke from her perfectly shaped nose, set in the middle of her quite beautiful and exotic face. She looked at me in a quite vampy way. Right then, however, I felt I'd just drunk a cup of poison and I was just waiting around for the final, fatal effects.

Leaning forward, Jane reached out. She patted my hand. "Don't look so gloomy. For years I've been trying to close down my *chakras* below the navel. I think over the years this has caused me problems on a personal level. You know what I mean? But lately I've become so good at shutting down my *Svadisthana chakra* that I think it isn't something I can easily open up again."

"I am dying here, Jane. I am really upset. What the fuck is a *Svadisthana chakra*?"

Jane patted her lower chest. "It's nestled in your core. Its female energy, my man. It's good female energy."

"Actually . . . Please, Jane. I'm feeling absolutely, totally miserable. I'm not up to talking about your *chakras* and your female energy right now."

"Well. Other things come up, you know. You know all is not lost until you believe it is, my friend." Jane took another deliberate hit on her cigarette. She fished in her purse and withdrew the plaque that she'd shown me.

Carefully, she centered it on the table. Then she reached into her purse again and withdrew another plaque identical to the first.

Deliberately, she squared this second plaque with the first plaque. "Better two than one, don't you think, sport?"

I stared down at the two plaques. At first, both ivories seemed identical but, after a bit of closer study, the second ivory was a sort of a progression from the stance of the elephants in the first ivory. Placed together, it was as if both ivories were in motion somehow.

From her bag, Jane withdrew a third plaque. Each plaque was a variation on its predecessor.

"This is torture, Jane. Torture. Stop. Please," I whispered.

Then, Jane produced a fourth and, finally, a fifth ivory plaque.

 Each plaque was part of a progression of the elephants' stance in the first ivory. Seen together, as a progression, the plaques exhibited elephants dancing.

On the table, Jane arranged the five plaques in sequence. In the dim light of Manhood's chicken palace, with my back to the restaurant wall, I stared down at the ivories. The plaques were a total miracle.

Each plaque depicted cavorting elephants in the dance of life.
They had once formed the belt of a princess or a queen perhaps.
Each ivory was an unreserved masterpiece. I saw how they fit
together now.

I sucked in my breath. "They are unbelievable. They are
astonishing. They are so beautiful."

I'd felt nothing in my life like the rush I got that moment. I
hardly dared touch the ivories. They were the impossible
objects. They simply swept me away.

"Five times 23 . . . let's see…that's 115 K that takes them.
Going . . . Going . . .' Jane seemed to be running her own little
auction. "Would you like to listen to a proposal?" she asked
suddenly.

This had become so aberrant, and the stakes were now so high,
I was afraid to hear what her proposal was. I nodded.

Over the ivories, Jane leaned forward. "The proposal is this . . .
The owners of these objects want you take them out of the
country to Europe. In Europe, you make the best deal you can
for these plaques. You then deposit half of the proceeds into a
Swiss bank account. We will give you the number. . They told
me you don't have to put any money up front."

"You don't want any money up front?" I was afraid to speak. It
was unbelievably generous, this proposal. "You'll absolutely
trust me with these things?"

"We will also provide you with $4,000 for traveling money to
get to Europe. So you can get around to wherever you need to

go. In addition, you also get safe passage through Afghan customs and immigration. But the final condition of this transaction is that, after this, you're on your own, my lad."

It was an implausible, unaccountable, wildly generous proposition.

At this point in time, the most expensive object that I knew about in the Indian art trade was a Mughal period painting from the imperial atelier of Akbar. It had sold in London for $10,000. These ivories, however, defied artistic value. The objects in front of me existed beyond the realm of the credible.

I took a deep breath. "And . . . If I accept? . . ."

"Of course you'll accept." Jane interjected. "How could anyone involved in the art trade not accept an offer like this? You were our very first choice to sell these, I might add. We've had a complete and thorough report of your comings and goings in India. We undertook a study of where you went and what you did." Jane paused.

"We paid the ever crooked people of the Indian CID an enormous amount of money to show us what was in your files. The Indians seem simply obsessed with foreigners and with you in particular about what you've been doing in India. I don't think they've ever seen an ex-student art collector before. Could you tell me why you've spent months at the Asiatic Society reading rooms in Bombay and Calcutta? The CID has no idea. They've been turning both libraries inside and out searching for your secret code. At that, the CID had no idea how you are getting your art out of India. You've seemed formidably discreet about your art and where it actually is."

I didn't know that the CID agents in Bombay, Delhi and Calcutta showed sold the contents of their files to the Afghans. I decided this was a heartening sign. Even more heartening was that I'd baffled even the CID in removing my art from the subcontinent.

"What if it turns out I'm not honest and I am afflicted by a desire to travel to remote places? What happens to you if I take these things and just disappear?"

Jane stared at me for perhaps five seconds. "Selim, the prince, is very careful. They went to a great deal of trouble finding out everything about you. About your schools. Your family. After a thorough search of your life, I would say that honesty seems to be a sort of a genetic failing of yours, at least from an Afghan point of view."

I laughed.

"At first, Prince Selim was quite baffled by you. I had to explain to him that there were whole Western countries where honesty is considered a virtue, and not a moral failing."

I took a deep breath. "So . . . what are my schools?"

Jane rattled off my schools, all of my schools. Then my university. She told me my mother's university and my father's university. It was very impressive, the work they'd gone to.

Jane continued, "Dara even had all your rug dealers gathered in. They were sent away for a bit. Dara thought that would concentrate your mind. They wanted you to able to center your

thoughts and not be distracted by rug negotiations."

I thought that was uncommonly kind, of Dara, considering my state of mind.

"I've been their guest for almost two years, "Jane continued. "I owe Dara and the prince a huge amount for taking me in. I agreed to approach you. Less threatening, I think, since we're friends. I don't think they like Americans. They think Americans are quite devious, in some unfathomable way. I think you are quite unusual. For an American, that is."

Amazing that both the new *courtier* sensation and the largest Afghan in the world thought I was a magnificent, solitary and good person! What more could I ask?

"So you will do this?" Jane asked.

I nodded.

"I'll get the best deal I can for you. Your money will be in the Swiss account." Jane paused and looked at me on last time. There was sadness in her eyes. "This is a one-off. Next week I'm leaving Kabul. I'm going to America and tending my growing mercantile empire. They don't want either of us in Kabul in case this blows up."

I watched Jane. I didn't answer for perhaps half a minute. "I thought of you as a permanent fixture here. My beautiful, ever present Afghan lodestar."

Jane looked away. There were tears in her eyes. She turned back and stared at me for a very long time in the smoky darkness of the restaurant. "That was very kind of you. Thank you dear."

Jane wiped her eyes with long fingers trying to master her emotions.

"Are you sure you don't want to go into the courtier business with me? You're utterly charming. You'd be very good. I'll know some quite very good contacts in the bazaars of France, England and America."

I laughed. "You go into the dress business. I'll come visit you on Carnaby Street. Better you than me."

Jane stood and hugged me. "Always, so mordant."

She looked at me one more time, then she turned and left the restaurant.

ROME, JANUARY, 1963

In Delhi, the Indian immigration and customs had waved me through their dangerous, tangled thickets of bureaucracy without a glance.

No one opened my bags. No one searched my bags. An incoming flight had just dumped its passengers into the customs area as I was leaving Delhi. The customs officers tore into their new batch of customers, absolutely shredding their luggage with not a second look at me.

Ten minutes after takeoff, I settled into a deep dreamless sleep and slowly the DC-8 rose into the Indian night. I was in Rome the next day, in the late morning. The Alitalia flight from Delhi to Rome was on time, precisely to the minute.

I took a bus into the city. The hotel I found was medium sized and anonymous. It was on a side street, a block and a half from the railway station. I'd found a hotel by asking the bus driver for a medium-class hotel within walking distance of the railway station. Down a nearby narrow street from my hotel, I found a nice restaurant. Curious about my expenses, I added up my liquid assets on the napkin.

I had $3,800 with me. It was enough money to live with my friends of the last years, the kindly Buddhists of the Maha Bodi Society in Bombay and Sarnath, for the next 50 years. At the back of the restaurant, I carefully considered my art selling campaign of the Afghan ivories.

After my meal and wine, I ordered a double espresso while I considered my plans, which appeared to me in a flash of yogic intuition of perfection and completeness—of paramita!

Thinking about the pageant of my life lately, it was all just about perfect. On the most happily positive note I could think of, I didn't seem to be preparing myself for a useful middle-class American life. I tried not to think of the draft. I tried not think of my now apparently obligatory US Army service in Vietnam. I tried not to think of my contemporaries lying face down, and blown to pieces in a water-filled rice field somewhere in the Mekong Delta. Progressively, I was becoming less and less patriotic.

I returned to my Roman hotel. I had a shower and then fell into bed for a much needed, dreamless sleep. At four-thirty the next morning, I exited the hotel by the back stairs. Circling back to the railway station through the deserted streets, I reached the Roman railway station. I bought a second-class ticket to London via Paris.

I boarded the 5 A.M. train to London. No one followed me onto the train at this early hour.

By three o'clock , and 10 hours of train journey, I had the last bits of my plan to sell the ivories in Europe.

Over the last few years, I'd become a sort of friend of one Monsieur Maurice Rheims who toiled in the fields of art commerce at the queenly Hotel Drouot in Paris. At the Drouot, the main auction house in France, Maurice Rheims was one of

the 77 government-licensed *commissaire-priseurs* (government-supervised auctioneers). It was my opinion that, in all of Europe, Maurice Rheims was without peer, in both his contacts and his almost monk-like studies of west Asian art. In another era, he'd have been a pirate captain, a buccaneer. In 1963 Maurice Rheims was the greatest negotiator of art deals in Europe.

At the center of my plan was a little known fact: since the late 1930s, Maurice Rheims had been the personal agent of a reclusive Armenian art collector named Calouste Gulbenkian. Gulbenkian was one of the richest and perhaps five greatest art collectors in the first half of the 20th century. After Gulbenkian died Maurice Rheims became the sole art dealer who dealt with the heirs of the always mysterious Gulbenkian.

As the train crossed the French border, I put the last of my plans in order. It was of paramount interest to me that, in Europe, no one knew where I was or where I was going. With the recent biographical excavations of my past by Dara and the prince, I didn't leave Kabul with great feelings of trust. I'd recently come to the opinion that one could ever be too paranoid in matters of art transport and art smuggling. It was a lesson Maurice Rheims had pounded into my head.

I resolved to visit Paris and to make a call at the Hotel Drouot.

* * *

PARIS, JANUARY 1963

It was Monday. I'd waited through the weekend.

I looked across the narrow alley towards the café opposite the Hotel Drouot.

For decades, Maurice Rheims sat in this café reading his morning newspaper. As always Rheims was there. On the left bank, by the Sorbonne, in my third-class hotel, I'd changed back into a nice grey suit. Inside a canvas U.S.-made Second World War gas mask bag rested the five Begram ivory plaques, which were wrapped in brand new pairs of thick winter socks. Maurice was the sort of person who'd love the baroque honesty of a serious art deal, wrapped up in winter stockings, inside an army surplus gas mask bag. I always felt it was the little personal touches that counted in commerce.

I crossed the alley and entered the café. Without invitation, I sat at Maurice's table. The auctioneer didn't look up. Behind his newspaper, he continued to read.

The paper didn't move. "Whomever you are, go away. I do all my business in my office. Not at breakfast."

I reached out and with my index finger lowered the paper. "Hello, Maurice."

For a terribly long moment, Maurice stared at me. He was a heavy man, gone to overweight, after decades of expensive culinary excesses. "I thought perhaps you were in Persia, or in horrible, infinitely awful Afghanistan, a drug addict in hell. I

simply shudder when I think of the terrible places you seem to favor."

"I need your help, Maurice." Why not just charge right in?

"It's a wonder you're still alive. I've always loved reading books of grueling travels. But it's always baffled me, my friend, why, year after year, you spend your time in ghastly places."

The auctioneer glanced over his shoulder. He motioned to the bartender. He pointed to his own cup of espresso, then at me. He raised two fingers.

Rheims peered at me over his largish bomber-style glasses. They had been framed in a kind of thick, unattractive black plastic. At some point in the past, perhaps he'd thought they were very sophisticated.

The auctioneer looked idly around the café checking out the other restaurant patrons, before turning back toward me. In my relatively short experience with such things, it seemed that Rheims' entire connection to the art world centered upon spying, and being spied upon, in the making of money.

For a long moment he watched me. "You always need my help. I've decided in your absence over the last year, since I last saw you, that I find you charming. But in the last year, I've also decided that I am getting an ulcer from dealing with fools and people who waste my time. I do hope you've appeared in Paris to both charm me and show me something remuneratively interesting."

No mucking around and being courtly for Maurice today.

Out of my gas mask bag, I produced a pair of attention getting rolled-up socks. Maurice pushed himself back from the table in mock horror. I next placed the socks on the marble table directly in front of him and, out of one of the socks, I removed a small paper packet. From the packet, I extracted one of the ivory plaques that Jane had first shown me in Kabul.

I slid the plaque across the table toward the auctioneer with two fingers.

Rheims was a man of meticulously kept habits and great concentration. He studied the object on the table from two or three angles. From his breast pocket, he extracted a loupe. He then picked up the plaque, and with long, bony fingers he adjusted the glass. For a few minutes, in complete silence, he studied the plaque closely under the perfect northern light spilling in from the alleyway behind him.

Finally, Rheims put the plaque down. The waiter brought two coffees.

Rheims sat in silence, gazing into middle distance with an unnerving concentration while I drank my cup of superb espresso.

Finally, Maurice looked up at me.

"Ivory. At least two thousand years old. Probably Indian ivory, since these don't appear to be either African ivory, or Egyptian objects. That would make this, I would say, one of the earliest Indian ivory objects in the world."

390 · Clark Worswick

I asked acidly. "I hope you still find me charming."

"Dear boy. For an object like this that is perhaps two and a half thousand years old, I must say, not only do I think you're charming, but you've also far exceeded any prospects that I've ever had for any American. Ever."

I nodded warily.

"I sometimes think, my young protégé, that I'm an even better judge of people than objects. I've always had great faith in your potential, despite your disastrous travels." Maurice patted my arm.

I was startled that Maurice suddenly had promoted me to his protégé.

After taking a sip on his coffee, Maurice settled on looking at me. "I love, by the way, your incredible very soigné presentation of this object. Bravo. Your awful bag is a standout, as well as your socks."

Maurice Rheims laid the plaque on the handkerchief he produced from his pocket. He covered the plaque so it could not be seen by anyone passing our table. In his profession, discretion was the food that nourished his very expensive lifestyle.

I loved collecting art, but I hated selling art. Hated it, hated it, and hated it.

Across from me, the auctioneer finished his now cold espresso in one draught. "I wanted to ask you when I saw you next. ...

don't you think that the people in our field are much less dependable than the objects they sell? My entire life has been consumed by the disappointments of the people who deal in art."

"Your life must have been very difficult lately Maurice," I answered sarcastically. I laughed. I couldn't help it. I could only take so much of this French dealer bullshit.

Maurice placed his hands over his temples and shook his head waggishly before suddenly giving me a charming smile.

I wondered if anyone would ever know the real Maurice? Was his whole presence as the hard-hearted, money-obsessed art dealer just an act? It was probably just one of his many performances, which were possibly just as numerous as his many suits of clothes. At that, how could anyone put up with the Drouot for a week, let alone decades? How could you put up with your colleagues who tried to insinuate their way into your deals, to then steal them?

Between Europe's best burglars and her fine art dealers, I wondered which group was more honest? How did I enter into a life of dealing with any of these people?

Abruptly, the auctioneer stood. He scooped up the ivory and put it in his pocket, then dropped a franc note onto the table. He grabbed my arm and then propelled me rapidly out of the café toward the alleyway.

On the street, we fled in the general direction of the Seine, with Maurice dragging me along.

"I'm sorry I am such a shit sometimes. One forgets who one is. It's an occupational hazard. Everyone wants a piece of you. You forget the sterner moral qualities you were raised with in order to follow the lower classes. Let's walk along together and try to forget the complete moral failings of the art world for a bit."

The women were out in heavy coats as they passed us. Men hurried past in mufflers with their hats pulled down in the wind. We strolled through one of the loveliest sections of Paris in the cold as shopkeepers threw up the shutters of their shops and surveyed the streets in front of them for customers.

In plain brown paper bags, deliveries of still-hot baguettes had been left in front of now closed but soon-to-open restaurants. When we were passing through the traffic around the Paris Opera Maurice turned to me and remarked conversationally, "I remember passing by this very spot near the Opera when I saw the largest art dealer in Paris getting carted away by the Gestapo. In the war, I was taught caution. I was touched by the immense frailty of human relationships."

Again, we began to walk. In complete silence we reached the Seine and we continued walking until we reached Maurice Rheims' destination: the Louvre.

Maurice ran a hand across his face. "We will now go to visit the director of the Louvre's office," he said.

Moving through the museum, we arrived at the director's office. A dour, thin and efficient secretary showed Rheims into the now empty director's office. On an easel across the room was a Lucas Cranach picture. Maurice stared at the painting for

a minute. He took his loupe out and studied the paint on the subject of the portrait's hand before he shook his head.

"Cranach painted hands in a very strange way. These hands are simply too good for this painting. A pity. Why do they always ask me to come here after they've bought paintings like this? Tell me," he asked. "Where does the Louvre get these awful things?"

"I think they come from art dealers," I said brightly, and Maurice laughed uproariously.

We left the Louvre and the higher mythic realms of art and disappointment.

Twenty minutes later, we were settled into another café. This café was near Les Halles. Maurice, who seemed to be known here as well, made a sign to the barkeeper for two espressos.

Our espressos arrived. Maurice Rheims settled back in his chair. Outside, it started to rain in freezing, driving sheets of cold that emerged from the sky with great force. Abruptly, Rheims rose and wandered off to make a telephone call.

For perhaps five minutes, I sat in the café waiting for Rheims' return.

I wondered about my objects. I worried about Maurice Rheims screwing me until Maurice returned. He sat at the table and stared at me. "So. To business"

From his pocket, Maurice removed the plaque in the handkerchief and unwrapped it. "What do you want to do with this plaque?"

"I want to sell it." I wanted to say we had to sell this to the Gulkbenkian family but I didn't.

"Not so simple."

"On to the source, then. I hope this makes it simple, Maurice. As part of what I'm going to you can tell people this object was an arm's length transaction, a "walk in" through the front doors of the Druout."

I hinted about my source in Kabul. He had some sort of a royal connection, and he trusted me with this object. I related the objects age. I related its supposed pedigree with the French archeological expedition of 1936, which had most probably unearthed the plaque 30 years before.

From my bag, I took out two more pairs of socks. I produced one object after another, until four more plaques appeared.

In fascination, Maurice watched as I placed each plaque on the marble table, and I sorted out all five plaques in their proper progression. On the tabletop, they were aligned now in a neat row so that the five plaques proceeded in the sequence of an elephants' dance.

Maurice reached out. He touched the objects. He savored their weight and their patina. Maurice sucked in his breath. He took

out his loupe and turned them this way and that in the late morning light, all the while, he was almost caressing the ivories.

"What magnificence! An object *formidable*. It is almost shameful these plaques are so grand, and so complete."

For a long moment, Maurice was lost in thought. Finally, he laid the last plaque on the table. "There is only one person who has the taste and intelligence to covet these objects. And I would say, my protégé, that there is only one person I know of who can pay a kingly price for these objects."

"And who is that?" I asked with trepidation.

"I think this is . . .certainly, a 10 percent commission. No, it is a 15 percent commission, given how badly you need my help."

I countered. "Ten percent. No more. I must pay the owners of these objects as well as you, Maurice."

Maurice Rheims stared down at the objects once again and muttered, "A monster. I have taken to my breast a monster that carries one of the greatest treasures I have seen in a Second World War gas mask bag, wrapped up in his dirty stockings. Done!"

Maurice Rheims slapped the table then he hoisted me upwards, wrapping his arms around me, crushing the air out of my lungs in a huge hug. After the French tried to cheat you on a deal, they set about beating you on the back or crushing you in sudden friendship.

Out of his suit jacket pocket, the auctioneer took his wallet from which he then removed a blank white card. After he sat he wrote a number on the card.

"He should own these objects. No one but him. It is 10 percent? Yes?" he asked tentatively, again. I think Maurice fully expected that I'd counter with 7.5 percent, or even 5 percent.

"Ten percent," I agreed.

I looked down at the card expecting a name or an address. Instead it was a seven-digit number. Presumably, this was the number of Maurice's Swiss bank account for his 10 percent of the deal.

Maurice bent forward and whispered the bank's name and location in my ear. Almost as an afterthought, he asked. "What do you want for these things?"

The commission first, then the price. Marvelous. He didn't care about the price. Could this be better? Glorious. I could dream up any price. I thought for a moment. "You are the greatest *commissaire-priseur* in France. You tell me Maurice."

Rheims threw his hands in the air. "Nothing like this has ever come up before," he shrugged elaborately in a French gesture of helplessness. "What am I to say? What can I compare these objects with? There is nothing comparable even in the Musée Guimet , where the nation keeps the Afghan Bactria objects."

"Go to the Musée Guimet again," I suggested helpfully. "See how this object measures up against what they have. I

guarantee, Maurice, that you will come back from the Musée Guimet with a great price for this object."

I paused, letting this sink in before continuing.

"Simply thinking of their provenance. They have been stolen from the French in the 1930's by the Afghans. Think of all the people in the world who hate the French. Think of all the people in the world who want to get the better of a Frenchman. Isn't that an awe-inspiring narrative? In addition, I can hint these objects were sourced from the king of Afghanistan's own treasure rooms."

I had a sort of queasy feeling in the pit of my stomach. If Maurice only knew.

Maurice Rheims pondered the gist of this narrative and then laughed.

"I think of all the people who hate the French, and the man I have in mind to buy this object has a special hatred of the French, even though he lived for 50 years in Paris. I think the price should be $450,000. That is a grand price, *non*? And 10 percent of course, to me. That is $45,000. *Bon*?"

"Totally delicious, Maurice," I answered.

I gathered myself together. Since that was about 70 percent more than I ever thought of asking, I had no problem agreeing to the price. In India, I'd learned that one of the greatest secrets of art dealing was to never, ever set your own price. Let the person on the opposite side of the negotiation suggest his price. *Always*.

Maurice took another card from his pocket. On it he wrote an address with a gold pen. "This is where the objects will be delivered. The man you will see is Doctor Perdigao."

"Doctor Perdigao?"

"Doctor Perdigao was Calouste Gulbenkian's family lawyer for thirty years. I think it is only Calouste Gulbenkian himself who can own these objects!"

It was very strange talking about a man who'd been dead for 11 years as if he was still here. "Gulbenkian is the client?" I asked.

Perhaps Gulbenkian was one of those people who had never died and who now lingered on forever in some kind of half-life beyond the grave. As far as I knew, Calouste Gulbenkian had died in the early 1950's.

"Of course. It is the great Gulbenkian himself who is the client. Who else could possibly buy these objects or take up this price we're asking? Do you think at some point the king of Afghanistan might miss his ivories?" Maurice asked suddenly in a worried way.

Maurice *knew*.

I ignored the question as much as I could, and I said. "I think the king has so many objects he's lost track of what he owns. Even if this source is the king's collection."

Rheims nodded slowly.

"If you could, please be sure also that you always speak of Gulbenkian in the present tense to Doctor Perdigao. We always speak of him in the present tense." Maurice Rheims leaned forward and, sotto voce, he delivered a bit more information on his client. "No one among his associates admits that Calouste Gulbenkian has a problem with his . . . how to say this? With his corporeal existence…"

What could I say about this strange information?

It had stopped raining. We left the restaurant and we walked along the Seine in the wind. Across the bridges, the left bank and the towers of Notre Dame disappeared in a low fog that hung above the river. We were the only people in the world.

Maurice Rheims buttoned his overcoat. "If you could, dear fellow, please remember one last thing about the Gulbenkian collaterals you meet.

When you go to Geneva, when you meet Doctor Perdigao, you must never mention money. Please. He will simply hand you an envelope containing a check. That will be that."

Maurice Rheims adjusted his carefully knotted silk tie. He moved his glasses high up on the bridge of his nose with his index finger. Along the river, a fine, cold winter wind froze me to the bone.

Rheims handed the plaques back. "Here. Take them and go with god my dear protégé." In the fog he disappeared.

* * *

WINTER, 1963

Geneva had the forlorn look it gets when a thick, cold ice storm hangs over Lake Leman, in winter.

Along the lake front, the first winter storm had rimed the boats with a patina of translucent blue-black ice. The trees had lost their leaves. I tucked my coat around me in the wind as I trudged toward a street filled with depressing, identical eight-story buildings. It was along here somewhere that the unpleasant Swiss art dealer Haussmann had his shop. Behind me, the lake had now become invisible in the growing storm. It was morning. My watch read 10:45.

Of all the large cities in the world, the one I least liked was Geneva, Switzerland. The people were cold and humorless. Geneva itself was rigidly bleak and unwelcoming. Seemingly, the city had been built by the architects who had replicated, in a single leap of the imagination, the look of a single street, then created hundreds of indistinguishable streets all the same.

Dr. Perdigao lived on a street off the Quai des Bergues. The street looked quietly affluent.

I still wore my nice grey suit. In Switzerland, you were your clothes and your shoes. In Paris, I'd borrowed a pair of Peel shoes from a friend in banking who'd gone to my school. He was used to my appearing, borrowing things, and then disappearing. He was used to getting his things back in a newly washed or polished condition, even if they were returned to Paris from places that had strange postmarks. I always made it a

point of honor to post back his borrowed belongings. In
Geneva, I changed my gas mask bag for a leather briefcase.
I was expected at precisely eleven in the morning. I rang the
bell of apartment number nine. The door of the building opened
on an electronic latch. The lobby beyond was deserted.

I entered the elevator and selected a floor button. On the fourth
floor, I pushed open the elevator door. There, in front of me,
stood a housekeeper. The woman was in her sixties. She wore a
neat uniform. Without speaking, she motioned me down the
hallway in front of her. Extraordinary, Japanese Ukiyo-e prints
from the late Edo period of the 18th century austerely lined the
walls of the private hallway.

At the end of the hall was the living room, the main feature of
which was a single gigantic window overlooking the lake.

The man across the room, under a lap robe, watched me without
blinking. He sat there wrapped up with some kind of Muslim
hat on his head. It was the kind of hat that Renoir used to wear
when he was an old man.

The silence was totally unnerving. Finally, the ancient man
gestured around the room behind me. When he spoke his voice
sounded like the rasping of footsteps moving through dead
leaves.

"Do you like my paintings?"

I turned, facing in the opposite direction.

As I stood there, I was actually speechless. I simply stared at the
walls in shock. Silently, I counted the paintings on the walls.

They were indescribable.

"I am amazed," I managed. Actually, I was beyond amazement and admiration.

"And by what, in particular, are you amazed by young man?" the old man rasped. In a voice broken by age he spoke again in a not-too-friendly way. "Your amazed by the view of the lake outside the windows, or you're amazed by an old man, who has some paintings of a certain type?"

I'd come here to deliver some art, not to get into an argument with a sour ancient.

I took a deep breath and I looked again at the paintings, as I moved towards them. Traveling along the walls, my eyes moved over the canvases and I looked at one, then the next, and still the next. Only one or two museums in the world had paintings of this gravitas and quality, which had been completed during the period of these artists, and the decades of these Impressionists.

"From the years during which this work was painted, I have never, ever seen work done at this level of art before."

I didn't mind that the old man was unpleasant. Seeing these paintings was worth considerable pain. What was on these walls defied imagination.

"In the world there are ordinary Van Gogh's," I said. "Then, good Van Gogh's and, finally, a few truly extraordinary Van Gogh's. Every one of these is extraordinary."

For a long moment, Dr. Perdigao watched me. He decided something and, when he spoke next, he was angry. "Let us do our business. I'm an old man. Let me go back to being an old man. You can leave, you can go out the door, and then still go on being young."

I placed my bag on a table and unzipped it. Next, I placed the ivories wrapped in their new coverings of manila paper next to a stack of art books published in Paris during the 1920's.

Across the room, the old man stared at me with watery blue eyes full of suspicion. There was not a vestige of humanity in his eyes. From what I'd heard, he'd spent too many years in Gulbenkian's company.

I couldn't help it. Almost against my will, I was pulled back again across the room toward Dr. Perdigao's paintings. In the soft winter afternoon light, the paintings only became more startling. They were simply breathtaking. They were barely of this world, they were so wonderful.

"So?" the old man asked querulously. "Tell me? What's keeping you from your sales pitch for the things Maurice Rheims described to me?"

I ignored him. I pointed first at a Cezanne, then next at a Van Gogh. "Does anyone else in the world know that these paintings exist? Each of these paintings is unique. I can't remember seeing any of them in any museum, or in any of these artists' catalogue raisonné. They are … unbelievable."

When I was 11 years old, my mother had taken me to my first Impressionist exhibition. I admired Cezanne, but I loved the

insanity and the passion of Van Gogh better. In the years between then and now, I'd seen every Impressionist painting by Cezanne, by Gauguin and Van Gogh that I could find, in a now forgotten number of museums, and books.

I turned back toward the old man.

Had he been able to stand up from the chair he was fastened, he'd possibly be only five feet high. A prisoner of age, he sat staring at me, then slowly he pointed towards the Van Gogh closest to me.

"Tell me who is the sitter of that painting, and the one next to it?"

I crossed to the wall and studied the paintings. I knew only too well who the sitter was.

"The subject is Pere Tanguy," I answered. "Two unknown portraits. Paris. 1887. It was Pere Tanguy who sold pigments to Van Gogh. His paintings of Pere Tanguy were made in exchange for raw canvas and colors when the artist was too poor to pay for them."

The painting was of a man with an unusually flat and broad face, wearing a straw hat. There were other examples of Van Gogh's sittings with Pere Tanguy, but none like these.

Again, I looked closely at the Cézanne's. Everything I knew about Cézanne suggested that these pictures, like the Van Gogh pictures, had never been exhibited in any museum or illustrated in any book. They had never been seen by anyone.

In his chair the old man whispered. "Amazing. You are a wonderful monster."

With great deliberation, the old man turned away from me. He stared through the huge apartment window at the mists over Lake Leman.

Beyond the window, it began to snow. The brief rain had changed to ice. In silence the old man sat there as ice beat against the glass. Finally, the old man turned and looked across the room at his paintings.

"Forgive me. I was thinking about my father. These are his paintings. My father bought these paintings from Pere Tanguy. He bought them at Tanguy's shop, in 1888, when the old man had no money and he needed food so that he could stay alive. They had no value when they were sold. My father's money was a gift to a starving old man."

In the silence, what was there to say? It was like the past closed up over both of us.

The old man raised his hands in hopeless gesture. "You see, I don't have anything else except the past. Forgive my anger."

It was utterly quiet in the apartment now, except for the ice beating against the huge window. "I never invite people into my apartment. I've never let these paintings out of my sight. Maurice Rheims said you were a very interesting young man. He said that I should admit you to my home and that you'd understand my paintings. I confess I didn't believe him."

"Your father must have been astonishing," I said. On the far wall, the paintings were an indescribable testament to a

remarkable man who for three, even four decades was in advance of anyone else in the Western art world.

"He was. Oh, he certainly was," the old man nodded.

He waved me across the room, toward the table upon which my ivories rested.

I crossed to the table and retrieved the ivories. I brought them back to another table at the old man's side. Carefully, I unwrapped them and I spread them out in order. The ivories appeared now as they would have appeared when they'd circled the waist of a queen, two thousand years before.

With great trouble, the old man rose slowly.

He took four arduous steps to study the objects on the table. Holding the edge of the table, he stared down at the ivories. With difficulty, he raised his right hand, then delicately he reached out and touched them. One after the other, he moved his fingers over the surfaces of the ivories.

"So beautiful. So very beautiful. Isn't it extraordinary that they still survive?"

Dr. Perdigao turned. I helped him back to his chair and, as though made of glass, the old man sat down ever so slowly.

Across the table, the old man seemed far away wrapped up inside of one of his long silences.

"Do you like my paintings?" the old man asked, finally.

"They are wonderful. They bring something into life I've never seen before."

"You are very unusual. I've never spoken to anyone about Gulbenkian. I have kept his wishes to this point." The old man paused. His right eye was watering and, in an almost angry way, he wiped away the tears which ran down his cheek. "I wish to tell you about Gulbenkian. Then, perhaps you will understand something new about art and collecting art.

"He was a man who'd lost everything necessary for a man to live. Yet somehow, he lived on and on, like myself." Dr. Perdigao swallowed with the difficulty of speaking.

"Few people ever knew Gulbenkian. This was because he was afraid of everything and everyone. Gulbenkian was actually an extremely simple man. It was my father who introduced Calouste Gulbenkian to art. Before he met my father, Gulbenkian bought art knick-knacks. He had a penchant for extremely bad Armenian-Russian-style icons of terrible quality. He thought that they had overtones of his desperate experiences of exile and of Turkish mass murder of the Armenians. It was very sad that art was so dark for him."

The old man began to cough. It was a horrible, wracking cough that seemed to come from somewhere deep inside his chest. I thought maybe, right then, he'd die in front of me. I watched him, unable to do anything to help. How did you help anyone who was this old? Dr. Perdigao took several ghastly deep breaths. The coughing stopped.

"When did your father meet Gulbenkian?" I asked.

The old man began to speak in a whisper. "They met in 1903. My father was an early collector of painters like Cézanne and Van Gogh. He was equally early with the then minor Italians of the Sienese quattrocento. Stefani di Giovanni, and Domenico Ghirlandaio, etc."

Dr. Perdigao took a deep breath. "My father bought art when no one thought Impressionist or post-Impressionist painting had any value."

The old man seemed to step back from the void. His terrible coughing seemed to have somehow invigorated him.

I didn't interrupt or venture an opinion. The old man continued.

"Isn't it every man's fate to create his own hubris? Did you know that when my father and Gulbenkian first met, Gulbenkian was a man with absolutely no future? When my father first met Gulbenkian, he was a minor Ottoman bureaucrat in Istanbul among thousands of others bureaucrats in 1906. Who knew what would happen to my father's 'little Calouste,' as my father referred to him in moments of frustration? But Gulbenkian was an avid student. He had a remarkable memory. Of course, who could have known what would happen to Gulbenkian, and he came to own 5% of all the oil in the Middle East."

"What sort of person was Calouste Gulbenkian?" I asked.

"For years I've thought about that. He was a man, I think, who never lived in any normal sense of the word. He was angry at everything. I think he was angry because he was born without a soul."

In futility, a frail hand rose from Dr. Perdigao's lap only to collapse downwards.

In the room, the only sound was the ticking of the clock. During our conversation, the world beyond the huge window was quietly covered in white. I didn't speak. I had no experience with extremely old people. Perhaps suddenly, Dr. Perdigao's heart would simply stop functioning as ice and now snow blotted out the city below us. I was afraid to break the spell of this place, the spell of the old man who inhabited only his past.

The old man gestured around the single room in which he now lived. His whole life appeared to have shrunk to this space.

"After Gulbenkian died in Lisbon, I went back to his mansion in Paris on the Avenue d'Iena where he'd lived for 40 years. I climbed the stairs to his bedroom. No one had ever entered this room while he was alive. I understand him now. I have my own my prison cell, just as Calouste had his.

In Calouste's bedroom was the bed upon which he'd been born. It was one of those awful Turkish confections of dark wood and unappealing Rococo shapes. It was the bed that you found at the center of every Armenian family throughout the entire Middle East. It was the bed where the Armenian nation was created."

The old man paused, remembering. "Nothing had been changed in this room since the time of Calouste's birth. After he'd become one of the richest men in the world, he'd transported this whole room with him to Paris. Gulbenkian had one of the most famous art collections in the world but on the walls of his bedroom were the awful oleographs of biblical scenes you see everywhere in the world where Armenians settle.

410 · Clark Worswick

On the floor were threadbare rugs. They'd been used by his family for 250 years. As I first stood in that room, I wondered for the first time what were the gigantic Gulbenkian art collections about? The tens of thousands of objects and paintings? What did they mean? It struck me that Calouste had been a captive of his past all his life. No matter what he bought or collected outside this room, he'd never managed to escape to a place that wasn't haunted. For all of us we never escape who we are, despite the illusions created by collecting art. These objects are ours, but only for a moment."

The old man fell silent. It was as though this conversation had utterly exhausted him. He pointed to a desk across the room. On top of the desk was an envelope. He waved me wordlessly toward the desk.

I got up and crossed the room.

I picked up the envelope. My name was written upon the front. From across the room, the old man waved at me that I should open it.

I tore open the envelope.

Inside was a check made out to me for half a million dollars. It was drawn on the Union Bank of Switzerland. There had been no bargaining. I was given 10 percent more than I'd asked for.

People didn't do business like this anymore. This whole extraordinary meeting was done totally on Maurice Rheims' good name. I put the check inside my jacket pocket. I turned

back toward the old man across the room. Only princes had once done business like this.

Across the room Dr. Perdigao was asleep. His chin rested on his chest. He was breathing deeply. His sparse hair had fallen down over his eyes. I crossed the room as silently as I could and covered him with his blanket that had fallen onto the floor. I retrieved my bag.

At the door, I looked back one last time to gaze at some of the greatest paintings ever created in the history of art. I looked over at their strange owner across the room, and I left him there.

 Outside the building, I went out into the cold of a city I didn't like. I hugged the walls of the buildings where the snow hadn't drifted. Before I reached the train station, I stopped at Maurice Rheims' private bank.

According to Maurice Rheims' instructions I deposited the check with my new banker. The banker smiled in his impenetrable, humorless Swiss way when he saw the size of the check. Who knew what these people thought? Who cared?

I gave instructions for a $50,000 deposit in Maurice Rheims' account. I next gave instructions to the banker to deposit the Afghans $225,000 to their numbered Swiss bank account in Basel.

I exited the bank. I was at the railway station in ten minutes.

I bought a ticket to London and ordered an espresso at the railway restaurant.

I thought of the conflicted, brilliant and vastly knowledgeable Maurice Rheims. Raising my small cup of espresso in the air, I saluted Maurice. Thanks to the auctioneer and to the very strange and wonderful Dr. Perdigao, I now had $225,000 in my new Geneva account.

* * *

JAIPUR, FEBRUARY 1963

After Geneva I went to London. In London I was depressed by the weather and an entire country that had lost 400 years of their history in India.

Tired of the cold of Europe, tired of commuters everywhere, I returned to India. I wanted to thank the old librarian for my near miraculous introduction to the Maharaja of Kishangarh and then to the history of Rathore clans of Rajasthan.

I arrived back in Jaipur, returning to the places I'd been last year. The trip for Delhi had taken half a day and it was now evening. From my hotel it was a few short blocks to the library and perhaps the librarian lived somewhere in the vicinity of the library.

The library it was closed.

I moved around to the back of the building trying to find if someone knew where the librarian lived. In the dimming light I discovered a small garden. As I moved toward the garden, I noticed that all the plants seemed to have been trimmed. The pots of flowers ringing the path were arranged in neat, well-watered rows.

When I turned a corner of the garden, in front of me was a bubbling fountain. Near the fountain on a bench a woman in a dark purple silk sari sat in the shade of a huge tree.

The woman had been reading a book but now she was staring absently into the darkening sky. She seemed distracted. I stood there. Startled out of her reverie, the woman looked over at me.

"I'm sorry to disturb you," I said. "I've come to visit the library, but it's closed for the day. Do you know perhaps where the old librarian lives. I would like to see him."

The woman tilted her glasses down over the bridge of her nose. She settled on looking at me, perhaps trying to decide where I came from. "It's a private library you know. What do you want of the librarian?" the woman asked in a British upper-class accent.

"I'm finishing the research we started together. I need some additional help concerning matters we were discussing, two months ago, so I need to meet the librarian again."

The woman was of late middle age. She had one of those light olive complexions that, over the span of centuries, was the result of exacting and extremely careful genealogical selection. Her accent and imperious look left no doubt that she was a descendent of one of the princely families of Rajasthan.

How could I explain why I was here? I suppose, really, I wanted to thank the librarian. I wanted also to unravel the continuing mystery of the Maharaja of Kishangarh's help. Without that help I'd never have gotten into the palace of the Maharaja of Kishangarh. When I came to think of it I never actually met the Maharaja, only his Aide-de-Camp.

The eyes of the woman still watched me. They were both curious now and unwavering. "And you are?"

"A student."

"Of which university might that be, if I may inquire?"

"I began studying Indian history at Santiniketan. My specialty is the history of the Rajputs."

The woman's eyes softened. She removed her glasses and placed them in a red, tooled, soft morocco leather case, which could only have come from Florence. Deliberately, she placed the case in her purse where it rested next to her on the bench. I saw the book she was reading. It was a British novel by William Golding called *Free Fall*.

The title seemed adequate in describing my own condition in India over the last few years.

After a moment I plunged onward, but now with a qualification. "Today few people seem interested in Rajasthan. The librarian was exceedingly helpful to me.

Doubt settled in the woman's eyes. "I did not know that Santiniketan had foreign students."

"They had two foreign students, an American and a Russian. At least I heard, while I was there, they also had a Russian student."

The woman laughed suddenly and looked amused.

"Well, since you don't look Russian, you have to be the American, don't you? And what is your name Mister American student?"

I told her my name.

The woman, with her imperious manner, asked me to sit on the bench. I moved forward. As commanded, I sat.

Each time I'd witnessed a sunset in Jaipur, it was truly miraculous. Gold turned to pink. Pink turned to deep rust red. Finally, there were reflections of the golden, dust-filled Jaipuri streets filling the walls of the garden. In the garden we watched the sunset and neither of us spoke.

"My driver is outside. I must go," the woman said, finally as she rose. "It has been very nice to meet you."

Looking up at her, I stood. "Could I ask you a question?"

Standing now in front of me, with a regal tilt of her head, the woman seemed amused. "Certainly, you may ask a question."

"Do you know the librarian well? Do you know Shri Yagya Narayan Singhji, His Highness, the ex Maharaja of Kishangarh?"

The woman put her hand to her mouth in a gesture of surprise. It was the type of gesture that extremely feminine women make when they are startled. In the darkness, her eyes opened wide.

Wrong question, I thought.

In India, in the landscape of the princely families were never spoken secrets. It was probably a very wrong question to ask. t I'd puzzled out the question, back and forth, for months. The

fact that the old librarian was a senior member of the
Kishangarh royalty, was the only answer that fit my strange
reception in Kishangarh.

The librarian, when I'd thought about, seemed to have worked
very hard and gone to extremely great lengths to both erase and
to escape from his past.

There was just light enough to see that the woman looked very
sad, and she took a very deep, slow breath.

"The Maharaja of Jaipur first brought me to this garden. He
brought me here to meet Yagya Singhji, the Maharaja of
Kishangarh. I came here first as a very little girl. Do you have a
moment. I will explain about YaYa as we called him."

Slowly the woman in her elegant purple sari returned to the
bench. She sat there looking down at her hands, before she
glanced at me.

" When Ya Ya Maharaj went into exile we protected him from
people of his family who would have harmed him. Ya Ya never
wanted to be the Prince, and one day he became a senyasi. Do
you know what Sanyasi's are?"

I knew what a Sanyasi was. Few Princes in India except
Gautama, the founder of Buddhism, appeared to have renounced
the world of material pleasures. In the recorded history of
millennial India, a Sanyasi was a man who roamed the roads,
and pilgrimage sites with nothing but a begging bowl for food.

He returned to Jaipur, and our family built him this library as his refuge from the world. We maintained this garden for him. I've come here over the decades to his garden."

"You are a Jaipuri princess?"

The princess nodded. "The Maharaja of Jaipur was my father. Of a certain class in Rajasthan, we were all princes or princesses. Our past and what we are today is only a historical fact."

The woman looked more closely at me, then she asked, "Were you fond of His Highness Yagya Singhji?"

I nodded.

The princess pointed off toward the rear of the garden into an area where it was now pitch black. "For decades, he always came here at dusk to watch the sunset. This was his favorite place in the world, he said."

"We found him near the rear of his garden. It appeared he'd simply gone to sleep. There was no one to tell really that he'd died two months ago." The princess fell silent but after a moment she continued, "The whole clan thinks that he died on a pilgrimage to Mount Kailas, as a Sanyasi. For decades, we kept his presence in Rajasthan a secret from all of them."

I more than liked the librarian in our brief meeting. I was the one who told them in Kishangarh I'd met him before he left on the pilgrimage to Mount Kailas. He'd made up this story for me to tell them, so I could get into the archives.

The Princess didn't speak for perhaps a minute. She placed her two hands to her forehead and stared into the garden. "My mother when she was young was like a daughter to the Maharaja of Kishangarh when he was on the throne. In turn when he gave up his throne, it was my mother who gave him refuge in Jaipur. For her , a large part of her own life became this garden, which was inhabited by the strange, very wise refugee she'd taken in. She never forsook him. When she died, Yagya Singhji became my very interesting responsibility."

The princess took a deep breath. She mastered the emotions that almost overcame her. To the Rajput, showing emotion was a sign of great, and perhaps fatal, weakness.

She began to speak again. "He so revered learning. He said it was the greatest tragedy in our lives, in the lives of the princely families of Rajasthan, that we had no interests in our past. He said that, in our appalling deserts, we'd performed feats of war and chivalry which were unique. He said we were remarkable. He said that, in the entire world, we were the last remaining martial clans to reign. We were survivors of wars and great treachery. In this place, in our past, he told us we preformed feats of chivalry unimagined in grandeur."

The princess took a deep breath.

"But no one listened to him. And now, along with everything else, we know he's gone as well.. No one will ever listen again to the siren song of chivalry. You see, we're finished."

"I listened to him," I said, quietly.

The past, and all it meant in India, had simply melted away for people like this. Her eyes moved from the garden back toward me. She was inconsolable.

Then, the princess spoke suddenly, even brightly. "Is there anything that we can do here for you?"

"Do you think the library will ever reopen?"

"We're a country of the future, haven't you heard this yet? No one is interested in history anymore. I think you should leave India and live in the future with the rest of the world. Make money. Build up a commercial empire. My advice, my young scholar, is to forget the past. There is no profit in it."

I tried to protest but the princess turned away from me. She moved down the darkened path toward the gate of the garden.

As she moved in the very last light of day, the princess looked ethereal and scarcely human. In her dark sari, she floated rather than walked. She stood there with her back to me at the gate.

"And what about his garden?" I called after her.

At the gate, she turned, "My American student. I can't allow myself to give him up nor can I bear to think of what we once were. I am so sorry. Please forgive my bad manners."

The princess's voice was utterly devastated now. She was truly beautiful. "I shall maintain this garden. It's the only piece of him we have left. In the future, it will be here for you to visit. You must come back."

She paused and then the princess turned and disappeared into the night.

After a minute, I approached the gate through which she'd passed. A single street lamp winked on. Down the street was a waiting limousine. I was just in time to see the figure of the princess stepping into a huge car. It turned and majestically moved toward me. As it passed, I saw that it was another of those miraculous Phantom 1 Rolls Royce sedans with black coachwork.

It drifted past me from another time. In almost utter silence it disappeared under the single street lamp into the darkness.

I began to walk down the streets of Jaipur. Cooking smells of dinner wafted out of each house. In the distance was the sound of Hindu evening prayers. A conch shell began to blow, temple bells began to ring distantly.

The princess had answered my questions about the future.

I left Jaipur the next day.

* * *

DELHI, FEBRUARY, 1963

The day before. in Connaught Circus, I occupied my now usual room at the Hotel Palace Heights on D Block, in Delhi.

Each time I returned to this hotel it seemed more ancient. I was always taken by the fact that the wide verandas and my room probably hadn't been painted nor retrofitted since the last imperial Delhi Durbar in 1911.

It was at this event that Queen Mary and King George presented 26,800 Delhi Durbar silver medals to the men and officers of the British Indian regiments then "protecting" India from the Indians.

Presumably, by some strange and incomprehensible Anglophobic logic, the British Indian colonial government thought it wise to give their native Indian soldiers special medals for this useful work. At the durbar ceremony, the sovereigns appeared in splendid coronation robes and they wore brand new crowns designed, just for the occasion by the best London jewelers.

The king-emperor's crown contained 6,170 exquisitely cut diamonds. Additionally, the crown was encrusted with settings of sapphires, emeralds and one giant red ruby set directly over the king-emperor's nose. The giant crown gave the king-emperor a headache,so the crown has never since been worn as part of the royal regalia.

In the heat, I drifted off to jet lagged sleep, feeling I was somewhere over Anatolia, or the deserts beyond Meshed. The next morning, old Mohan, the hotel bearer, knocked at my door, which meant that my breakfast was ready for me on the wide terrace outside my room. I threw on my shirt and pants. On the veranda was my breakfast, resting next to my morning newspaper, and waiting for me beside an oversize, steaming, white tea pot. Alongside the pot, was a large white cup and saucer with a small creamer full of fatty buffalo milk. Buffalo milk was unique and indispensable in the makings of a rich Indian *dudh chai*. My world seemed justly ordered. It was perfect.

In the heat of the morning sun, I thought back to England and the winter cold of northern Europe.

I remembered the huge chop of the channel and my dreadful crossing. As I thought about it, there had not been a single five minutes in Europe when I hadn't felt totally paranoid over the sale of the Afghan ivories. In London, I viewed the stocks of Indian miniatures at Spinks and Maggs Brothers. Nothing as yet compared to my Kishangarh paintings on the London market.

I still couldn't believe my good fortune. That morning at breakfast, I hardly yet believed the fact that selling the ivories worked out so well, and I was now extremely solvent.

After a few weeks in India I contemplated a leisurely tour of the southern parts of Asia. I wanted to travel to Singapore, then up the spine of Malaya to Thailand. I wanted to visit a dirty little town I'd found called Phuket, which had one of the nicest beaches I'd ever been to in Southeast Asia. Then, I'd return to

Bombay and travel to Hyderabad, where I knew a collector named Jagdish Mittal, who could point me towards some Decanni paintings to add to my collection.

I poured my tea, buttered my toast and ate my eggs slowly, savoring the indolence of not having to worry about money and not having to be anywhere in particular.

I felt the world was absolutely right. However, the image of the two men I'd seen the night before, when I climbed the stairs to my hotel nagged at me, like tiny footsteps in the dark. They'd been across the street from the hotel; they'd been watching for something.

Definitely, they were CID. But then, I'd seen CID police everywhere I'd traveled in India for years.

After stretching, I opened the morning newspaper. I took another sip of tea and had an absolutely brutal, immediate, and awful sinking feeling.

On the bottom of the first page, over a headline done in 24-point type, was an article titled, "Afghanistan: Nephew of King Zahir Imprisoned for Theft in Kabul."

"Oh, Christ!" I whispered.

The article continued, "Kabul, December, 29. Unnamed sources have informed us that the interior minister of Afghanistan has been remanded into police custody in connection with thefts from the Afghan imperial collections of art treasures."

Underneath this heading, the article then plumbed the depths of very bad news for me.

"It has been alleged that the interior minister and nephew of the king, Prince Selim, has been part of an ongoing conspiracy to loot the treasury of the Afghan monarch. Allegedly stolen from the royal collections were objects of precious art and important archaeological objects. Under Afghan law, a royal special commission has been charged with investigating these improprieties, with severe punishments."

Prince Selim, my erstwhile friend, I recalled was the minister of interior affairs as well as the minister responsible for the Afghan police and for the kingdom's internal security. The prince was also the head of the customs and immigration police and, as I recalled, he was the head of the Afghan archeological and museum departments as well.

King Zahir must have been quite put out to imprison his nephew, over this problem of stolen art objects.

The article went on to detail somewhat dolefully, "Also implicated in the accused conspiracy is the vice minister of the Interior Ministry, Mr. Dara Jalali, of the royal household. Both members of the royal government have also been implicated in a larger conspiracy, which, over the years, has resulted in vastly overinflated government contracts for Afghan military procurement, and for the theft of possibly hundreds of objects taken from the royal treasury."

In a kind of horrible fascination, I drew in a slow breath.

I read onwards. "In regards to the putative art thefts, after intensive police investigation, it appears also that the vice minister of the Interior Ministry, Mr. Dara Jalali, is also implicated. Through connections with leading international art criminals, Mr. Jalali arranged for numbers of objects precious to the patrimony of Afghanistan to be illegally transported out of the country."

"Intense investigations are proceeding. Implicated in this international art theft ring are both British and American citizens who are presently being sought for their connections to this affair."

Could this be any worse for me? After I was apprehended in India, then extradited northwards to Kabul, I'd get a sentence of perhaps two hundred years in an Afghan jail. I was 23 years old.

Probably, by now, they'd arrested the driver who'd taken me up to the border, along with the Interior Ministry official who'd accompanied me.

The police in Kabul would throw them into a pit full of spiders, scorpions and deadly mountain snakes.

I couldn't recall if they'd franked my passport at the Afghan border of Torkham. If they had, they'd now have my name and my passport number. I rushed back to my room, knocking over a chair in the hallway. In my room, I got out my passport and opened it.

By some oversight, the Afghan border police hadn't stamped my

visa coming into or out of Afghanistan. Looking carefully at a splotch of ink on my passport, it looked like my Pakistani visa itself had become colonized by the remains of a truly large squashed bug.

When I studied the visa, I noticed that the Pakistanis apparently hadn't franked their visa page either. Small things. Thank God for small things that became big things.

The article had implicated "other" Europeans and Americans. When I thought it over, there was no shortage of whacked-out Americans and Europeans in Kabul ready for any desperate adventure. This suggested the usual procedure in Kabul when detecting criminality, to determine who was a criminal: Round up five or six Westerners. Charge them with crimes against the state, whatever the crime may have been and, after a few months stay in Kabuli jail cells, most of these dope addled unfortunates would confess to anything.

God help these poor souls. Wrong place. A truly dreadful future. They'd get to spend their next few potentially productive decades learning Pashtun, a language that sounded like you were chewing dirt.

When I dwelt upon it, I hadn't actually seen Dara or Prince Selim for possibly a year. It was Jane who'd conducted all my recent negotiations on behalf of the prince.

I hoped fervently that in the last weeks Jane had left Afghanistan to take up her life of *haute coutier* and fashion in the West. I hoped that fervently! I hoped also that Prince Selim and Dara would work around their own problems with the king.

It seemed to me that in Kabul, members of the royal family had fallen short of money. They'd decided to whack off some of the king's treasures. Zahir Shah, the King of Afghanistan, was notoriously tight with money, and perhaps after these thefts had been discovered, he'd decided to punish random members of his own family.

In my hotel room, I dug out a small mirror work bag that fit around my chest. I dropped one Leica M2 that I'd bought in Hong Kong into the bag. Next went sunglasses, a hat, three shirts and an extra pair of shorts. Cash. I stuffed $4,250 in 50-dollar bills into my money belt, along with two passports.

The older passport was decorated with six accordion-long extensions representing nearly two hundred thousand miles of travel over the last four years. On each of my American passports was a different name. I shoved the mirrored bag into the small of my back.

The rest of my possessions I left for the Criminal Investigation Division.

Ready to go. Finally, for me, India was over.

Time to leave.

The End

POSTSCRIPT

Looking back at the pageant of it all, in the Indian art world there was a moment in the early 1960' when classical Indian art launched itself into the dazzling trajectory of a just invented Russian space vehicle.

If you were early into the market acquiring Indian classical art and antiquities, it was like watching a drag racer loaded with nitro fuel burst off the starting line. What you witnessed was nothing less than the miracle of acceleration, and of gigantic "g-forces" at work.

In Jaipur, Indian paintings, that cost a dollar in 1961, were selling for $50,000 in London by the late 1960s. Similarly, in 1961, Buddhist gilded statues taken out of Tibet, after the Chinese invasion, were sold in Delhi by the refugees outside the Khadi Emporium for 40 and 50 dollars. By the late 1960's, five years later, these same sculptures were selling for tens of thousands of dollars in both Europe and America.

But then something happened in India.

By the beginning of the 1970s, as these prices of Indian art levitated upwards into the stratosphere, an attempt was made by the Indian government to preserve their antiquities. Henceforth, all art dealing, and the unregistered export of art, with the exception of goverment permitted art exports, was made a criminal enterprise.

See: A Villanious Trade The Curse of the Outcast Artifact

In the Colaba section of Bombay, where I first began collecting Indian classical art, the former Indian art dealers would not admit that they had ever dealt in antiquities. When asked if they sold art, these dealers protested that they were simple curio dealers. It was a lovely turn around for an intensely greedy group of people, who apparently had returned to their earlier, simpler roots.

In India some of these dealers were humble merchants of reproductions and curios. Abroad, these same dealers began to travel more frequently in a trade that had turned into big business.

The largest Indian antiquity dealers now ran their deals from New York, or London, or Switzerland. Collectors paid for their purchases by wire transfer into a numbered international account in a tax haven country.

Good Indian classical art soared to hundreds of thousands of dollars, then millions of dollars for a particular "piece." I vividly remember Manu Narang, who became one of the biggest art dealers in India. In the late 1950's, before his successes as an art dealer, Manu was sleeping on a park bench behind the Prince of Wales Museum in Bombay.

But the Indian classical art world was not primarily a story of curio dealers who became art dealers, nor about the few foreigners who came to India to collect amazing art.

The core of the Indian art collecting world was established by the Indians themselves in the 1950's, and the 1960's. Almost

universally and selflessly, it was the Indian collectors who supported classical Indian art by preserving and collecting magnificent, otherworldly Indian objects. In India virtually no one else took any notice, nor cared the slightest about the artistic treasures of an entire subcontinent.

Perhaps a collector had managed to save antiquarian sculptural masterpieces from the melt pot of the scrap metal dealers of Ahmedabad or Nagpur in western, or on the pavements of the Chor Bazaar in Bombay. Spread out on the pavements in the thieves market they discovered bronze art works created during the last thousand years.

In Northern India other collectors had been in the countryside picking up sculpture amidst the ruins of kingdoms forgotten by time, and peasants with their onion crop unearthed extraordinary masterpieces.

But all of this changed, for both the Indian collectors and myself from 1963 onwards. The market began to thin out. Fewer objects appeared. In this growing scarcity, I became intensely distrustful of all Indian art deals. I became intensely suspicious of *provenance* and the origins of high-priced art. I also worried about art sourced from temple thefts, and fakes.

In the early 1960's, there were no such things as fakes in the Indian art field. Who would fake something that he sold for 30 dollars? It took longer and was more costly to fashion a good fake than you could ask for an original. By the late 1960's this changed, and the art duplication industry switched into high gear. In my own opinion, anyone who bought stone sculpture or

an Indian "miniature painting" after the late 1960's bought objects that were almost universally faked.

If by some malign happenstance a collector had been lucky enough to be both a citizen/resident of India, and an art collector in the 1950's, and the early 1960s, he collected during the golden period of Indian art gathering. It was a moment when virtually everything was available. But in a universe of fewer and fewer pleasures for the collector of Indian classical art, I reserve my greatest pity for the collector who lived in India during the decade of the 1970's.

During the tenure of Prime Minister Indira Gandhi, the government of India sought to completely curb the private collection of Indian art on the subcontinent. In 1972 the Central Indian government enacted a new set of laws titled *The Antiquities and Art Treasures Act.*

The law read: "On and from the commencement of this Act, it shall not be lawful for any person, other than the Central Government or any authority or agency authorized by the Central Government … to export any antiquity or art treasure." Shipping art out of India became an energetically prosecuted criminal endeavor. Additionally, by law, if you possessed anything as a collector, you were now obligated to register with the government each and every piece of art you owned that was over 100 years old.

The laws for "possession" were draconian. If you didn't register your art objects, they could be confiscated by the government because you were now a criminal. By means of these new laws,

the government simply torpedoed Indian ownership of Indian classical art and antiquities. If you were a prince or a postal clerk it was a sad end for a generation of people who had both loved Indian classical art, and who spent lifetimes rescuing this art.

In India, collecting art was now deeply suspect. It became not only unpatriotic, but in government speak, it was also "selfish". The result, of course, was that no Indian collector worth his salt admitted to owning anything except for his "reproductions." In this new era of Indian art, with what I imagine was a puckish sense of humor, a collector would exhibit his truly terrible forgeries, while his "real" art was known only by rumor.

For myself sometimes I think of my own art collections. I go back to when I began collecting. To me it seems that governments today create huge numbers of laws governing both the sale and the international transport of art.

Recently laws in America have been put into place restricting any museum in the country from accepting art objects, even as donations, without foreign sourced official government export permits of this art. Happily collections formed before 1970 are exempted by law. But remember in 2016 this is 46 years ago.

In 1959 I began to walk that narrow line between art collecting and governments. Seen from my own point of view, my crime was moving my art from one place to another. I was considered a criminal. My crime was possession.

See:

*http://www.mfa.org/collections/provenance/acquisition
s-and-provenance-policy*

In the United States, after 2008, the American Association of
Musueums forbade the collecting of antiquities acquired after
1970, without country specific export certificates.

Guardians, The Elephanta Caves, Bombay, 1959

BOOKS

CLARK WORSWICK

The books below: *The Last Empire, Princely India, Imperial China,* and *Japan* were the first books ever written on classical 19th century photography where 70% of the world's populations live. These books were of places, and landscapes that, were then unchanged.

The Last Empire, Photography in British India, 1855-1911 (1976), Aperture. Introduction by Lord Mountbatten, Additional Text Ainslie Embree. 10th edition in print

Imperial China, Photographs 1850-1912 (1979) Crown Publishers. Additional Text, Jonathan Spence.

An Edwardian Observer, The Photographs of Leslie Hamilton Wilson (1978) Crown Publishers.

Japan, Photographs 1854-1905 (1978) Alfred A. Knopf). Additional Text, Jan Morris

Princely India, Photographs of Raja Deen Dayal,1884-1910 (1980) Alfred A. Knopf. Additional Text, J.K. Galbraith.

Walker Evans: The Lost Work (2000) Arena Editions.

Kenro Izu: Sacred Places (2001) Arena Editions. (The Photography book of the Year, 2002) Edward Curtis: the Master Prints (2001) (2 Editions) Arena Editions

Abbott/Atget (2002), Arena Editions, Santa Fe, NM

Festival of Lights: Photographs of India at Night (2004) Giraud Foster, Essay By Clark Worswick, Man & Lion Press

Paris Changing: Revisiting Eugene Atget's Paris
Photographs of Robert Rauschenberg, (2007)
Princeton Architectural Press, N.Y.

Sheying: Shadows of China, 1850-1900. (2008)
Turner Books, Madrid

Gardens of Sand, Photography in the Middle East 1859-1900, (2010) Turner Books, Madrid 2 editions

Walker Evans: Decade by Decade, (2011) Hatje Kantz,
Collaboration with James Crump. Prize as: "One of
the ten best books of the year published in the United States,"
The American Library Journal

*The Orchid House: Art Smuggling and Appointments in
India and Afghanistan,* (2012) Midnight Books, 1st Edition

*The Orchid House: Art Smuggling and Appointments in
India and Afghanistan,* (2016) Midnight Books,
(2nd Edition)

ArtMachine: A Reinvention of Photography 1959-1999, (2016)
Midnight Books

*The Rivers of Forever:The Chinese Photogqphs of Donald Mennie
1905-1926 (2019) Midnight Books, Samidzat 1.*

*The Great Within: Photographs of India: The British
Raj and Princely India in the 19th century. (2019)
Midnight Books/ Samizdat1 2019*

Photographs of India, 1959-1999. Clark & Joan Worswick.
Midnight Books/ Samizdat1 (2019)

Ethiopia, The First People, Clark & Joan Worswick. (2019)
Midnight Books/ Samizdat1

California Manufacturing the Future, Clark Worswick.
Midnight Books/ Samizdat1 (2019)

*]****

ABOUT THE AUTHOR

In the 1970's Clark Worswick's book *The Last Empire*, with an introduction by the last British Viceroy to India Lord Mountbatten, contributed to a re-examination popularization of the grand epoch of the British Raj. The book is in its tenth edition. Worswick has written eight books on west-Asian subjects and his books have been selected as "Best of the Year" by *Time*, *Newsweek*, *The Sunday Times* (London), *The New York Times*, and *The Washington Post*.

In 2010 a book on his extensive collection of photographs by the iconic photographer *Walker Evans: Decade by Decade* was selected as "One of the ten best books of the year" published during 2011 by *The American Library Journal*.

The Orchid House is for the most part based on actual events. The remaining portions this work are posed as "biographical fiction", the purpose of which is to protect still living persons from the scrutiny of the Indian Criminal Investigation Division.

Made in the USA
Coppell, TX
17 November 2021

65930106R00243